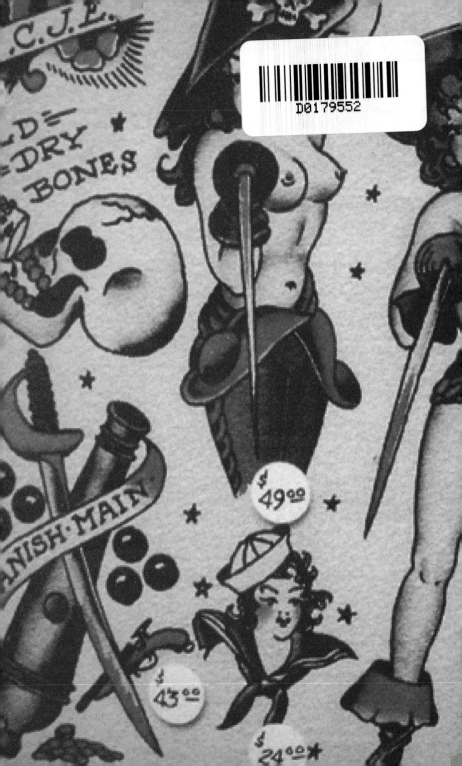

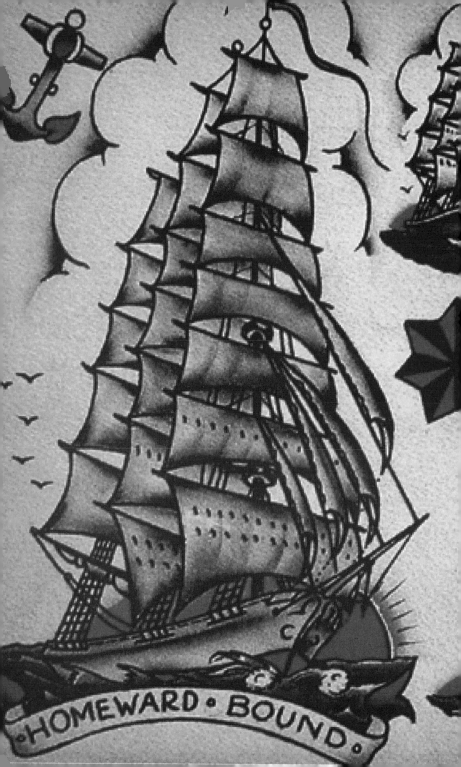

HOMEWARD • BOUND •

# The Body Adorned . . .
## In Fact and Fiction

- ELIZABETH McCRACKEN tells a tale of romance, loss, and a walking, breathing love letter . . .

- On a literary canvas WILLIAM T. VOLLMANN paints a portrait of a skinhead girl who wears her rage on her thigh . . .

- KAROL GRIFFITH recalls how she animates her art, from fruit to flesh...

- From a historical palette, MADAME CHINCHILLA tracks the sinuous, true trail of the illustrated woman . . .

- RICK MOODY describes how he paid homage to his literary achievement in a place where no prize committee can find it . . .

- In a story of deliverance, ALEJANDRO MURGIA follows a motorist who picks up a temptress with the mark of danger on the highway to hell . . .

- DEENA METZGER reflects on her own liberation through illumination of an intimate bodily scar . . .

## Dorothy Parker's Elbow

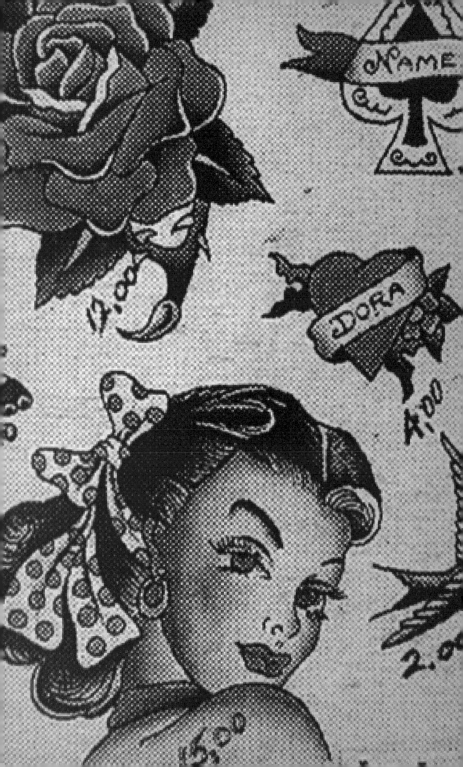

# Dorothy Parker's Elbow

## Tattoos on Writers | Writers on Tattoos

*Edited by*

Kim Addonizio

*and*

Cheryl Dumesnil

**WARNER BOOKS**

An AOL Time Warner Company

Warner Books, Inc., 1271 Avenue of the Americas, New York, NY 10020

Visit our Web site at www.twbookmark.com.

An AOL Time Warner Company

Printed in the United States of America

First Printing: October 2002
10  9  8  7  6  5  4  3  2  1

ISBN: 0-446-67904-6
LCCN: 2002107286

*Book design and text composition by Ralph Fowler*
*Cover design by Brigid Pearson*
*Cover photo by Tim Ridley/The Image Bank*

*For the tattooed—*
*and those who love them.*

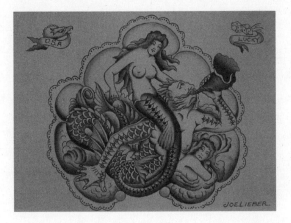

Thanks to our agent, Rob McQuilkin, for his enthusiasm for this project and his understanding of what this book is about; and to Amy Einhorn and Sandra Bark at Warner, for making it fun. We're also grateful to the Santa Clara University English Department for administrative support, especially Christine Mielenz, Ahmad Ahmadi, and Carole Wentz, and to all the writers who lent their support and their voices to keep the project alive. Special thanks to our partners, Robert Specter and Tracie Vickers, for staying up late to discover proofreading skills they didn't know they had.

# Contents

# Introduction

Once the terrain of drunken sailors and circus freaks, in the past twenty years the American tattoo parlor has attracted individuals as diverse as our nation's population. Whatever the motivation or background, no matter how large or small the design, baring your flesh to the tattooist's needle initiates you into the tribe—a tribe that has grown enormously in recent years. Celebrities and star athletes flash tattoos for the paparazzi and fans. Across the country, yearly tattoo conventions draw thousands of the curious, the initiated, and the deeply committed. The local newsstand carries a variety of tattoo trade magazines, with images and articles that range from the obvious to the erudite. Grocery stores display temporary tattoos to boost point-of-purchase sales, and henna tattooing has replaced face painting at community art festivals. Business magazines recommend temporary tattoos as an alternative to traditional promotional gifts like pencils and paperweights. Even Butterfly Art Barbie—a recent incarnation of that icon of regressive femininity—wears a tattoo on her belly. Though Mattel deleted the word *tattoo* from Butterfly Barbie's box to appease conservative parents' fears, they also include butterfly stickers for children to wear, just like Barbie.

Clearly, tattooing has emerged from the underbelly to the surface of the American landscape. And as the popularity of tattoos has expanded, so has the art itself. No longer restricted

to Bettie Page look-alikes, muddy blue anchors, and ribbon-wrapped hearts reading *Mom,* today's tattoo images make bold statements of personality, as individualized and varied as any art form.

Unlike other fashions, hobbies, and interests, tattooing, by its very definition, does not lend itself to fads—it creates permanent art. Perhaps that explains why, despite its move from the social fringe to a newly won place in the American mainstream, tattooing retains an aura of glamour and edge. In a culture that fears commitment, loves individualism, and takes guilty pleasure in the macabre, tattoos fascinate. Ask anyone who sports a tattoo—as soon as you reveal that you have one (or two, or three), the questions begin: "What did you get? Where did you get it? Can I see it? Have you ever regretted it? Did it hurt?" Or, as our mothers asked us, "Why would you want to do *that*?" Behind every tattoo stands a story that people want to hear. Our interest in those stories led to *Dorothy Parker's Elbow*. In fact, the title came about when we discovered that this irreverent author, always ahead of her time, had a star permanently inked on her elbow.

A few well-known authors from previous generations—including Herman Melville, Flannery O'Connor, and Sylvia Plath—wrote tattoo stories in their time. And when we put out our call for contemporary writing, we found some of our most talented authors following that lead, offering us varieties of experience and attitude that match the wide-ranging meanings of tattoos themselves. It's not surprising, of course, that tattooing, a language of symbols, should find some correspondence in literary language, in stories and poems that use symbol and metaphor to probe the meaningful moments of human experience with sharply etched words. Not surprising at all that top-notch writers would produce such a fas-

cinating array of work on an art form that, since its beginnings in ancient Egypt, has helped to define and challenge our sensibilities.

*Dorothy Parker's Elbow* includes offerings from several well-known writers and a few newcomers. Herman Melville writes about a nerve-racking experience on Typee, where he feared that natives would tattoo him against his will. In Flannery O'Connor's "Parker's Back," we read about a man who attempts to keep the love of his devout wife by having Jesus inked on his back. Mark Doty tells the stories behind his tattoo, while J. D. McClatchy explores everything from primitive ritual practices to Modern Primitives. In her lyrical reflection, tattoo artist Madame Chinchilla covers the history of the tattooed woman, while Karol Griffin teaches us how one learns to tattoo, first on a grapefruit, then on a devoted friend's skin. Joy Williams, Rick Moody, Darcey Steinke, and others contribute short takes on the practice. In "A Toda Máquina," Alejandro Murguía takes readers on a fast-paced road trip with a *vato* who falls for a tattooed stranger and throws his own self-destruction into high gear. Poet Denise Duhamel gives us a pantoum that begins with—who else?—Tattoo, the diminutive seventies star from TV's *Fantasy Island*. Auschwitz survivor Paul Steinberg remembers the day a concentration camp official tattooed his wrist. Deena Metzger describes the liberation she feels, symbolized by the tattoo that winds around her mastectomy scar. As this partial list of contents shows, tattoo literature covers the range of human experience, from the absurd to the profound.

Ultimately, tattooing, like writing, taps into existential questions: Who are you? Where do you belong? These days, in relationship to the tattoo world, everyone belongs somewhere: You are tattooed, you are thinking about it, you are

disgusted by it, you create tattoos on others, you almost did it, you wish you hadn't, you're afraid of needles, your cousin has the names of five ex-girlfriends on his forearm, you are hiding an inch-wide butterfly on your shoulder blade, you have orange and red flames crawling up your legs, you have always wanted the words *Carpe Diem* emblazoned on your rear end. No matter how you feel about tattoos, these writings will get under your skin.

*As he entered the shop, he felt himself to be in a mysterious region, a place more precious than any he'd visited. Here must be his sexual desire. White papers of all sizes covered the clean, white walls. Female pirates, snakes winding around razor-sharp white swords, sapphire cats larger than a human head whose fingernails were black or blackened roses, anchors stuck into the tails of large scarlet and magenta fish whose eyes held the maps of treasure seized through murder, and other oddities of the rainbow covered the white pieces of paper.*

*The walls were worlds.*

KATHY ACKER
*Empire of the Senseless*

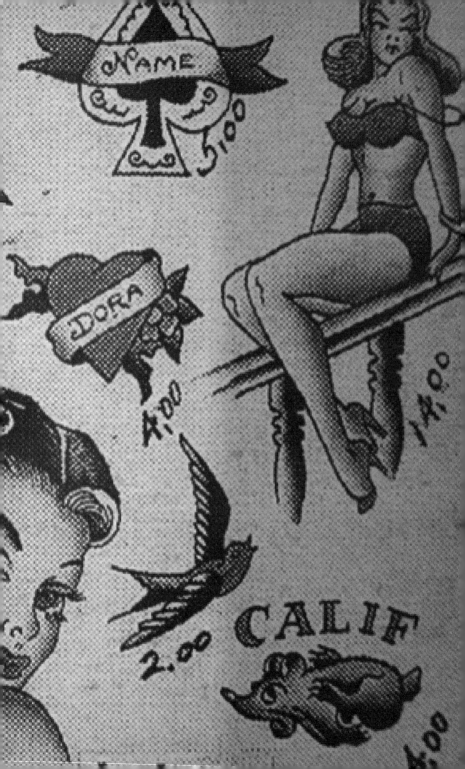

# Dorothy Parker's Elbow

## *from* The Illustrated Man

**RAY BRADBURY**

It was a warm afternoon in early September when I first met the Illustrated Man. Walking along an asphalt road, I was on the final leg of a two weeks' walking tour of Wisconsin. Late in the afternoon I stopped, ate some pork, beans, and a doughnut, and was preparing to stretch out and read when the Illustrated Man walked over the hill and stood for a moment against the sky.

I didn't know he was Illustrated then. I only knew that he was tall, once well muscled, but now, for some reason, going to fat. I recall that his arms were long, and the hands thick, but that his face was like a child's, set upon a massive body.

He seemed only to sense my presence, for he didn't look directly at me when he spoke his first words:

"Do you know where I can find a job?"

"I'm afraid not," I said.

"I haven't had a job that's lasted in forty years," he said.

Though it was a hot late afternoon, he wore his wool shirt buttoned tight about his neck. His sleeves were rolled and buttoned down over his thick wrists. Perspiration was streaming from his face, yet he made no move to open his shirt.

"Well," he said at last, "this is as good a place as any to spend the night. Do you mind company?"

"I have some extra food you'd be welcome to," I said.

He sat down heavily, grunting. "You'll be sorry you asked me to stay," he said. "Everyone always is. That's why I'm walking. Here it is, early September, the cream of the Labor Day carnival season. I should be making money hand over fist at any small town side show celebration, but here I am with no prospects."

He took off an immense shoe and peered at it closely. "I usually keep a job about ten days. Then something happens and they fire me. By now every carnival in America won't touch me with a ten-foot pole."

"What seems to be the trouble?" I asked.

For answer, he unbuttoned his tight collar, slowly. With his eyes shut, he put a slow hand to the task of unbuttoning his shirt all the way down. He slipped his fingers in to feel his chest. "Funny," he said, eyes still shut. "You can't feel them but they're there. I always hope that someday I'll look and they'll be gone. I walk in the sun for hours on the hottest days, baking, and hope that my sweat'll wash them off, the sun'll cook them off, but at sundown they're still there." He turned his head slightly toward me and exposed his chest. "Are they still there now?"

After a long while I exhaled. "Yes," I said. "They're still there."

The Illustrations.

"Another reason I keep my collar buttoned up," he said, opening his eyes, "is the children. They follow me along country roads. Everyone wants to see the pictures, and yet nobody wants to see them."

He took his shirt off and wadded it in his hands. He was covered with Illustrations from the blue tattooed ring about his neck to his belt line.

"It keeps right on going," he said, guessing my thought.

"All of me is Illustrated. Look." He opened his hand. On his palm was a rose, freshly cut, with drops of crystal water among the soft pink petals. I put my hand out to touch it, but it was only an Illustration.

As for the rest of him, I cannot say how I sat and stared, for he was a riot of rockets and fountains and people, in such intricate detail and color that you could hear the voices murmuring small and muted, from the crowds that inhabited his body. When his flesh twitched, the tiny mouths flickered, the tiny green-and-gold eyes winked, the tiny pink hands gestured. There were yellow meadows and blue rivers and mountains and stars and suns and planets spread in a Milky Way across his chest. The people themselves were in twenty or more odd groups upon his arms, shoulders, back, sides, and wrists, as well as on the flat of his stomach. You found them in forests of hair, lurking among a constellation of freckles, or peering from armpit caverns, diamond eyes aglitter. Each seemed intent upon his own activity; each was a separate gallery portrait.

"Why, they're beautiful!" I said.

How can I explain about his Illustrations? If El Greco had painted miniatures in his prime, no bigger than your hand, infinitely detailed, with all his sulphurous color, elongation, and anatomy, perhaps he might have used this man's body for his art. The colors burned in three dimensions. They were windows looking in upon fiery reality. Here, gathered on one wall, were all the finest scenes in the universe; the man was a walking treasure gallery. This wasn't the work of a cheap carnival tattoo man with three colors and whisky on his breath. This was the accomplishment of a living genius, vibrant, clear, and beautiful.

"Oh yes," said the Illustrated Man. "I'm so proud of my

Illustrations that I'd like to burn them off. I've tried sand-paper, acid, a knife . . ."

The sun was setting. The moon was already up in the East.

"For, you see," said the Illustrated Man, "these Illustrations predict the future."

I said nothing.

"It's all right in sunlight," he went on. "I could keep a carnival day job. But at night—the pictures move. The pictures change."

I must have smiled. "How long have you been Illustrated?"

"In 1900, when I was twenty years old and working a carnival, I broke my leg. It laid me up; I had to do something to keep my hand in, so I decided to get tattooed."

"But who tattooed you? What happened to the artist?"

"She went back to the future," he said. "I mean it. She was an old woman in a little house in the middle of Wisconsin here somewhere not far from this place. A little old witch who looked a thousand years old one moment and twenty years old the next, but she said she could travel in time. I laughed. Now, I know better."

"How did you happen to meet her?"

He told me. He had seen her painted sign by the road: SKIN ILLUSTRATION! Illustration instead of tattoo! Artistic! So he had sat all night while her magic needles stung him wasp stings and delicate bee stings. By morning he looked like a man who had fallen into a twenty-color print press and been squeezed out, all bright and picturesque.

"I've hunted every summer for fifty years," he said, putting his hands out on the air. "When I find that witch I'm going to kill her."

———

The sun was gone. Now the first stars were shining and the moon had brightened the fields of grass and wheat. Still the Illustrated Man's pictures glowed like charcoals in the half-light, like scattered rubies and emeralds, with Rouault colors and Picasso colors and the long, pressed-out El Greco bodies.

"So people fire me when my pictures move. They don't like it when violent things happen in my Illustrations. Each Illustration is a little story. If you watch them, in a few minutes they tell you a tale. In three hours of looking you could see eighteen or twenty stories acted right on my body, you could hear voices and think thoughts. It's all here, just waiting for you to look. But most of all, there's a special spot on my body." He bared his back. "See? There's no special design on my right shoulder blade, just a jumble."

"Yes."

"When I've been around a person long enough, that spot clouds over and fills in. If I'm with a woman, her picture comes there on my back, in an hour, and shows her whole life—how she'll live, how she'll die, what she'll look like when she's sixty. And if it's a man, an hour later his picture's here on my back. It shows him falling off a cliff, or dying under a train. So I'm fired again."

All the time he had been talking his hands had wandered over the Illustrations, as if to adjust their frames, to brush away dust—the motions of a connoisseur, an art patron. Now he lay back, long and full in the moonlight. It was a warm night. There was no breeze and the air was stifling. We both had our shirts off.

"And you've never found the old woman?"

"Never."

"And you think she came from the future?"

"How else could she know these stories she painted on me?"

He shut his eyes tiredly. His voice grew fainter. "Sometimes at night I can feel them, the pictures, like ants, crawling on my skin. Then I know they're doing what they have to do. I never look at them anymore. I just try to rest. I don't sleep much. Don't you look at them either, I warn you. Turn the other way when you sleep."

I lay back a few feet from him. He didn't seem violent, and the pictures were beautiful. Otherwise I might have been tempted to get out and away from such babbling. But the Illustrations . . . I let my eyes fill up on them. Any person would go a little mad with such things upon his body.

The night was serene. I could hear the Illustrated Man's breathing in the moonlight. Crickets were stirring gently in the distant ravines. I lay with my body sidewise so I could watch the Illustrations. Perhaps half an hour passed. Whether the Illustrated Man slept I could not tell, but suddenly I heard him whisper, "They're moving, aren't they?"

I waited a minute.

Then I said, "Yes."

The pictures were moving, each in its turn, each for a brief minute or two. There in the moonlight, with the tiny tinkling thoughts and the distant sea voices, it seemed, each little drama was enacted. Whether it took an hour or three hours for the dramas to finish, it would be hard to say. I only know that I lay fascinated and did not move while the stars wheeled in the sky.

Eighteen Illustrations, eighteen tales. I counted them one by one.

Primarily my eyes focused upon a scene, a large house with two people in it. I saw a flight of vultures on a blazing flesh sky, I saw yellow lions, and I heard voices.

The first Illustration quivered and came to life. . . .

# A Toda Máquina

**ALEJANDRO MURGUÍA**

She was hanging around the parking lot at an AM/PM in Sacramento, a little Chicanita with tight jeans tucked into lizard-skin cowboy boots and a small suitcase held together with duct tape. Her sunglasses sparkled with rhinestones, giving her a glitzy look that didn't fit in around here among the trash and homeless pushing shopping carts. This was the rough part of Sacra, where desperate women turned tricks in cars under the shadow of the State Building. She wasn't exactly hitchhiking, *me entiendes,* but she didn't need a sign that said here was a *huiza* ready to split Dodge.

I'd nearly finished pumping the fifteen gallons of Supreme when she came up behind me and said, "Can I ride with you to the freeway?" Her voice had something about it that made my stomach tighten up a notch.

I turned around real slow like and there she was in the shimmering heat of the parking lot, suitcase at her feet, hands on her hips, and jeans that looked like she'd taken a brush and painted them on, being careful to detail the seams and pockets. I didn't know if she carried good luck or bad, but I should've known. Lizard-skin cowboy boots. Rhinestone sunglasses. A wild bush of hair framing her oval face. I've always been a chump for women, so I said, "*Órale,* hop in."

Without another word she threw her suitcase in the

backseat and slid in front, against the window, away from me, a coil of plastic bracelets bunched up on her left wrist. I'd been a long time in the country without female company except for Sage Pumo, a Hoopa Indian, wide as a bear, so this little smoke of a woman had most if not all my attention.

I floored the Camaro and shot out of the parking lot. "So what's your name?" she asked. I told her mine and she told me hers—Adelita Guerra. "Nice to meet you," she said. "It's always good to make new friends." She offered her hand, and I shook it. It was a worker's hand, rough and stained from picking walnuts, maybe yesterday. She dug into her front pockets for a frayed pack of Juicy Fruit and offered me one. "Naw. Go ahead," I said. I didn't tell her I hate gum. She chewed smacking her lips, happy as a kid on a school trip. I had Los Lobos playing on the tape deck, "La Pistola y el Corazón," music that makes you crave a nice cold one. It'd been years since I'd drunk a beer, but you never forget.

When we came to the freeway on-ramp, she sat up. "This doesn't look good. Can I ride to the next town?" I glanced at her from the corner of my eye, and that tightness in my stomach just got tighter. I couldn't exactly kick her out in the middle of nowhere, so I hit the on-ramp with a thump and revved the Camaro out, angry at what I'd gotten myself into.

I kept my mouth shut and my eyes on the road, not wanting to look at her. Still, I could sense her gauging me, like a good hustler on the prowl. On my way to Sacra I'd seen a head-on collision by Redding, two cars twisted into pretzels with no survivors, and that's what I was thinking about a few minutes later when she asked, "*Pues,* where we going?"

I checked the rearview mirror for Highway Patrol and ignored her question. Adelita shrugged as if she didn't care, and tapped her boots, grooving to the music. It took a few miles before I settled in to enjoy the big monster working under

the hood of my cherry-red Camaro Z-28 that made the white stripes of the road zip by in a blur. A string of red-and-black magic beads swayed from my rearview mirror, keeping time. Then she started drumming her fingers on the dashboard, like she was playing a piano or something, and I had to sit up and pay attention. She held her head up, like a prize filly, with arrogance and confidence. That's what first pulled me to her, made me question myself. I moved into the fast lane to get clear of an eighteen-wheeler that was hogging the road, but I had no real hurry to get anywhere. I pulled on my goatee and pondered her question. Where are *we* going? *We?* I hadn't thought about us as *we*. More like—her there, and me here. *¿Qué no?* I lived happy outside of Weaverville, along a desolate stretch of gravel road at the edge of the Trinity Wilderness, a free man, just me and my music. My nearest neighbor, Sage Pumo, occupied a cabin several miles down Highway 299. At night, I had a clear view of the stars in the California sky. So I didn't need complications, and I had enough grief since my dog Reagan got squashed by a logging truck.

I looked her in the eye. "I'm headed south."

"Then I'll ride with you. I'm going to Vegas."

I took a closer look at her. "Why's that?"

"I'm a singer. I sing *rancheras, huapangos, boleros.* I also play the accordion. I'm going to be a star."

"There's a lot of talent in Vegas. Lots."

She frowned for just a second, like that thought had never crossed her mind.

"But I'm good, I'm real good. When I sing, I feel it all inside me. In here." And she jabbed a thumb at her heart.

Man, some people are real naïve. I didn't want to discourage her with tales of good girls gone bad selling themselves for a dime of meth, so I flipped the tape to the other side.

We were crossing the heart of the San Joaquin Valley, miles of tomatoes and strawberries separated by irrigation ditches, and crop dusters flying low, spraying a fine pesticide mist over the perfectly laid-out furrows. Two thin vapor trails, almost faded, crossed in the eggshell blue of the sky. The sun was slanting down behind us, setting the mountains on fire. Adelita removed her sunglasses and laid them on the dashboard. She squinted at the mean farm fields, and the corners of her eyes crinkled up where the first crow's-feet were beginning to take a grip. She crossed one knee over the other, drummed her fingers some more on the armrest, and hummed a tune I couldn't make out. I didn't want to stare at her, but she was kinda pretty in a country sort of way. In her late twenties, I guessed. Don't get me wrong, Adelita seemed game, like she'd been around the block a couple of dozen times. Her mouth had that hard edge women get after twenty-five when they figure out life's not going to treat them right.

But I wanted some details. "So where you from?"

She tossed her head back over one shoulder. "From there."

"Sacramento?"

"Colusa."

Colusa, land of dust and walnuts. I could see why she'd want to leave. "How'd you get to Sacra?"

She answered with a throaty, wicked laugh that stood the hairs on my arm at attention.

I took a wild guess. "You running away?"

"You could say that."

"A bad relationship?"

"Sort of."

"What? Husband?"

"Are you *loco*? No husband."

"You have family? Kids?"

"You sure ask a lot of questions."

"Maybe you should go back."

"Never."

"The kids'll be worried about you. I can always turn around."

"Try it and I'll jump out right here. I'll never let a man tell me what to do. Ever. I'm through with that."

I could tell she was serious. And it really wasn't my business. We passed Santa Nella and I had the Camaro doing eighty and thinking that driving alone ain't so bad. I checked the fuel gauge and figured out when I would need to make another pit stop. Up ahead, a black, ominous cloud funneled out of the middle divider; something was burning. I eased off a notch on the gas.

I noticed she was staring at my tats.

I had the Virgen of Guadalupe emblazoned in India ink on my right forearm. Two chubby angels beneath her feet unfurled a banner that said *Perdóname Virgencita*. On each knuckle of my right hand was tattooed a letter. My other forearm had a blue heart, and inside the heart *Norma/Por Vida*. I was sixteen when I did that one. I even had a little Native American glyph on my shoulder for Sage.

Adelita was eyeballing the Virgen, so I said, "You want to touch? Go ahead."

She scooted closer to me and touched the Virgen de Guadalupe. Her fingernails were like needles puncturing my skin. She left her hand on my arm a second longer than necessary, as if feeling my strength.

"Ever seen tats like these?" I said.

"Not really. Where'd you get them?"

I shrugged. "Tough tattoos. Long, sad stories."

"You don't want to tell me, do you? What's the matter, don't you trust me?"

"It's not a question of trust."

"What is it then? You afraid I'll tell *The National Enquirer*?"

Crazy woman. I don't know why I said, "You'd look real fine with one."

She shot a look at me that burned right through my skull.

"Where would you put it?"

That surprised me. Where would *I* put it? Where would I tattoo her for life? I pressed my thumbnail just under her blouse into her shoulder, leaving a red mark like a half-moon. The air around that part of the valley must have been highly charged with electric particles, because touching her hit me like a live wire. A pure jolt of energy. I would not lie, *carnal*. At the same time, I saw the object on the middle divider was a semi rig that had jackknifed, the steel cab all mangled, charred, and smoking like a plane wreck. A fire crew hosed the wreckage with streams of water, but it was too late. No man could have survived that accident. We passed by it in a flash.

Adelita scooted back to her seat and I mentally rehearsed the business I had in El Ley. Under a false compartment in the trunk were forty Ziploc bags of red-haired sinsemilla. This stash belonged to Sage, her whole harvest. Her first husband had left her seven hundred acres of prime mountain real estate complete with underground springs; her second husband had left her a tractor. I was just her neighbor and a hired hand, but already I felt like husband number three. I helped plant the crop during the spring and watered it in summer, running a PVC pipe from the underground source to the budding plants. Sage held the main percentage, and I usually made enough to keep in buds during the winter months, and, if I was lucky, to survive till the next harvest. This year, though, I had offered to unload the crop with my main man

in Pico Rivera. Tyrannus Mex was a boxcar of meanness, the main connect in East Los, and he paid cash on the line. So I was making the run with ten pounds of the highest-grade herb in the world. Real triple-A stuff. Sage and I were looking at maybe fifty grand in pure profits, just like the big boys running paper scams. My percentage would be enough to live in style for a whole year.

But working up close in the mountains has a way of stripping you down to bare emotions. After toiling in the herb garden, I would relax with Sage in the sweat lodge, where I had a chance to consider her ample, hairless body and her sizable breasts under braided black hair. One of her nipples pointed up and the other pointed down, and that just increased my curiosity. During those late summer months a female bear had taken to showing up every morning around my cabin, and when the bear started looking good, I feared for my sanity. So instead I squeezed my skinny hips between Sage's broad thighs, and she rubbed us both to warmth and human comfort.

The night before my trip, Sage and I were snuggled under her Pendleton blanket. Suddenly she sat up. "Maybe you'd better not make this trip. I had a dream last night about you, and your luck's about to run out." "Naw," I said to Sage, "I don't believe in dreams." Then we humped like bears in the woods, with lots of growls and thrusts and groans and moans, but not much passion. Sleeping with Sage Pumo wasn't exactly love, but it was convenient.

I did have other business in El Ley, and the thought of it kept me quiet for miles. El Ley had stopped being my town a long time ago. I was going back to bury my only brother, a half brother really. Even though he was the product of my father's affairs, and we never lived in the same house, we spent a lot of time together as teenagers. We have a saying in the bar-

rio that fit the two of us—Blood is thicker than mud. But he'd been on the streets awhile, and I'd lost touch with him. Ten years maybe without hearing from him, then the yellow envelope from the V.A. office with the cold notice. He'd either been robbed or beaten, or both, nothing in his pockets but thirty-four cents when they found him drowned in the El Ley River. The El Ley River that's about three inches deep. I wondered if they would bury him with the box full of medals he'd brought back from Vietnam. He'd been an honor student in high school—who would have guessed this would be his end? But it was. And the anger of it kept me burning, kept me awake many nights. I was going back because it was the right thing, but I wanted to leave quick and clean before the jaws of El Ley clamped down on me again.

Adelita pressed her knees together and withdrew into her own world. I scraped all thoughts about her out of my mind and drove on. We were by Kettleman City, the road like an arrow aimed at nothing, the sky big as a canvas, with two small puff clouds blowing across the blueness like tumbleweeds. The only signs on the road warned PATROLLED BY AIRCRAFT. This empty land could make anyone a desperado.

"I'm taking this exit," I said. "You decide what you want to do."

She sat up, looking at me as if I'd insulted her, then she turned away and looked out the window, like there was something to see, the Grand Canyon perhaps.

After parking, I went to the head and took a long leak, taking my time to shake my thing dry, hoping that maybe Adelita would be gone by the time I got back. But when I stepped out there, she was still scrunched down in the car. So I bought a pack of sunflower seeds in the Quick Stop and kept my eyes on her just in case she'd step out to stretch her

legs or use the head. But she wasn't taking any chances. I felt sorry for her and brought her a soda when I came back.

"I guess that means you want to ride," I said.

"That's right," she said.

If women are a puzzle, this one had a thousand mismatched pieces. I pulled back onto the freeway and tried the radio for a while, but picked up nothing but static and a country preacher begging donations and spewing hate and prejudice. Just what this country needs. So I snapped it off. Adelita was chewing on a hangnail, not looking at the road.

Finally I said, "So what songs you know?"

She looked up at me like a puppy that wants to please. "You want me to sing?"

"No. I want you to tap dance backwards."

She put one hand over her mouth to hide her smile. Then she sang, *bajito* at first, a little unsure of herself, one of those classic *boleros* from long ago, "Perfidia," a song of passion, heartache, and betrayal. Linda Ronstadt had nothing to worry about. Not yet anyway. Adelita went off-key on the high notes, and she forgot every other line and just kinda scatted her way through the lyrics. But her voice and phrasing simmered with raw emotion that moved even a coldhearted *vato* like me. With a few lessons, who knows how far she'd go?

Then she did something I wish she hadn't done. She hummed a few bars of "Historia de un Amor," and I remembered everything I wanted to forget. Of all the songs in the world, "Historia de un Amor" held bitter memories of three summers I wasted in Soledad Prison, lifting weights, playing dominoes, killing some slow time. Another *pinto*, Shorty from Visalia, a tattoo artist with a disfigured face, did my tats. He plucked a thread from a blanket, tied three needles to a Popsicle stick, then dipped the jailhouse invention in a bottle

of India ink. He outlined the Virgen first, a jab at a time, then filled in the details, the rays shooting out behind her, the hands folded in prayer, the two angels. It was my idea to add the banner and the words. Working from a photograph, Shorty made the Virgen look like Reina Sarmiento, my outside woman. Later, he did the moon and the stars at her feet. It took him six months to finish. This was late-at-night work, another *pinto* keeping a lookout for the bulls, while Shorty worked the needles, and each jab stung like a betrayal or a false kiss. At lockdown time, with the cell block quiet, I spent each night in my bunk tracing the cracks on the gray ceiling, knowing my friends were living their lives, having kids, going to parties, and I was doing time, eating off metal plates, walking the yard, watching my back, and going to sleep rubbing my cock to those train whistles blowing lonesome as coyotes, wondering if anyone remembered me on the outside. And her singing that one song brought it all back, indelible as any tattoo.

After Adelita finished she was silent for a moment, like she was waiting for the applause. I was lost in my own memories.

"What do you think?" she asked.

"You're sad. But you have talent."

She smiled, and I noticed she had one black tooth near the back of her mouth. "The minute I saw you, I could tell you were the man for me."

Let me tell you, *carnal,* sometimes a man gets tempted to throw everything away for a woman. Like there's one of those Oaxacan carnival devils on your shoulder, the ones with the red horns, giving you bad advice. Just pushing you to do something stupid. A man has to be on guard for these moments. And it looked like one of these moments was upon me. I took a closer look at her. She wasn't much you could hold on to, thin as a fence post really, and that Colusa soil still

dirtied her nails. But I had a powerful urge to bury my face in that wild hair of hers and smell it. I wanted to feel what it was like to squeeze her in my arms and wake up in the morning with her dark face next to me. And I could feel myself sinking into her temptation like I was waist deep in quicksand.

I'd stayed away from temptation for years. Especially Chicanitas, my only heavy vice, those brown girls. I'd been through the bad hurt before. Real bad. Back in the days with Reina Sarmiento. My one true love. My always and forever babe. Her name in blue letters on the knuckles of my right hand. I ruined my life for her, lost three years in Soledad, taking the rap when we were busted holding two kilos of some potent Jamaican ganja. I threw a beer can at the cops when they busted the door down and got an assault tacked on the possessions charge. That meant a felony, some extra time. And when I came out, what did Reina have waiting for me? I had a stash of nearly ten grand before the takedown, and she couldn't tell me where the money was. Down her arm and up her nose. I loved that woman so much, had kissed every nook and cranny of her body, had dipped my tongue between her legs and over her breasts, now I wouldn't kick her in the ass if she bent over. So you see? That's why I don't believe in love.

After the *pinta* I had gone north to get as far as I could. To get as far from the grief and drugs and booze of East Los as probation would allow. Now my colors were neither red nor blue, I was neither Norteño nor Sureño. This was my first trip back in ten years, and I was tense. I meant to make the deal with T-Mex, sign the forms for my brother's funeral, and be out within twenty-four hours. And never go back.

Adelita pulled down the sun visor, then, looking in the mirror, rolled her hair up and knotted it in a bun. A small curl slipped out of the knot and down her nape, and that just drove me crazy. Right there I would have sold my soul to hang

like that curl and kiss the back of her neck. She reached into the backseat and hauled her suitcase up front, ripped the tape off, and I could see all she had in there was a beat-up accordion and a pint of peach brandy. The real sweet stuff. She shoved the bottle at me.

"Have a drink with me, cowboy."

I licked the dust from my lips. "No, thanks."

I fished in the ashtray for the joint I'd been hitting on the night before with Sage. Up to this minute I had forgotten about her premonition. Now here I was with a woman who was a dream chaser.

I fired up the roach with the car lighter, sucked in a little jet stream of smoke, and held my breath like a blowfish. Then I blew a rush of purple smoke that clouded the Camaro. I'd been sober for years, just smoked a little—once a *vato loco,* always a *vato loco,* and the last thing I wanted was to start drinking. Booze was poison to me. I had too much Indian blood, that's what Sage told me. But Adelita tipped the bottle to her lips, and a thin line of brandy trickled down her mouth. I noticed her mouth, wide with full lips, the kind I like. She wiped her mouth with the palm of her hand.

I was holding the roach with my fingernails. "Care for a hit?"

"No. It's bad for my voice."

Once the herb came on, the landscape stretched out, the seconds floated by, and the miles seemed farther apart though I kept a steady eighty. A bug went *splat!* on the windshield, leaving a dribble of yellow liquid. I could feel the bug's pain, its surprise at suddenly flying into something solid when it thought the sky was clear. *Splat!* There went another one. I was too sensitive to be in the fast lane, so I moved over to the middle lane and slowed to seventy. And I thought of Shorty doing hard time in Soledad. A woman he loved had poured

scalding water on him while he slept, leaving half his face melted like wax. But he survived the county hospital doctors. Months later, he ran into his ex-wife and her new *vato,* in the Reno Club in Sacra. Shorty didn't care about her anymore, but a fight started anyway and he stabbed the *vato* with a five-inch blade, right in the neck. So now one man was paralyzed and another in prison, and the woman who'd caused it all flew off free as a *golondrina. Pobre* Shorty. He should have walked away from her when he had the chance. Poor, stupid Shorty. I learned in the joint there's nothing more dangerous than loving a woman the way Shorty had loved, blind as a worm, the way I had loved Reina Sarmiento. The woman didn't exist that was worth your life. And I intended never to love a woman, any woman, that bad again. But that was the only way I knew how. And faking it with Sage was the coward's way out.

Adelita turned quiet too. She hunched in her corner of the front seat, her knees crossed, and didn't sing anymore, just sipped her brandy through tight lips. Every now and then she'd take a quick glance at me, then look away. The only sound came from my Camaro ripping off the miles. After a while she turned to me, with just a hint of pleading in that voice I would have followed anywhere.

"I need a ride to Vegas," she said. "You want to take me, be with me when I make it?"

I couldn't believe it. Why did I always find the crazy ones? The ones even the devil didn't want. "It doesn't work that way," I said. "You can't just take two people from the middle of nowhere and mix them."

She glared at me, eyes all fired up with anger. "Why not? Or do you want that whole game playing first? *Tú sabes,* the sweet-talking and the playing around like you don't know what you're after. I'm through with that. Either you come

with me or you don't. I'm not asking you again." She pinned me down with those arrowhead eyes of hers.

I stuffed the last handful of sunflower seeds in my mouth and crushed them viciously. Hell, I knew I could get along with her, I could tell, but Virgen María, what was she like day after day? Passion is fleeting—I knew that much. One morning you wake up and they want to sit on your face, and you just can't handle it that early, even with the most beautiful woman, so that kills the romance right there. And she was tough, the type that would get back at you while you slept. I could see that. Maybe she poisoned her ex–old man, and that's what she was running from. Or maybe her ex was getting ready to come after her. Maybe there was no ex, maybe it was a husband. So there was that to worry about. She didn't seem too concerned about her kids, either. And I didn't need troubles. I especially didn't need her troubles.

Just to test her, I said, "You maybe have money to get there? You know the old saying, Gas, grass, or *ass.*"

"I'll pay you somehow."

I turned my eyes back to the road: "*Chale,*" I said, "I have business in El Ley."

That hurt her. She stared out the window for a while, like there was something to see, but I knew there was nothing out there. Finally she spoke, pleading but not pleading.

"You don't seem like a bad man. That's all I've ever known. Since I was fifteen."

I didn't want to listen to the oldest story in the world.

"A woman needs some kind of protection. Or else bad men will take advantage of her." She tilted the bottle up and took a long swallow. Wiped her mouth with her hand again. "It's not easy raising two kids alone. And no man wants a woman with kids, I don't blame them. But all I've ever wanted to do was sing. I'd sing in the fields, just to ease that

pain in my *corazón,* right here where it hurts all the way through your back. I'd sing under the trees during lunchtime, or after work, whenever I could. And people were always saying I should get paid for it and they'd pass the hat. You know what you get paid for picking walnuts?"

"I don't really care," I said.

"Not very sucking much."

She took a deep breath, shook her head, took another drink. Now she really unleashed it on me.

"My last boyfriend, you know, he did some things to me . . ."

Damn, I wanted to stop the car, get out right there in the middle of nowhere, and show her not all men were animals.

"So I left my two boys with their *abuelita.* And split."

"I'm glad you did." And I looked at her, sitting sad as a bird on a wire in winter.

"I'm sure you had to," I said.

"But you're different, I can see that. You have *corazón,* like me." And she took another swig and smiled, looking like a little girl. A little girl on the run, telling stories and nipping her brandy.

The honesty of her confession wrapped around me like tule fog, and there was nothing else to say. I thought about a woman like her, alone on the road, making her way with strangers who offered rides. The sort of trouble she could get into—being kinda good-looking, and a little crazy and all. Leaving her kids behind must have hurt some, I guess. And who knows what that boyfriend did to her. She'd probably been chained to the stove, or worse, and this was her only chance, her last chance at life. It was tragic. I mean there was a tragedy waiting to happen, and I didn't want it to happen. I had to admire her taking the risk, getting set one day, packing her things into that patched-up suitcase and slipping out to

chase her dream. I just didn't know where I fit in. I'd wasted the first half of my life already, and I sure didn't want to blow the rest over a piece of nearly flat Chicana ass.

Before my life had gone to hell, I'd been a guitarist, sat in on some of the first gigs Los Lobos played when they were still a garage band. Five years passed, and then time in the joint, and after I came out I didn't remember what I had started out to be. Didn't give a damn either. Now I only wanted to live my life, die in peace, be buried and forgotten. My dreams had withered in the day-to-day survival. But something about Adelita was rubbing off on me. Just watching her sit there, a hurricane being born, I felt the itch to do things again, to take chances. Live life at full throttle. It was that funny feeling I'd gotten when I first saw her.

The green freeway sign read LOS ANGELES 90 MILES. I'd been driving six hours. I was tired and thirsty; the thin film of dust over the Camaro seemed to cover me too. I turned to her and said in a voice I didn't recognize, "Let me have a sip of that brandy." That was my choice. Had nothing to do with her. I washed some of that cheap stuff down my throat and handed her back the pint. My eyes burned like I was giving up the ghost.

She was measuring me. "I bet I know what you're thinking."

"What's that?" I squinted at the road so she couldn't read my mind.

"You'd like to kiss me."

"It's pretty hard when I'm doing seventy on I-5."

But a kiss is not what I was thinking. I was thinking I had just taken my first drink in ten years and was ready for more. The road to damnation—someone once said—is paved with wine, women, and weed, and I had a full house. I checked the rearview mirror. The magic red-and-black beads that my

shaman friend Maestro Andres had given me hung like a broken piñata, and they seemed to have lost the power to protect me. Adelita slid over next to me and placed her hot little hand on my thigh. The speedometer went straight up.

With Adelita I knew it was going to be all the way, all the time, without regrets, double or nothing. I checked her out sideways and I said, "What about that tattoo?"

Without so much as a blink she reached up and pulled down a corner of her blouse, revealing a sunburned shoulder. The red half-moon of my nail mark was still visible on her skin. Her voice a sultry whisper wicked as a night on the delta: "I've never been tattooed."

I thought of Reina and Sage and all the other *huizas* I carry stitched on my body. But here was a woman willing to do it for me. Willing to go all the way—*a toda máquina.*

"A heart on fire is what I'm going to put there. Then we'll be a pair. *Por vida.*"

She leaned over and blew her hot breath in my ear. My foot went to the metal and the Camaro took off, as if wanting to fly. Then she pressed a hot kiss on my mouth, her plastic bracelets clacking in my ear. This is it, I thought, no going back. I closed one eye and swerved down the middle of that four-lane highway, knowing there was not another car on the road, only her and me, our tough tattoos, and the radials running over those little plastic squares that separate the lanes, going *fuckit fuckit fuckit.*

# Grapefruit Flesh

**KAROL GRIFFIN**

A grapefruit slathered in petroleum jelly is quite possibly the most slippery object in the world, especially if you're trying to hold on to it while wearing latex gloves. It's virtually impossible to clutch a slick grapefruit in one hand while tattooing it with the other.

You can't start right in tattooing on human skin—I mean, you *can,* and some people *do,* but when you think about it, it isn't a very good idea. So many elements to consider, like depth and angle and grain and control. There's more to tattooing than needles and skin; you have to consider the responsibility inherent in the business of transforming other people's bodies, other people's lives. So you start with a grapefruit. You study and practice under the tutelage of someone who knows what they're doing. For me, this person was Slade Fiero.

On the surface, Slade was a cocky person with an omnipotent attitude about his profession and few qualms about what might or might not constitute a good business deal. He often traded tattoos for drugs or guns or stereo equipment. One time, he traded a tattoo for a human head. In essence, he embodied every negative connotation of the tattooist, all rolled into a stocky little package with a bushy mustache and

neatly manicured hair. Underneath this facade, though, Slade was soulful, an artist at heart who happened to tattoo.

I trusted him.

At first, my tattoo apprenticeship seemed more like indentured servitude, but I didn't mind. I was filled with self-importance as I unlocked the door of the shop. Even the most odious task was a treat. I trotted around behind Slade like a gleeful puppy, tidying up the shop between appointments and watching him work. I picked up paper towels soaked with green soap, ink, and blood that Slade had tossed in the general direction of the trash can. I secured stainless-steel needle tubes with a toothbrush and pipe cleaners before sterilizing them in the autoclave. I made stencils and ran Slade's errands. I mixed pigment from powder so fine that it coated my skin with a rainbow of dust, which smeared and stained when I tried to wipe it off.

I worked in the tattoo shop five days a week, devoting myself wholeheartedly to every aspect of my apprenticeship, determined to do my best, convinced that this was my destiny. Even though I wasn't making money at it yet, I was committed. I knew that I should have looked for another job, at least something part-time, but I couldn't justify spending much time in the straight world of retail when I could be in the tattoo shop instead. Eventually, financial pressure forced me to reevaluate. I found a job, one day a week, which was perfect. On Mondays, when the shop was closed, I worked in a bookstore down the block. I managed to scrape by on food stamps, and for extra cash, I held the hands of frightened (or more often, lecherous) tattoo clients for five dollars each.

During the first three weeks of my apprenticeship, I never

touched a tattoo machine. I was beginning to think I'd never get a chance to actually tattoo, that apprenticing was nothing more than an exercise in janitorial work. This made me grumpy, but I didn't know what to say. I just kept picking up dirty paper towels and vacuuming, with increasing resentment.

One day I slammed open the door of the tattoo shop, determined to speak my mind. Slade was one step ahead of me.

"Don't say it," he said, smiling. "I know. You're sick of the bullshit, right? You want to tattoo, right? You wonder why I've made you do all the grunt work around here."

His words paralyzed my preargument icy frown.

"Humility, doll." He laughed. "It's not all about ink and skin. You've got to learn to have the right attitude—otherwise, you'll go down in flames. But I've got a surprise for you. Today, you tattoo." Slade handed me a pair of latex gloves and set a cup of black ink and a cup of petroleum jelly in the ink rack. He took out his outliner machine, showed me how to assemble the needlebar and the tube and attach it to the machine. He pressed the foot pedal, and the machine hummed merrily in his hand. Slade reached under the counter and pulled out a grapefruit. He demonstrated proper depth, speed, and angle, deftly freehanding a gruesome skull on the grapefruit. He treated the grapefruit like a customer, like it was a real tattoo on a real person. He rubbed the grapefruit skin with petroleum jelly as he worked, and wiped away the excess ink with a paper towel wound between the fingers of his working hand.

When he had outlined the skull, he unplugged the machine and tossed a second grapefruit at me. "If you go too deep, it'll squirt you in the eye." He left me alone with my work.

I tried to do what Slade had done. It had looked so simple. But the machine that had seemed weightless when it was

resting in my palm became unwieldy and painfully heavy when I tried to hold it properly, gripping the tube like a pencil and balancing the weight of the machine in the air above my thumb. I rubbed a glob of petroleum jelly on the surface of the grapefruit, dipped the needles into the cup of black ink, and pressed the foot pedal. The sound thrilled me. The machine shook with power, fast vibrations that rattled my hand. With the needles poised above the grapefruit, I pressed the foot pedal again, took a deep breath, and touched the tips to the crinkly skin.

The grapefruit popped out of my hand and rolled onto the floor. I retrieved it and managed to skewer it on the needles, causing a great burst of grapefruit juice to shoot into my eye. By the time Slade returned, I was covered with black ink and Vaseline. My hair was decorated with sticky juice and pulp, and I was sobbing quietly. Slade had made tattooing look virtually effortless, and I was disappointed to find that it was not. Grapefruit juice stings when it hits the eye, but that was only part of it. I was frustrated beyond belief by the time Slade returned.

"Lighten up," Slade said. "You'll get the hang of it. We've got plenty of grapefruit and all day to practice." He showed me again, and sat next to me while I tried once more to tattoo a fresh grapefruit. After the tiniest dab of petroleum jelly, the grapefruit burst out of my hands as though it were trying to escape.

"Can't I take the gloves off?" I pleaded. "It might be easier. I'm almost certain that I could hold on to it if I didn't have to wear the gloves."

"Nope. It has to be realistic." Slade laughed as he took in my disheveled, ink-and-pink-grapefruit appearance. "Here's a tip, though. Don't cover the whole thing with Vaseline. It's not a sex toy that you're trying to lubricate; you just want the

ink to pool up in a line, so you can see where you're going. Just put a little dab on the part you're working. Wipe it off when you're ready to move on."

I set my jaw and tried again. I made a wiggly line. I was tattooing.

My hand ached from the strain of the tattoo machine when I woke up the next morning. I couldn't quite get all the dried pulp and black ink washed out of my hair. I was hoping that this day would be better. Easier. Maybe it would be really busy, and there wouldn't be time for my lesson. Maybe I'd have to spend the whole day tidying up after Slade.

When I arrived at the shop, I noticed with dismay that four grapefruit were sitting in a row in the curve on the dentist's chair in Slade's tattoo room. Three of them were plain, just hunkering there, but the fourth had been stenciled with a tattoo design, a skull in a fedora hat that I recognized from one of the flash sheets that hung in the front room. Its hollow, purple eyes gazed at me malevolently.

Slade pointed at each grapefruit in turn. "Circles," he said. "Squares. The alphabet. Fill the whole thing. Then do that one." He smiled and pointed at the skull stencil.

I fitted a needlebar into a tube and clamped it into the machine. I pulled on a pair of gloves and sat down to my work. I made circles, which was much harder than I had expected. I tattooed big circles and little circles, lopsided, wonky circles. It seemed impossible to make the lines meet. The needles skittled across the grain of the grapefruit skin as though my machine had a mind of its own.

Squares were just as bad. I couldn't draw a straight line on a round, pocky surface, and again, try as I might, the lines didn't meet at the corners. The only thing that kept me going was the fact that the grapefruit didn't spit juice in my eyes half as often as they had the day before. It was late afternoon

before I was ready to try the stenciled skull. I ignored the screaming muscles in my hand and gritted my teeth, determined to do my best.

*If it's worth doing, it's worth doing right.* My parents taught me that. When you start something, you finish it. I doubt that my parents expected me to apply these lessons to something like tattooing, but the lesson was so deeply ingrained that I had no other choice. When I was finished with the skull, I wiped it off with green soap and held it up. It was not great, but it was the best tattoo I'd done. Slade examined it closely, praising some lines and criticizing others. I took it home like a proud parent, cradling it in my lap and staring lovingly at it as I drove. I placed it on my bookcase, where I could admire it all evening.

The next day, a banana was lying on the chair like a minimalist still life. I worried about what my afternoon might hold in store, tattoo-wise, and was relieved when Slade reached for the banana, peeled it, and popped it into his mouth. He pulled another banana from under the counter and handed it to me.

"No, oo cand eab dabt." He shook his head frantically and tried to swallow a mouthful of banana pulp. He gulped down the banana. "Don't eat it." He fitted a shader bar, with seven needles on the end, into a flat tube and affixed it to my machine. I stood there, banana in hand, waiting for further instructions.

"Color it in," Slade said.

"Color what in?"

"The whole thing. Solid." He laughed and left the shop.

It took me all day to make a not-quite-ripe banana solid black. I held up the mushy result for Slade's approval, a hopeful smile coloring my face.

"Man, if that were a person, he'd be in a heap of hurt,"

Slade said. "See this? Hamburger. It's going to scab up bad. The ink's going to fall out with the scabs, and leave one mean-looking scar. That's not a tattoo, that's maiming."

"I'm sorry," I said, more to the banana than to Slade.

"Well, you've got to know when you're doing it wrong so you'll know when you're doing it right."

Slade picked up a new banana and the shader machine. He showed me how to use the shader properly, pushing the needles against the grain of the banana peel in small circles, back and forth, never digging too deeply into the peel. When he was done, his banana still looked like a banana, only black.

I practiced until my bookshelves and kitchen counters were littered with tattooed fruit in various stages of decay, but no amount of tattooing on fruit could have prepared me for tattooing a real person.

A tattoo is created by embedding pigment in living skin. The pigment is poked through the epidermis and adheres to cells in the underlying elastic pad of tissue. Tattoo needles are not hollow. They do not inject pigment. Instead, the needles poke holes in the skin and leave pigment behind. Epidermal tissue heals over the pigment, and the tattoo is visible through a thin layer of scar tissue. Once healed, the tattooed skin feels just like the surrounding skin. It is just as ticklish, just as warm.

"You've got to find yourself a guinea pig," Slade said. "You know, someone who will let you tattoo them, even though they know it's your first time."

"Rick," I said. Rick was my favorite ex-boyfriend, and the only thing Rick liked better than tattoos was fast cars.

Slade nodded and laughed. "There you go."

On the off chance that Rick might balk at this opportunity, I drew up a special piece before I asked him. A swirly, art

nouveau, tribal piece that, from the right angle, spelled out *Cuda,* Rick's all-time favorite car. The way I figured it, I could draw *Cuda* in big block letters, offer to tattoo it on Rick's forehead, and he wouldn't even hesitate.

Rick was lying on a creeper underneath a 1972 Challenger when I pulled into his driveway.

"Hey," I said, "do you want another tattoo? For free?"

"What?" The heels of his boots churned up a small dust storm as he kicked the creeper out from under his car. I knelt down beside the rear fender and held out the drawing. Rick frowned and ran a grease-covered hand through his wild hair. I turned the design sideways, and he sucked in his breath. "'Cuda'?"

I nodded and smiled.

"Right on. When can we do it?"

The next night, after the paying customers left, Slade locked up the tattoo shop and turned the OPEN sign around to the side that said WILL RETURN AT above a plastic clock face with adjustable red plastic hands. Rick sat down in the chair and tugged the leg of his pants up to his knee. I shaved his calf with a straight-edge razor held in shaky hands. I did everything just the way Slade had taught me, rubbing musk-scented Mennen Speed Stick deodorant across a folded paper towel and wiping it across Rick's skin. I put the drawing on a sheet of ditto master, ran it through the thermofax, and pressed it against Rick's skin. Slade sat in a chair with his arms folded, watching me.

"You realize," Slade said, "that tattooing is an enormous responsibility. You are changing another person, and I don't mean just by the ink in their skin. You have the power to create something that will change a person's life forever, and this can be both good and bad."

I rolled my eyes. This pronouncement seemed redun-

dant; Slade, Rick, and I were covered with ink, the most tattooed people in town. If anyone should know how this changes your outlook on life, it should be the three of us. But when I looked up at Rick, his lower jaw was hanging slackly, and he was staring at Slade as though he were eyeing a preacher.

Slade leaned forward and stared into my eyes. "In some cultures, this is recognized as a ritual. And even here, even now, you have to look to the past to have a sense of what you are undertaking. This is a powerful thing. It's more than a job. You are—" he gestured toward Rick—"his priest and devil, all mixed into one. Don't take the spiritual aspects lightly. Even though tattoos are material goods in a consumer culture, a tattoo is also a primal scream, permanently etched into the skin." Slade leaned back and lit a cigarette.

"Wow, man," Rick said. "That's intense. I never thought about it like that."

"I come up with some pretty deep shit when I'm stoned," Slade said. "Thought that one up yesterday."

It was just like Slade to say something profound and chalk it up to marijuana. He didn't seem to want anyone to know that he was a thinker, that he lay awake at night, stone-cold sober, pondering his life and the responsibilities it entailed. I'd seen him do it. Of course, I'd also seen the other nights, when it all got to be too much, and Slade fired up his bong time and time again until he nodded off to sleep, accompanied by the television turned up so loud that it drowned out any possibility of words or thought. He'd taught me well. I knew about the responsibility and the dedication. But was I ready?

I assembled my machine and pulled on a pair of gloves. I stared hard at the stencil because my only other choice was to

look Rick in the eye and give him an opportunity to change his mind.

"Go ahead and start," Slade said. "That stencil's ready and we don't have all night."

"I don't think it's quite dry," I said. I smudged a finger across the purple outline, and the stencil smeared away from the line. "See? I think we'd better wait just a little bit longer."

All the thoughts in my head began to swirl into a tornado of doubt. I knew how to tattoo, in theory. That wasn't the problem. I didn't want to hurt Rick, which was sort of silly when I thought about it. He knew how it was going to feel. He wanted me to do it. So hurting Rick wasn't really the problem either. The problem, I realized, was that this was a giant step. I might as well be getting married, at least if I was going to accept Slade's interpretation of responsibility and commitment. As soon as I touched the needles to Rick's skin, I was tying myself to tattooing for the rest of my life.

I still had a choice. I looked at the machine in my hand, the dry stencil on Rick's leg. It wasn't too late to back out.

Then the unmistakable thrill of anticipation set in, the mysterious combination of fear and uncertainty mingled with glee and uncontrollable excitement. The thrill coursed through me like electricity, dripping from my fingers and toes like beads of water, or sweat. The sweet pulse of my own blood pounded in my throat, my ears, my heart, pushed by fear, shutting out everything else.

I looked down at my hand like it belonged to someone else. The tattoo machine was clasped in my fingers, gleaming with promise, and Rick's leg was ready and waiting. My breath was low and fast with anticipation, desire. *This is a good thing. A happy new beginning. This is what I want.* Being a tattoo artist would be the perfect reconciliation between ambition

and sensation, between responsibility and creativity. The mere thought of tattooing was providing the scary, thrilling sensation I craved, and it seemed that if any career could possibly approach that level of sensation on a regular basis, tattooing would be it. Tattooing promised to be wild enough to keep my interest forever. I'd been looking for something like this all my life.

As I wound a folded paper towel around my machine hand and dabbed a bit of petroleum jelly on the edge of the stencil, I pretended that Rick's leg was just a great big banana. I dipped the needles into a cup of ink, stretched Rick's skin with my right hand, pressed the foot pedal, and traced the needles along the stencil line on Rick's skin.

When I wiped away the excess ink, there was only a faint red line with a squiggle of black ink dotting it here and there. I looked up at Slade, helpless. This wasn't like tattooing a banana. It wasn't anything like that at all.

"You can't be afraid of hurting him," Slade said. "Just concentrate and do your job."

I took a deep breath and tried again. This time, the line was solid. Perfect. Before long, I was lost in the sensation, and the reality of ink and skin gave way to the more ethereal realization of layers and life. The heat of Rick's skin rose through the latex, and even though my gloves were sweaty, the powder inside was pushed into every crevice of my hands, arid and itching. My fingers pressed and pushed the skin until the muscles in my wrist and thumb screamed. The vibrations from the machine, and the little give of the skin before the needles punctured it, bounced through the nerves of my stretching hand. My left hand moved slowly, methodically drawing the machine along the stencil line. Dot by imperceptible dot, inch by inch, plain skin became permanently marked.

Layer after layer, latex like the connecting wall of a dividing cell. On either side, skin—his and mine—and beneath that, muscle and bone, nerve endings and blood. The heat that rose from Rick's body was markedly more pronounced on the freshly tattooed part, cooler outside the lines. His blood rushing white cells to the area of invasion, fighting against what his mind had decided to do; his blood busily transporting excess ink to the nearest lymph node for storage. All this for a picture on the skin. It wouldn't be worth it if it didn't mean something more, somewhere else.

After the outline was complete, I changed to a shading machine and a needlebar with thirteen needles arranged in a tight circle. I was ink blind within an hour, black Rorschach blotches on my eyelids every time I blinked. I concentrated on the needles, on the skin, concentrated myself into a half-hypnotic state where, it seemed, the difference between animate and inanimate was exaggerated yet overlapping. Like an LSD trip, everything blended together, yet was distinctly separate. Rick's inhaling and exhaling echoed in my ears, carefully measured and exact. I found myself holding my breath from time to time—forgetting, actually, to let the air in and out—and trying to catch up with hungry, ragged whooshes. I pulled Rick's skin away from the calf bone just like Slade taught me, tugging it down onto the muscle so that the tattooing wouldn't be quite as painful. The small of my back hurt from leaning forward in the same position for such a long time, and my eyes ached from squinting at needles puncturing skin. It seemed there was no stopping, that I was compelled to color Rick's body cell by cell, no matter how long it took, a tattoo purgatory from which there was no escape, but which was actually quite nice once you got used to it.

Several hours later, the *Cuda* tattoo was a solid black welt with a halo of red inflammation. The pores were enlarged,

like the pocks on an orange peel, exactly the way Slade said skin should look when it's been worked enough. I spritzed Rick's leg with liquid green soap, coated the tattoo lightly with petroleum jelly to keep the blood from welling up, and sat back while Slade and Rick examined my work. Slade arched his eyebrows like he was pleasantly surprised, and gave me a little nod. I grinned, biting my lower lip between my teeth to keep from laughing with satisfaction and pride.

Rick ran one finger tentatively along the redness next to the tattoo. "Didn't hurt a bit," he said.

I looked at Rick's welted, orange-peel skin colored solid black. Blood oozed through the ink, and when I looked up, Rick's face was white except for two splotchy circles on his cheeks. I was grateful for his lie.

# Blackie, the Electric Rembrandt

**THOM GUNN**

We watch through the store-front while
Blackie draws stars—an equal

concentration on his and
the youngster's faces. The hand

is steady and accurate:
but the boy does not see it

for his eyes follow the point
that touches (quick, dark movement!)

a virginal arm beneath
his rolled sleeve: he holds his breath.

. . . Now that it is finished he
hands a few bills to Blackie

and leaves with a bandage on
his arm, under which gleam ten

stars, hanging in a blue thick
cluster. Now he is starlike.

# My Tattoo

**MARK DOTY**

I thought I wanted to wear
the Sacred Heart, to represent
education through suffering,

how we're pierced to flame.
But when I cruised
the inkshop's dragons,

cobalt tigers and eagles
in billowy smokes,
my allegiance wavered.

Butch lexicon,
anchors and arrows,
a sailor's iconic charms—

tempting, but none
of them me. What noun
would you want

spoken on your skin
your whole life through?
I tried to picture what

I'd never want erased,
and saw a fire-ring corona
of spiked rays,

flaring tongues
surrounding—an emptiness,
an open space?

I made my mind up.
I sat in the waiting room chair.
Then something (my nerve?

faith in the guy
with biker boots
and indigo hands?)

wavered. It wasn't fear;
nothing hurts like grief,
and I'm used to that.

His dreaming needle
was beside the point;
don't I already bear

the etched and flaring marks
of an inky trade?
What once was skin's

turned to something made.
Written and revised
beneath these sleeves:

hearts and banners,
daggers and flowers and names.
I fled. Then I came back again;

isn't there always
a little more room
on the skin? It's too late

to be unwritten,
and I'm much too scrawled
to ever be erased.

Go ahead: prick and stipple
and ink me in:
I'll never be naked again.

From here on out
I wear the sun,
albeit blue.

# To the Engraver of My Skin

**MARK DOTY**

I understand the pact is mortal,
agree to bear this permanence;

I contract with limitation; I say no
and no then yes to you, and sign

—here, on the dotted line—
for whatever comes, I do: our time,

our outline, the filling-in of our details
(it's density that hurts, always,

not the original scheme). I'm here
for revision, discoloration; here to fade

and last, ineradicable, blue. Write me!
This ink lasts longer than I do.

# Dyeing a Three-Dollar Bill

### FRANK MARTINEZ LESTER

A row of metallic lockers. Oversized safety pins hang from the slats of the doors, holding various articles of quietly declarative and utilitarian gym clothing, navy blue, striped gray and red, tank tops, socks, workout shorts. I sit cooling off, draped with a towel, from a half hour in the sauna. A man appears at the end of the aisle, drops his bag on a portable plastic seat and quickly vanishes. The bag is yellow mesh. It is filled with various articles of gym gear, all in color-coordinated variations of pastel. A dispenser of lotion, a bottle of shaving cream, a water bottle. Something about this bag tells me he is gay. The bag sits on the chair for ten minutes. The man doesn't come back. He hasn't even opened his locker. He won't be back until I'm gone.

The tattoo on my left shoulder, which he has just seen, would cause a lot more consternation and tension in the city where the Master Locks in this gym are manufactured than they do here in San Francisco. In Minneapolis, I would probably be a scandal; in Tulsa, a pariah; in Montgomery, seeping blood from a blunt head wound. Even here, though, in the city-state of tolerance, in a public gym known for its past reputation as a haven of public sex and drug activity, a place that in the seventies and eighties rivaled famous bathhouses for debauchery, I get overly lengthy stares, askance looks, sidelong glances, rudely slammed doors, sharp barks of "Excuse

42

me" from irritated fellow patrons. I tell myself it is not nearly as bad as it would be almost anywhere else, but even here it is not always certain that I am safe, not certain that someone is not going to erupt in rage one of these days when I am showering or steaming or lifting weights. It is that old junior-high-school-gym fear at large again, the buzzing tension, the unavoidable nudity, the assault of rank sweat when you open the door to the shower room. But have I not brought this tension upon myself? Am I not now my own junior high bully?

The tattoo is a two-inch pentagram, simple, large, blue, with a red Pisces symbol inscribed in its center. It is not upside down. It is upright. But I cannot expect others to know the distinction. Most people, when they see a pentagram, think satanic. Mine is a declaration of faith—pagan faith to be exact. But I cannot expect others to know this. I cannot expect that taking the time to explain my tattoo to a stranger will clear up the insult. The locker room I am in is full of hardy working-class men in their forties and fifties who lumber in to steam and shuffle and discuss the murders and kidnappings on the five o'clock newscast and the box scores, along with a smattering of gay men, who quietly stuff their lockers and retreat to the shower benches and chat about upcoming trips with their lovers to Amsterdam and Ibiza. It is hard to believe that most of the men here, if not practicing, were raised Christian, and immediately react with alarm to a symbol that, after a steady barrage of television and movie images associating it with hostility to Christianity and other established institutions (I think of the Carl's Jr. ads with scenes of a vengeful woman biting into a juicy burger, her pentagram-wearing medium watching gleefully, as meanwhile, across town, relish stains appear on a bride's white dress), signifies an open threat, if not evil.

Tattoos are as commonplace in San Francisco as Queen

Annes and summer fog. You see them everywhere, and sometimes you wonder why you never see tattooed dogs or cats. The marks are sometimes florid, covering an entire limb, an entire chest, an entire back, an entire body from neck to toe. Usually they are subtler, a crucifix on a forearm, a Celtic ring around an ankle or a calf, a butterfly or a teddy bear on a hip. One of my roommates once got a tattoo of the cute orange tiger from the comic strip "Calvin and Hobbes" affixed to his rump, thinking, I guess, that it would make him, as a bottom, more winsome to tops. (He could have invested in a blue hankie and saved a few Jacksons.) No matter what, when you see a tattoo here, it is a fashion manifesto, a signal of coolness, an advertisement that you belong to a trend. This is the same way nose piercings and goatees and fisherman's caps have gradually wound their way into the fabric of the street. Slowly, if you live here long enough, you begin to see the trends fade back into the woodwork, fewer Prince Alberts, more jokes about them. Newer trends replace the fading ones. But tattoo shops are everywhere here, in flats, storefronts, corner shops, malls, and they show no sign of vanishing, no sign of being drowned by newer fads. There was a craze for a while that involved temporary tattoos made of henna. This fever lasted about six months. There is something about permanently marking yourself (even when you know that in an emergency you could get the tattoo removed with a costly laser treatment) that seizes the imagination in a way that no dilettante dye ever could.

The gay men who see my tattoo almost never know what to make of it, or of me. I can count at least a half dozen times that I have slept with men who, in the middle of sex, asked me whether my tattoo was a sign that I was a "devil worshipper." I often pause when I am fucking around with someone I have just met before I take my shirt off, still, even now that I

have been tattooed for over two years, trying to gauge what the reaction will be when he sees the brand. I have no way of knowing how many potential partners have taken a pass on me when they have seen the tattoo first.

When I got the pentagram, my best friend told me, "You can say good-bye to your usual types." He was referring to my regular carbohydrate diet of wholesome, responsible, well-fed preppy fags, the ones who drive nice BMWs and Saturns and own stock options and have tastefully decorated flats in Noe Valley and walk their golden retrievers every morning through Buena Vista Park in hopes of randomly bumping into Mr. Right. The boyfriend I broke up with a few months before my pentagram was a conflicted graduate of Biola University, a premillennialist school in Southern California that shares a name with a brand of yogurt made in Greenland and has the stated mission of "graduating followers of the Lord Jesus Christ who are equipped with technical and relational skills to live and work with integrity, diligence, humility, and spiritual discernment." I suppose you could say that my conversion to paganism was a reaction against this boyfriend, but, on the other hand, you could also say a number of other things about my conversion, none of which have anything to do with him. However, the tattoo does provide a certain grim insurance that I will never become intimate with anyone remotely like him again. You might say I have automatically selected myself out of an entire bracket of potential suitors. Ironically, even with the enforced quarantine, the attraction of these men continues to haunt me. It might even be fiercer now that I know that they are that much more unattainable.

I thought my first tattoo would be something along the lines of the bold black *HIV*+ I saw once, carved on the shoulder of an earnest-looking Hispanic man on the contents

page of *POZ* magazine. This would be a method, I mused, of bringing up my serostatus without bringing it up. The guy I was courting, or the guy I was flirting with, or the guy I was cruising, would see the mark on my shoulder, and he would either turn and walk away, or he would overlook the tattoo and there would be no further debate, no messy questions, no complications. The mark would have the added advantage of thumbing its nose at the main legacy of William F. Buckley, Jr., to the library of American political discourse, his infamous pronouncement that persons with AIDS should be forcibly tattooed on their buttocks and arms for instant identification.

Nowadays, however, an *HIV+* tattoo is about as declassé as an Alice in Chains CD. Another trend come and gone. For a while, gay clubgoers were wearing tattoos in block letters on their upper arms that spelled out *HIV–*. Once they seroconverted, they might or might not go back to their tattooist and get the extra slash that changed the minus sign to a plus. AIDS as fashion statement.

My tattoo has a way of identifying me as "other" that resonates with people who see it; it puts them off balance without them knowing precisely why. "There's just something about him." That something may attract people who savor the mystery of the riddle of discovering who I am. That something may also deflect those who know, just by seeing my bright blue stamp, that they don't even want to think about what it represents and what I represent. It is as though I am a traveling shadow. An elaborate insect whose bright colors ward off predators. A three-dollar bill that has been stained with banker's dye.

I have fantasized about a world that exists behind an invisible portal, a world in which everyone sports tattoos that identify exactly who they are and what they mean. This man

walking past you on the street has a tattoo that tells you that he is a raging Republican with a nasty smoking habit. This man in the café at the counter has a tattoo that tells you he likes to read William Burroughs and John Rechy. This man on the bus seat next to you has a tattoo that tells you that he secretly longs to be licked from head to toe for hours on end by someone who looks exactly like you. There is something resolutely fascist about a fantasy involving a world in which everyone is tattooed. There is also—the flip side of every fascist's boot—a sense of order, a sense of harmony, a sense of relief. A sense of belonging. Buckley, ever the cynic, had his finger right on the pulse of that urge.

# *from* "The White Knights"

### WILLIAM T. VOLLMANN

Bootwoman Marisa, hater of Brandi, her sixteenth birthday more recently behind her than her conviction for assault with a deadly weapon, got a ride to North Beach to have her fourth tattoo done, waiting coolly in Bronson's living room where meanwhile a pleasant time was had by others watching videos of Mark Pauline piercing dead dogs' heads with remote-controlled drills, burning dead cats with a flame-thrower, firing cardboard missiles full of gunpowder, throwing switches to make dead rabbits walk backwards—"This is *weird*!" Marisa said, not meaning it, sitting on the couch with her felt hat beaked over her forehead, her thick black lines of eyebrows poised above a dinosaur romance. She had a very pretty oval head—I say head, not face, because hairlessness makes the boundary between head and face vanish so that there is only head, the cheeks and temples curving with in-evitable naturalness around to the ears and back to the gray stubble (something other than hair) growing out from the bone. It was a finely colored head that Marisa had, clean and marbled like the freckled stone stairs fronting San Francisco houses. The lighting in Bronson's living room caused a deli-cate shadow to deepen the tone of the right side, bisecting her perfect nose, which must have been crafted of special pink mollusk ceramic, like her lips. She leaned back in Bron-son's couch, knees up, blinking her dark eyes and rubbing her

dirty black sneakers on the cushions. There was a bunch of safety pins stuck in her earlobes. Her black leather jacket, stuck full of badass buttons and a Hitler iron cross, glittered with galaxies of zippers.—"Man, I hate your dog," she said. "If she bugs me again I'm gonna kick her jaw off."—Her boyfriend was a Nazi skin in Chicago called James who blew up cars by dropping Ping-Pong balls full of Drano into the gas tank.—Six D-cell batteries in the same place will accomplish the same object, Marisa explained, although in that case the car-bomber had to be patient for the two weeks that it took for the casings to dissolve.—She bought acid in sheets and mailed them to James, who sold them at a considerable profit in Chicago, where skinheads were cool, where skinheads were organized, said Marisa, where it was all for one and one for all. He did not share these profits with her.

The tatt was going to be a dragon, on the right upper thigh. Marisa really needed it, just as Yama needed to get more tatts on his arms (he was gonna get a Joker with an evil-ass face, like a red and black Checkered Demon). Marisa undid her suspenders and slipped her trousers off, grinning. Although she still had her shirt on, her naked thighs and her naked head made her as naked as a hairhead wearing no clothes at all; and this equivalence made her more ordinary, especially since most of her other tatts, such as the red, white and blue boot on her upper arm, were hidden by her shirt; and so, most of her Aryan props gone, she was just another naked girl. No one takes special account of Nazis when they are naked. Marisa sensed this and became tentatively, submissively young—"My legs are so fat," she said.—Beginning to outline the dragon on her thigh (he was not ready for his needles yet), Bronson bent over her in his studio of rainbow skulls, while she half-sat, half-lay on the tattooing couch, which was actually an old trunk with a sleeping bag folded

on top. Marisa stared into the yellow oval of brightness around the filament of the light bulb, Bronson's music going *"Ooooooh, bunga-bunga bunga-bunga,"* and Bronson pen-sketched, holding in his other hand a fat phallus of deodorant which he applied now and then to keep the ink from rubbing off. Marisa, leaning back on her elbows, looked down at him and lay back, her head overhanging the couch, gazing now at a solar corona on canvas on the ceiling; and she played with the loose strap of her underpants. She had plump pink thighs.—"I can't stand pain," she said, but she wore a Nazi shirt.—"Oh, God," she said, "it's gonna be such a beautiful dragon; I've been waiting for this for such a long time now that I know I really need it on my body." Her pubic curls were the reddish brown of dead roses.—This sixteen-year-old looked hardly like a bootwoman at all now as she lay there, all her prized difference receding to her mouth. This mouth, a hallmark of her narcissism, pouted downward, toward herself, so that one couldn't readily tell whether she was sullen or just self-absorbed.—Bronson, who had green barbed arrows tattooed into the back of his neck, like lizard vertebrae, now began seriously to work. At the rattle of the tattoo gun, Marisa's eyelashes suddenly fluttered, the shadows beneath them somehow darker now, bluer than they had been. I will pass over her cries and the sweat that burst out on that smooth, round skull, like that of a furry muskrat; while Bronson drilled slowly under her skin, wiping up her blood with a wad of tissue, and the sticky flesh of her thigh clung to the swab as it moved. From behind, Bronson's ear was red and distinct against her white flesh. Her thigh was as pale and soft as a flounder. The needle went in. Sometimes Bronson set the gun down to yawn and scratch at the callus on the middle joint of his second finger, known to those in his trade as the Eye of the Octopus. Marisa recovered herself better with

each pause, as the needle lengthened the irrevocable lines already pierced into her thigh; biting her lip bravely at these required mutilations, she smiled wider and wider, smiled wet-lipped until the dragon was outlined on her thigh in ink and blood. Now she was even more essentially and unarguably a bootwoman.—"Are you done?" she said, "are you done? I want to see! If anybody comes up, maim, kill, destroy!", as she buckled her dirty jeans. She put her leather skinhead jacket back on, regaining more and more of herself with each button. When she'd first bought it, she'd broken it in by getting fucked on it. In the righthand pocket was her street knife. "Oh, kill, maim and destroy!" she screamed, making fists in the air. "I want to sucker-punch somebody!"

# Skin

**JOSEPH MILLAR**

*for Joel*

He tightens a thin veil of plumber's tape
over a one-inch ebony dowel stretching the hole
in his earlobe and shows me the steel hooks

they stuck in his back before he was hoisted, mute
dreadlocked carcass, over the darkening fairgrounds.
Only the first two layers, he says, you don't want

the muscle to lift. If you've drunk enough water
the previous month the skin loosens easily,
"tenting" seven inches away from the bone,

and you hang there in shock, dazed, cold, bright trails
of plasma streaking the rib cage, body's soft candle lit
from within: trapped synapse, radiant icy adrenaline.

Sioux war chief, scarred Druid, flayed Christian mystic:
the dark Asian horse tattooed on one shoulder
blows its blue dragon breath down toward his heart.

# "When I was a kid . . ."

### LARRY CRIST

When I was a kid the only people who had tattoos were cons, bikers, and sailors. My slightly older crime mentor gave me two tattoos at my buzzed request. Having made the decision, I drank heavily as he prepared the needle and India ink. On two separate occasions, Jim placed a *13* on my shoulder, and *FUCK* down my middle finger. At fifteen I was obsessed with the word, as well as becoming acquainted with the act. I thought it would look cool on my right hand, on that particular finger where I also sported a brass ring made in jewelry class with *FUCK* going across.

My mother was only too happy to help pay for its removal, which cost a small fortune, also requiring two trips to the doctor to the tune of a thousand bucks—a lot of money then, a lot of money now. Not only that, but the skin graft deleted only the letters *U & C*. The *F & K* over the knuckles required sanding. The doctor did some, but the remainder I had to sand myself using fine sandpaper, and then swathing the bloodied knuckle in bleach-soaked gauze.

Twenty-five years later there is a slight scar, the *F & K* indistinguishable, obscured by other scars—the fighting knuckle. The *U & C* gone completely but covered with hair due to the skin graft.

The *13* is still where Jim put it. I never see it on my shoulder, nor did my mother, so it survived. The same cannot be said for Jim, who died at eighteen in a CAMP marijuana raid.

# For Lysa, Who Tattoos Me in Her Miami Living Room

### LISSETTE MENDEZ

Across Washington Avenue, limousines
disgorge their starched and shimmery
occupants in plumes of laughter and hunger
into a landscape confettied with sex and paste jewels.
"I dreamt this," she tells me, straddling my right knee,

her needled machine poised near the hollow
between my shoulder and my clavicle, and I smell
the incense and tobacco suffusing her T-shirt
but we're not touching and behind us is Monday
night's parade of moon and sea, palpable

in this room of six windows where a steel table
serves as altar: bottled pigments, paper towels,
Vaseline, surgical soap in its squirter.
Snap and pull of latex gloves within the blue
glow from the street lamps, tattoo of lacquered nails

against a cheap lighter, hiss of flame against
the mouth of the cigarette, clang of glass and metal
against the city's midnight machinery
while practice stencils flutter to the floor.
"I dreamt this, you have perfect skin," she tells me again

as the thump of hip-hop blurs into the needle's whine
and my eyes decant salt pearls that fall and fuse
with the ink and blood welling along the delicate strokes
of the kanji that will anchor me.

# Lace

**MICHAEL WATERS**

It was nothing, really, just a story
overheard at some party, the speaker
an attractive woman with a tattoo—
a miniature bluebird—bruising her left ankle.

How the hot needle had hurt, the bluebird
swollen and suppurated, but—
here's the part I can't forget—
how in the waiting room she'd thumbed

through glossy photographs of flesh
the artist had illustrated,
and come upon a torso
tattooed with a filigree of lace,

lace over breasts and back and waist,
a blouse so fine-spun and subtle
its bearer might slip among us,
not even the sober able to tell . . .

I don't know why this story
stayed with me through cheap whiskey,
the late hours, the heartbreak
of losing touch with a lover, but

I still can't shake the image of her
below a lattice of wisteria,
wearing nothing but light, milky
cursive, language sewn onto her skin

that I would begin to decipher,
given the chance again,
filament by filament,
until I might make sense of lace,

the ephemeral attachments that exist
between one person and the next,
between stories we embrace,
each story becoming our own.

# Triangle Tattoo

**CHERYL DUMESNIL**

Wood-planked floors, twelve-foot
ceiling, a wall of glossy snapshots—
dragonfly, water lily, barbed wire
spiraling a woman's thigh. The artist
bends over my lover's shaved leg,
his palate of paper cups filled with ink.
Through her skin, three finches
emerge on a blackberry branch,
ink mixed with blood beading her calf.
For the third time, I run downstairs
to the car, slap the gearshift into
neutral, roll over the parking cop's
chalk mark, buying us time. Hours
I sat beside them, telling stories,
changing the music, rubbing color
back into her fingertips. Now I
lean against the car and listen—
the buzz of the needle piercing
her skin, the heart-shaped sign
swinging its rusted chain. This is
my job—he will change her body
forever, I will love what she becomes.

# It's Bad Luck to Die

### ELIZABETH MCCRACKEN

Maybe you wonder how a Jewish girl from Des Moines got Jesus Christ tattooed on her three times: ascending on one thigh, crucified on the other, and conducting a miniature apocalypse beneath the right shoulder. It wasn't religion that put them there; it was Tiny, my husband. I have a Buddha round back, too. He was going to give me Moses parting the Red Sea, but I was running out of space. Besides, I told him, I was beginning to feel like a Great Figures in Religion comic book.

He got dreamy-eyed when he heard that. "Brigham Young," he said. "And some wives."

I told him: "Tiny, I've got no room for a polygamist."

Tiny himself had been married three times before he met me, one wife right after the other. I only had him, the one, and he's been dead six months now.

I met Tiny the summer I graduated high school, 1965, when I was eighteen and he was forty-nine. My cousin Babs, who was a little wild, had a crazy boyfriend (the whole family was worried about it) and he and some of his buddies dared her to get tattooed. She called me up and told me she needed me there and that I was not to judge, squawk, or faint at the sight of blood. She knew none of that was my style, anyhow.

We drove to Tiny's shop over on East 14th because that's where Steve, the crazy boy, had got the panther that had a toehold on his shoulder. The shop was clean and smelled of antiseptic; Babs and I were disappointed. Sheets of heavy paper in black dime-store frames hung on the walls—flash sheets—arranged by theme: one had Mickey Mouse and Woody Woodpecker; another, a nurse in a Red Cross cap and a geisha offering a drink on a tray. A big flash by the door had more ambitious designs: King Kong and Cleopatra on the opposite sides of one page, looking absentmindedly into each other's eyes.

Tiny was set up on a stool in back, smoking a cigarette, an itty-bit of a man next to a Japanese screen. He was wearing a blue dress shirt with the cuffs turned back, and his hands and arms were covered with blue-black lines: stars across the knuckles, snakes winding up under the sleeves. The wide flowered tie that spread out over his chest and stomach might've been right on a big man, but on Tiny it looked like an out-of-control garden. His pants were white and wrinkled, and there was a bit of blue ink at the knee; a suit jacket, just as wrinkled, hung on the coat rack in back.

He eyed our group, scowled at Steve and his two friends, and solemnly winked at me and Babs.

"So," he said. "Who's the one?"

"Me," Babs said, trying to sound tough. She told him what she wanted: a little red-and-black bow on her tush. He asked her if she were old enough; she got out her wallet and showed him her driver's license.

Steve and his friends were buzzing around the shop, looking at the flash and tapping the ones they really liked.

"Keep your hands off the designs, boys," said Tiny. "I can't tattoo a fingerprint." He turned to Babs. "Okay. Come back of the screen." There was something a little southern in

his voice, but I couldn't pick out what it was. He jumped off the stool, and I saw that he was about a full foot shorter than me. I'm six feet tall, have been since eighth grade. I looked right down on top of his slick black hair.

We all started to follow him. Tiny looked at us and shook his head.

"You boys have to stay out here."

"I'm her boyfriend," said Steve. "I've seen it before, and I'm paying."

"If you've seen it before, you'll see it again, so you don't need to now. Not in my shop, anyhow. You"—he pointed at me—"come around to testify I'm a gentleman."

He beckoned us back of the screen to a padded table, the kind you see in doctors' offices, only much lower. Tiny turned around politely while Babs lowered her blue jeans and clambered up. He spun back, frowned, pulled down just the top of her yellow flowered underwear like he was taking fat off a chicken, and tapped her. "Right here's where you want it?"

"That's fine."

"Honey, is it fine, or is it what you want?"

Babs twisted to look, careful not to catch his eye. "That's what I want."

He squirted her with antiseptic, got a razor and shaved the area good. I sat on a folding chair across from them.

Tiny loosened his tie, slipped it off, and hung it, still knotted, on a peg on the wall. "Hey Stretch," he said, looking at me. "What's your name?"

"Lois."

"Lois. Like Louise?" He rolled his shirtsleeves up further. Babs was holding on to the table like a drowning sailor, and Tiny hadn't even got the needle out yet.

"Lois," I answered, and fast, because I had to talk to him over Babs's hindquarters and that made me a little self-

conscious, "after my Uncle Louis. I was going to be named Natalie, after my Uncle Nathan, but then Louis died and Mom liked him better anyhow."

"My name is Tiny. No story there but the obvious." He picked up an electric needle from a workbench and hunted for the right pot of color.

"I'm Babs," said Babs, reaching around for a handshake. Tiny was looking elsewhere, and he dipped the needle in some black ink and flipped it on. "For Barbara?" he asked, setting into her skin.

"A-a-a-a-bigail. Ouch." She gripped the table.

"Honey," said Tiny, "this doesn't hurt. I got you where you're good and fleshy. Might sting a little, but it doesn't hurt."

"Okay," said Babs, and she sounded almost convinced.

"For Abraham," I said suddenly. "Abigail after Abraham."

"Pretty girls named after men," said Tiny, taking a cloth and wiping some ink off of Babs so he could see what he was doing. "Thought that only happened in the South."

Looking back, it seems like he took an hour working on Babs, but now I know it couldn't have been more than ten minutes. He looked up at me from time to time, smiling or winking. I thought that he was just one of those flirty types, one of those bold little guys, and that if he had been looking at Babs in the face instead of where he was looking at her, he would've flirted with her the same. Years later he told me that he was bowled over by all those square inches of skin, how I was so big and still not fat. "I fell for you right away," he said.

Up until then, I'd always thought it was only sensible to fall in love with tall men so that I wouldn't look like so much of a giantess. That way we could dance in public, in scale, no circus act. It didn't matter, though: I never had a date all through high school, couldn't dance a step. I spent my time in movie houses, because most movie stars looked pretty tall,

even if it was only a trick of the camera, a crate under their feet in love scenes.

Tiny, no doubt, no tricks about it, was short, but he charmed me from the start. His charm was as quick and easy as his needle, and he could turn it on and off the same way. On the Tuesday afternoons I visited him before we got married, I saw all types jangle the bell on the front door as they pushed it open: big men, skinny kids, nervous couples gambling on love forever. Most of them asked the same thing: "Does it hurt?" To people who rubbed him wrong, he'd say, "If you're worried about it, I guess you don't really want one"; to those he liked, chiefly the women, he'd drawl, "I could make you smile while I do it." He could, too; he could tell your background by the feel of your skin, and would talk about ridiculous things—baseball scores, recipes for homemade beer, the sorry state of music—anything but the business at hand.

He could even charm my mother, who, on meeting Tiny, this little man only two years younger than her, was grieved to discover she liked him.

When he was finished with Babs, he put on a bandage and handed her a little white card that said *How To Take Care Of Your New Tattoo.* It had his name and address at the bottom. She read it and nodded. He turned and gave me a card, too.

"Anything for you today?" he asked me.

"No, no. I'm a chaperon, that's all."

"Too bad. You'd tattoo great. You're pale—high contrast." He reached up and tapped me on the collarbone.

Babs looked a little white herself now, standing up, zipping her pants. Tiny got his tie and put it back on, tightened it as we walked around front.

"I like to look natty," he told me. Then he said to Steve, all business, "Eight dollars."

The boys crowded around Babs, who was suddenly look-ing pleased and jaunty, shaking her head: no, it didn't hurt; no big deal; no, not now, I'll show it to you later. I'm still the only member of the family that knows she has that tattoo.

"You wanna stick around and chat awhile?" Tiny asked me, pocketing Steve's money. "Tuesday's my slow day."

The boys turned and looked at me, like I was the tough one all of a sudden; I could see Babs was jealous.

"Sure," I said.

"Careful, Lois," said Steve. "By the time that character gets through with you, you'll be the tattooed lady."

But he didn't give me my first tattoo till a year later, the day after we were married: a little butterfly pooled in the small of my back. Five years later, he began referring to it as his "early work," even though he'd been tattooing for twenty-five years before he met me. That didn't rankle me as much as you might think—I liked being his early body of work, work-in-progress, future. That little butterfly sat by itself for a while, but in five years' time Tiny flooded it with other designs: car-. nations, an apple, a bomber plane, his initials.

When I told my mother about that first tattoo, she said, "Oh Lord. Is it pretty?" Like all good mothers, she always knew the worst was going to happen and was disappointed and re-lieved when it finally did. But she didn't ask to see that tattoo, or any of the ones that followed. Sunday afternoons, when I went to have lunch with her, I dressed very carefully. I cov-ered myself whenever I left the shop, anyhow: I hated nosy women in the grocery store trying to read my arm as I reached for the peas; I suspected all waitresses of gossiping

about me in the kitchen. On my visits to my mother, though, I was extra wary. Through the years, my sleeves got longer, the fabrics more opaque. I never wore white when I visited her: the colors shimmered through.

How could I explain it to my mother? She has always been a glamorous woman, never going anywhere without a mirror, checking and rechecking her reflection, straightening, maintaining. When I was a teenager, there were days that I didn't look in a mirror at all; I avoided my shadow passing in shop windows. Makeup hated me: mascara blacked my eyes, lipstick found its way onto my teeth and chin. At best, on formal occasions, I would peer into the rectangle on my lipstick case, seeing my mouth and nothing more. Tiny changed that. He caught me kneeling on the bathroom counter trying to get a glimpse of part of my back between the medicine chest and a compact, and he went on a campaign, installing mirrors, hiding them. He put a triple mirror from a clothing shop in our bedroom, put a full-length mirror over the bathtub. Once, I opened the freezer and saw my own reflection, chalked up with frost, looking alarmed in a red plastic frame in front of the orange juice.

Most of Tiny's own tattoos were ancient things that he'd done when he was just starting out. He learned the art traveling with the circus in the thirties, could only practice on himself or a grapefruit, and sometimes there wasn't a grapefruit around. The top of his left thigh was almost solid black with experiments.

When we were first married, he revealed a different tattoo every night, all of them hidden away: one night, a rose on a big toe; next, a banner that said E PLURIBUS UNUM half-furled in the hinge of his armpit; the next, his own signature,

crooked and ugly, on the inside of his lip. One night, he said, "Are you ready?" and before I could answer he turned his eyelids inside out, and there was a black star floating on the back of each one, isolated, like a scientific experiment.

"Flipping them up," he said, turning them back, "hurts more than the needle does. I was young and drunk and crazy when I had those done, and the guy who did them was younger and drunker and crazier. I'm lucky he stopped there, didn't tattoo my eyeballs scarlet red."

He showed me all these designs like he was performing magic tricks, and sometimes I expected him to wave his hand over his toe and the rose would disappear and end up cupped in his palm; or the banner would finish rolling out from under his arm straight into the air, and go up in a flash of fire; or his name would unwrite itself; or I would fall asleep and find, in front of my own eyes, those floating stars, as black and unruly as Tiny's hair.

It didn't take me long to get used to the feel of the needle. I learned to love it. Tiny gave me maybe two tattoos a year for our first four years of marriage. Little ones. The bigger ones took form over several months, or even longer. He sometimes did sketches for them on his own knee. I started sitting in the shop in a halter top and high-cut, low-slung shorts, ready to get up and turn a thigh this way or that, showing the customers how the colors went. I saw the same sorts of people I'd seen Tuesdays before I married Tiny, plus others: businessmen, priests, telephone operators, school-board members. Now they started asking me: "Does it hurt?" I told the truth. Of course it hurts, about the same as a vaccination, a lightly skinned knee, but less than a well-landed punch, a bad muscle

cramp, or paying the bills. And look what you get: something that can't be stolen, pawned, lost, forgotten, or outgrown.

In the late sixties, when Tiny was still working on a small scale, every time I got a new tattoo, I'd steal a daily touch—I would feel the scab starting, covering the colors, and I'd get impatient and think about peeling it off myself. Tiny'd read my mind and bawl me out, so I'd just run my finger over the tattoo, feeling the outline raised up like it always is when fresh. Then it'd peel by itself, and one day I'd put my finger down and not be able to tell the difference in skin: It'd really be a part of me. And that's when I started wanting another one.

After we'd been married ten years, Tiny got interested in art. Mother had given me a big book called *Masterpieces of the Renaissance*—she wanted me to latch on to something, to go to college, and she figured art history, all things considered, might appeal to me. It was a beautiful book—the gloss of the paper made all the paintings look just finished; the pages gave off the scent of brand new things. I read it the day I got it, and set it aside. The next afternoon, I picked it up and all the reproductions had been taken out with a razor blade. No Raphael, Michelangelo—just a tunnel of empty frames where they'd been, front of the book to back.

I ran down to the shop, grumbling. The plates from the book were tacked up on the wall; Tiny was eyeing an El Greco and sketching.

"What do you think you're doing?" I asked, hands on my hips, the way my mother stood when she started a fight.

"Take off your pants," he said.

"You ruined my book."

"I saved your mom's inscription. When I'm finished, we'll tape all the pictures back in. Come on, Lois, I want to try something."

"I don't feel like getting tattooed today, thank you very much."

"Pen and ink, that's all. I just want to sketch something."

"Sketch it on paper."

"Paper doesn't curve as nice as you. It'll only take a minute. Please?"

So I gave in, and Tiny sketched something on my hip in ballpoint pen. He didn't like whatever he'd done, and wiped my hip clean with rubbing alcohol. The next day he tried again. He took his time. I got a book to read while he was working (I couldn't get interested in something that wasn't permanent), but I couldn't figure out how to arrange myself. I leaned this way and that, holding my book at arm's length, and Tiny told me to stop squirming. Every night for a week he sketched and erased. At the end of the sessions, my hands would be dead asleep from trying to hold the book steady, and when I hit them on the edge of the table, trying to rouse them, they'd buzz like tuning forks. He never let me see what he was doing.

One night at the end of the week, after closing, Tiny said he had achieved what he wanted. He planned to tattoo it on my hip as a surprise.

I balked; my hip was my own, and I wanted to know what was going to be there. He promised that it would be beautiful and decent and a masterpiece.

"You'll love it," he said. "I've got this painting racket figured out."

"Okay," I said.

He decided to do the work upstairs at home. I stretched out on the bed, and he put on some Bing Crosby. Tiny loved Bing Crosby and at one point wanted to tattoo his face on me, but I put my foot down on that one. He gave me a glass of wine; he often let me have a glass, maybe two, when he was working on me. Never more, because it was against his strictest principles to tattoo a drunk.

He started at eight and worked until eleven. Tiny had a light touch, and by the end of the evening I had a little bit of El Greco. The colors weren't quite right, but it was mostly wonderful, the face of a Spanish monk blooming on my hip: Fray Felix Hortensio Paravicino. Tiny was good, believe it.

He adapted a lot of paintings from that book, did them up in flash and hung them in his shop. Few people asked for those designs—he thought of them mostly as eye-catchers, anyhow—but one skinny lady had the Mona Lisa put on her back, all those folds of fabric, the little winding roads in the background.

"Lucky she's built like a boy," Tiny said, meaning the woman, not Mona Lisa. "Otherwise, the picture woulda been all lopsided."

We went to the Art Center every now and then and wandered through one square room after another. I tried to get Tiny to look at my favorite thing there, a little Van Gogh landscape, but he always shook his head.

"That guy," said Tiny. "He's not a painter, he's a sculptor."

All those paintings and little descriptions made me sleepy; I would sprawl on a bench while Tiny practically pressed his nose to the oldest canvases.

We made the guards very nervous.

———

Tiny started to work bigger all the time, and put designs on my arms, down my legs. Eventually, he left only my hands, my feet, my neck, and face blank—I can still get dressed and look unmarked. But look at me undressed, see how he got better over the years: his patriotic stage, his religious stage. He liked greens and reds especially, and fine single-needle outlines, which he called "rare and elegant." I've got George Washington on one arm and Lincoln freeing the slaves on the other; I've got a garden planted between my breasts, Japanese peonies and daisies, reds and faded yellows; I've got a little pair of arms sinking into my belly button captioned HELP LET ME OUT.

My life drove my mother crazy. All she wanted was for me to become miraculously blank. I broke her heart—that was my job. She let me know her heart was broken—that was hers. She loved me, loves me. She has had a thousand lives: as a girl, she was pretty and could dance and flirt; her mother died, and she learned to take care of her father and older brother, and still she was happy, poised, and courted. She worked her way through college cleaning houses; she went to law school and New York and had a practice for a while; she married the owner of a women's clothing store and moved to the Midwest; she went to Indianapolis to learn how to fit women's underwear, and has her G.C. (Graduate Corsetiere) from the Gossard School. When my father died in 1955, she took over the shop herself and ran it for twenty years. She has taught ballroom dancing, travels to foreign countries; she is a small-business consultant, the vice-president of her temple, and president of the sisterhood. She used to paint, sculpt, needlepoint, and knit, and there is a table in the front hall of her apartment that she made sixty years ago. My mother be-

lieves in being able to start fresh whenever life demands. Tat-
toos confound her.

One Sunday when I was thirty and just beginning to be-
come the tattooed lady (Tiny had started the Ascension the
week before), my mother poured me a cup of coffee and said,
"Sweethearts carve their names on trees, not each other. Does
it ever occur to you that you are not leading a normal life?"

"Yes," I said. "Thank you." I adjusted my pants and peered
at my ankle to see whether I had embarrassed myself, whether
a tattoo had managed to come loose and slip to the floor. My
cousin Babs, who had just had a baby, was coming to lunch,
too, and my mother and I sat on the brocade sofa waiting.

"I just feel that you're painting yourself into a corner,"
Mom said to me. "How's Tiny?"

"Doing very well," I said. "Business is up." My mother
winced.

The doorbell rang. Mom answered the bell and ushered
in Babs, still a little thick around the middle, but elegant in
her suit, stockings of just the right color, curled hair.

Mom sat her down on the sofa.

"Honey," she said. "How's the darling baby?"

"A baby, all the way," said Babs. "No, he's fine, he's sweet."

"Well," said Mom. "Look at those nice clothes."

Babs had calmed down in the passing years; her parents
had offered her a car if she stopped seeing Steve, and it was a
better-than-fair deal. After college, she met and married a
high school principal turned local politician, and she seemed
to have lost every drop of wildness in her.

The sight of a well-dressed Babs never failed to surprise
me. "No one would ever suspect you had a reckless youth," I
told her.

"It's true," said Babs. She looked at me with some regret
and sighed. "Now I'm a nice married lady who sometimes

has one too many glasses of whiskey at one of my husband's parties and then tells the truth." She sighed and shifted her weight on the sofa cushion. I imagined her bow tattoo pricking her skin, an old war injury kicking up.

The three of us sat there and chatted about local news, babies, recipes. We covered ourselves. Looking at my mother, I realized how little I knew of her. Recently, I had gone through her desk, trying to unearth a phone book, and found a doctor's bill for a mammogram, detailing two suspicious spots, the next appointment. My heart jumped whenever I thought of it. Did her body show what happened next? Her face didn't, and nobody—especially me—asked my mother such things. Babs, too—besides that bit of color, what else: stretched-out stomach, the zipper of a surgical scar?

I knew myself under my green pantsuit, could tap George Washington on the chin, prick a finger on the thorn of a rose, strum an apocalyptic angel's wing, trace the shape of a heart Tiny'd given me after our first fight.

Anyone could read me like a book.

When my mother took the dirty dishes to the kitchen, I leaned toward Babs.

"Watch that whiskey," I told her, "or sometime you'll drop your pants to show a visiting dignitary the colorful result of a misspent youth."

She looked sad and understanding. "Oh," she whispered, "I *know.*"

That night, after Babs left, my mother took me to her bedroom closet to give me some of her old clothing. She was almost as tall as I was and very fashionable, her hand-me-downs nicer than my new things.

"Here," she said, handing me a pile of skirts and dresses. "Try them on. Don't take what you can't use."

I started for the bathroom to change.

She sighed. "I'm your mother," she said. "I used to fit girdles on women with stranger bodies than yours. You don't have to be modest."

So I undressed there and tried on the clothes, and my mother looked at me and frowned. Afterward, I sat down on her bed in my underwear and lit a cigarette.

"Wouldn't you like something to eat?" she asked me.

I did, but couldn't. I had just taken up smoking because I had put on a few pounds, and Tiny told me I better cut it out before I changed the expressions of all the tattoos. If I wasn't careful, Washington and Jesus and Fray Felix would start to look surprised or, at best, nauseated.

"No thanks," I told her.

My mother, who only smoked in airports and hospital waiting rooms ("All that cleanliness and worry gets to me," she'd say), slid a cigarette from my pack, took mine from my hand, and lit the end of hers. She looked at all of me stretched along the bed, started to touch my skin, but took her finger away.

"Well," she said, blowing out smoke, "you've finally made yourself into the freak you always thought you were."

I looked at her sideways, not knowing what to say.

"Actually," she said, "you look a little like a calico cat."

My mother was wrong. I never felt like a freak because of my height: I felt like a ghost haunting too much space, like those parents who talk about rattling around the house when the kids move out. I rattled. It's like when you move into a new

place, and despite the lease and despite the rent you've paid, the place doesn't feel like home and you're not sure you want to stay. Maybe you don't unpack for a while, maybe you leave the walls blank and put off filling the refrigerator. Well, getting a tattoo—it's like hanging drapes, or laying carpet, or driving that first nail into the fresh plaster: it's deciding you've moved in.

When Tiny turned seventy, he retired. His hands were beginning to shake a little, and he hated the idea of doing sloppy work. We still had the apartment over the shop, and Tiny kept the store open so that people could come in and talk. Nobody took him up on the tattooing lessons he offered; after a while, he tried to convince me to learn. He said I'd attract a lot of business. I told him no, I didn't have the nerves, I wasn't brave like him.

I took a job at the public library instead, shelving books. I worked in the stacks all day, and when I came home, Tiny'd be asleep. I'd know that he'd been napping all day so that he'd be awake enough to stay up and chat. He was getting old fast, now that he wasn't working.

I pulled the dining room table into the shop's front window, because Tiny liked to see who was coming and going. He knocked on the glass and waved, even to strangers. One night, a week before his seventy-sixth birthday, his arm started hurting halfway through dinner.

"I'm calling an ambulance," I said.

"Don't," he told me. "It's like saying there's something wrong. It's bad luck."

"It's bad luck to die," I said, and phoned.

———

He was surprisingly solid in that hospital bed, unlike his roommate, who looked like he had withered away to bedding. After a week, that roommate disappeared and was replaced by a huge man, a college professor with a heart problem.

One day, Tiny asked me an impossible favor. He wanted me to bring in the needle and put my initials on him.

"Ah, Tiny," I told him. "I'm not ready to sign you off yet."

"You have my initials on you, but I don't have yours. It's bad luck."

"I don't know how."

"You've seen it a million times."

The college professor was eavesdropping, and he looked a little queasy.

"We'll get caught," I whispered.

"We'll be quiet."

"This is a hospital," I said, like maybe he hadn't noticed.

"Sterile conditions," he answered.

So I brought the needle and some black ink the next day, rolled up my sleeves, got to work. We had to bribe the professor quiet, but he was easily bought. All he wanted was quart bottles of Old Milwaukee and the sort of food that would kill him. We turned on the television set to drown out the needle's hum. The professor pretended to sleep, so that if a nurse came in he could plead innocent.

We lived in terror of those nurses. One of them might walk in on us or notice something new on Tiny's arm. Tiny might die while I was working on him, and the hospital would conclude tattooing was some weird form of euthanasia. The professor might raise his price and demand fancier food, imported beers I couldn't afford.

I started with a G, and put an E on the next day. That afternoon, when I was just sitting there watching Tiny sleep, he raised his eyelids to half-mast and muttered, "I wish I woulda finished you."

"I thought I was finished, Tiny," I said.

"Nope," he said. He put a hand on my arm; his nails were rippled like old wood. "A tree, for instance. You don't have a tree."

"Where's room?"

"Soles of feet, earlobes. There's always room. Too late now. But you'll change anyhow, needle or no. For instance, when I put that George Washington on you, he was frowning. By the time you're my age, he'll be grinning ear to ear." He yawned, then suddenly pulled himself onto his elbows, squeezing the one hand on my arm for support. "I mean, tell me," he said. "Do you feel finished?"

"Yes," I said, and although I was thirty-nine, it was true: it hadn't occurred to me until that minute that I'd have to exist after he was gone.

The next day I was putting a T on his arm when Tiny said, "Do me a favor, Lois, huh? Don't forget me?"

The professor began to giggle in bed and ended up laughing, hard. "Do you think she'd be able to, even if she wanted? Look at her—she's a human memo board."

I really thought that I would keep on going, that I'd put a letter a day on him for a year, more. I hoped it would keep him going, because he seemed to be giving up a little.

By the end of the week, Tiny's arm said GET WELL in letters of all different sizes.

"Well," he said. "It's a little boring."

"It's going to get more interesting."

"It better," he told me, smiling. "Tomorrow you can put on a horseshoe for luck. Get fancy. Put on a heart for love."

"Okay," I said. But he died in the night, left without my name or love, with only my good wishes on his arm.

"What's going to happen to you now?" my mother asked me. "What if you want to get married again? What man will want you when someone else has been scribbling all over you?"

A month after Tiny died, Mama told me she was going to start inviting nice young men to our Sunday lunches. She bought me new outfits, unrevealing ones, and told me that we should keep my figure secret—she always referred to it as my figure, as if, over the years, I had put on a few things that could easily be taken off. I go to keep her happy, and sit on one side of the sofa while the fat divorced sons of her friends flirt with her instead of me, knowing that'll get them further. Sometimes I eat fudge and don't say one word all afternoon.

Every day I get up and go to work at the library, dressed in short skirts, short sleeves, no stockings. The director has told me that I'm frightening people.

"I'm sorry," I told her. "These are my widow's weeds."

Three weeks ago I got a letter from a young man on the coast, a tattooist who said that Tiny was a great artist and that I was proof of it. He wanted to take my photo, see the whole gallery. I packed him a box of Tiny's things, old flash sheets and needles and pages of El Greco, and told him to study those. He called me and said I was better than any museum. I told him that I apologized, that I understood, but really: I am not a museum, not yet, I'm a love letter, a love letter.

# *from* The Tattoo Hunter

## J. ACOSTA

My conscience is tattooed. My tattoos are not on my skin. (Not true: I have kisses and scratches tattooed on my back.) I have tangos tattooed upon the nostalgia of a mouth; poems tattooed on my apocalyptic anxiety; my chest was tattooed forever by a woman of water who inscribed upon it her name with menstrual blood and said to me, "You are mine motherfucker, only mine." Anyone will do. Each tattoo tells a story. Could be you . . . Sometimes the story is not of a tattoo but of a scar. Lightning upon the skin. Let me be me, let me be yours. The tattoo is a freely chosen scar.

Our love stories leave scars upon the skin of the kiss, upon the alcohol that we drink, upon the uncertainty of the days that go by. Each morning our nakedness shows us those scars. But the tattoo is a marking of sovereignty upon the skin. An exclusive territory of shadows, a shadow of light, a bullfighting ring of epidermic calligraphy and melancholy. Calligraphy of sadnesses of rituals fulfilled in the name of that modern pain produced by the anxiety for freedom.

I have tattooed on my retina a painting by Magritte, a regret on my esophagus, a tongue on my crotch, a silence on the decade of the seventies. I have tattooed on my throat the words I did not say, the ones I spit, the ones that live in the uncertain future of my unborn children. Tattoos of semen on the backs of lovers of pointless one-night stands; of lubricants

in the vagina of an eternally sad woman; of red wine dripping down the breasts of a woman in a hotel close to the Paseo de la Reforma. Tattoo or scar of a woman I met in a bar; of ten women I met in ten bars who loved me in the motels of drunkenness. Tattoo or scar of faked orgasms, of condoms strewn on the floor, of beer, of exchanged telephone numbers on fleeting napkins. Anyone will do, could be you. Sexual scar. Scar of the solitude of the end of the century. Let me be your love. . . . Let me be your tattoo.

# Incision

### GARNETT KILBERG COHEN

Aligning the incision
after the operation so the
design matches
is not
as easy
as it seems;

a mermaid falls from proportion,
one breast drooping lower than

the other;
a snake's head hangs loose;
an anchor just misses
hooking a wave.

Think of ripped letters,
puzzle pieces.
John loves
who?

# "After the surgery . . ."

**SUSAN TERRIS**

After the surgery where they took the breast tissue and the nipple, after twisting a back muscle across my chest for shape, they grafted skin for a new areola, cut a fishtail, formed a small bud shaped like a rose, tattooed it (*Pigment and palette, Beige 10, Beige 1, Pink 1, Brown 2*)—a numb, artificial rose on a man-made hill (*Hedge-clipper hum of needle, sting of punctured flesh*), and I see the rosebud, but how can I tender it now?

# First Poem for You

## KIM ADDONIZIO

I love to touch your tattoos in complete
darkness, when I can't see them. I'm sure of
where they are, know by heart the neat
lines of lightning pulsing just above
your nipple, can find, as if by instinct, the blue
swirls of water on your shoulder where a serpent
twists, facing a dragon. When I pull you
to me, taking you until we're spent
and quiet on the sheets, I love to kiss
the pictures in your skin. They'll last until
you're seared to ashes; whatever persists
or turns to pain between us, they will still
be there. Such permanence is terrifying.
So I touch them in the dark; but touch them, trying.

# Snakes

## JENNIFER ARMSTRONG

I'm trying to choose between boysenberry yogurt and raspberry—wondering which would leave fewer seeds stuck in my teeth—when the stained–T-shirt, jean-sagging male specimen beside me at the dairy case says, "Hey! You've got a lizard crawling up your arm." I actually look at my arm and of course I see the tail of the exquisite Celtic snake I have tattooed on my arm poking out from the edge of my sleeve. I'm tempted to say, "Oh? You have a tiny earthworm cowering in your pants." Damn it, my tattoo is a personal thing, not something to use for a pick-up line. Well, one time I asked Michael if he'd like to see my tattoo in much the clichéd way of saying, "Do you want to come up and see my etchings?" Even now, if I close my eyes, I can feel his tongue tracing the path of the apple blossoms drifting over my breast and belly. But it was *my* come-on line, not some slob's buying sour cream. Yep, he had potato chips and beer too. Figures. He winks at me and says, "I have a snake. I'll show you mine if you'll show me yours." I consider lobbing both the boysenberry yogurt in my right hand and the raspberry in my left at him. But I'm a nice person and so I carefully set both yogurts back on their respective piles and turn to slowly walk away when his voice stops me for the third time. "I got this tattoo after my father died. It helps, sort of." I turn back and look. He's holding up his shirt for me to see a vivid red and gold snake encircling his navel. My eyes find his. They are so blue.

# Parker's Back

## FLANNERY O'CONNOR

Parker's wife was sitting on the front porch floor, snapping beans. Parker was sitting on the step, some distance away, watching her sullenly. She was plain, plain. The skin on her face was thin and drawn as tight as the skin on an onion and her eyes were gray and sharp like the points of two icepicks. Parker understood why he had married her—he couldn't have got her any other way—but he couldn't understand why he stayed with her now. She was pregnant and pregnant women were not his favorite kind. Nevertheless, he stayed as if she had him conjured. He was puzzled and ashamed of himself.

The house they rented sat alone save for a single tall pecan tree on a high embankment overlooking a highway. At intervals a car would shoot past below and his wife's eyes would swerve suspiciously after the sound of it and then come back to rest on the newspaper full of beans in her lap. One of the things she did not approve of was automobiles. In addition to her other bad qualities, she was forever sniffing up sin. She did not smoke or dip, drink whiskey, use bad language or paint her face, and God knew some paint would have improved it, Parker thought. Her being against color, it was the more remarkable she had married him. Sometimes he supposed that she had married him because she meant to save him. At other times he had a suspicion that she actually liked

everything she said she didn't. He could account for her one way or another; it was himself he could not understand.

She turned her head in his direction and said, "It's no reason you can't work for a man. It don't have to be a woman."

"Aw shut your mouth for a change," Parker muttered.

If he had been certain she was jealous of the woman he worked for he would have been pleased but more likely she was concerned with the sin that would result if he and the woman took a liking to each other. He had told her that the woman was a hefty young blonde; in fact she was nearly seventy years old and too dried up to have an interest in anything except getting as much work out of him as she could. Not that an old woman didn't sometimes get an interest in a young man, particularly if he was as attractive as Parker felt he was, but this old woman looked at him the same way she looked at her old tractor—as if she had to put up with it because it was all she had. The tractor had broken down the second day Parker was on it and she had set him at once to cutting bushes, saying out of the side of her mouth to the nigger, "Everything he touches, he breaks." She also asked him to wear his shirt when he worked; Parker had removed it even though the day was not sultry; he put it back on reluctantly.

This ugly woman Parker married was his first wife. He had had other women but he had planned never to get himself tied up legally. He had first seen her one morning when his truck broke down on the highway. He had managed to pull it off the road into a neatly swept yard on which sat a peeling two-room house. He got out and opened the hood of the truck and began to study the motor. Parker had an extra sense that told him when there was a woman nearby watching him. After he had leaned over the motor a few minutes, his neck began to prickle. He cast his eye over the empty yard

and porch of the house. A woman he could not see was either nearby beyond a clump of honeysuckle or in the house, watching him out the window.

Suddenly Parker began to jump up and down and fling his hand about as if he had mashed it in the machinery. He doubled over and held his hand close to his chest. "God dammit!" he hollered, "Jesus Christ in hell! Jesus God Almighty damm! God dammit to hell!" He went on, flinging out the same few oaths over and over as loud as he could.

Without warning a terrible bristly claw slammed the side of his face and he fell backwards on the hood of the truck. "You don't talk no filth here!" a voice close to him shrilled.

Parker's vision was so blurred that for an instant he thought he had been attacked by some creature from above, a giant hawk-eyed angel wielding a hoary weapon. As his sight cleared, he saw before him a tall raw-boned girl with a broom.

"I hurt my hand," he said. "I HURT my hand." He was so incensed that he forgot that he hadn't hurt his hand. "My hand may be broke," he growled although his voice was still unsteady.

"Lemme see it," the girl demanded.

Parker stuck out his hand and she came closer and looked at it. There was no mark on the palm and she took the hand and turned it over. Her own hand was dry and hot and rough and Parker felt himself jolted back to life by her touch. He looked more closely at her. I don't want nothing to do with this one, he thought.

The girl's sharp eyes peered at the back of the stubby reddish hand she held. There emblazoned in red and blue was a tattooed eagle perched on a cannon. Parker's sleeve was rolled to the elbow. Above the eagle a serpent was coiled about a shield and in the spaces between the eagle and the serpent

there were hearts, some with arrows through them. Above the serpent there was a spread hand of cards. Every space on the skin of Parker's arm, from wrist to elbow, was covered in some loud design. The girl gazed at this with an almost stupefied smile of shock, as if she had accidentally grasped a poisonous snake; she dropped the hand.

"I got most of my other ones in foreign parts," Parker said. "These here I mostly got in the United States. I got my first one when I was only fifteen year old."

"Don't tell me," the girl said, "I don't like it. I ain't got any use for it."

"You ought to see the ones you can't see," Parker said and winked.

Two circles of red appeared like apples on the girl's cheeks and softened her appearance. Parker was intrigued. He did not for a minute think that she didn't like the tattoos. He had never yet met a woman who was not attracted to them.

Parker was fourteen when he saw a man in a fair, tattooed from head to foot. Except for his loins which were girded with a panther hide, the man's skin was patterned in what seemed from Parker's distance—he was near the back of the tent, standing on a bench—a single intricate design of brilliant color. The man, who was small and sturdy, moved about on the platform, flexing his muscles so that the arabesque of men and beasts and flowers on his skin appeared to have a subtle motion of its own. Parker was filled with emotion, lifted up as some people are when the flag passes. He was a boy whose mouth habitually hung open. He was heavy and earnest, as ordinary as a loaf of bread. When the show was over, he had remained standing on the bench, staring where the tattooed man had been, until the tent was almost empty.

Parker had never before felt the least motion of wonder

in himself. Until he saw the man at the fair, it did not enter his head that there was anything out of the ordinary about the fact that he existed. Even then it did not enter his head, but a peculiar unease settled in him. It was as if a blind boy had been turned so gently in a different direction that he did not know his destination had been changed.

He had his first tattoo some time after—the eagle perched on the cannon. It was done by a local artist. It hurt very little, just enough to make it appear to Parker to be worth doing. This was peculiar too for before he had thought that only what did not hurt was worth doing. The next year he quit school because he was sixteen and could. He went to the trade school for a while, then he quit the trade school and worked for six months in a garage. The only reason he worked at all was to pay for more tattoos. His mother worked in a laundry and could support him, but she would not pay for any tattoo except her name on a heart, which he had put on, grumbling. However, her name was Betty Jean and nobody had to know it was his mother. He found out that the tattoos were attractive to the kind of girls he liked but who had never liked him before. He began to drink beer and get in fights. His mother wept over what was becoming of him. One night she dragged him off to a revival with her, not telling him where they were going. When he saw the big lighted church, he jerked out of her grasp and ran. The next day he lied about his age and joined the navy.

Parker was large for the tight sailor's pants but the silly white cap, sitting low on his forehead, made his face by contrast look thoughtful and almost intense. After a month or two in the navy, his mouth ceased to hang open. His features hardened into the features of a man. He stayed in the navy five years and seemed a natural part of the gray mechanical ship, except for his eyes, which were the same pale slate-color

as the ocean and reflected the immense spaces around him as if they were a microcosm of the mysterious sea. In port Parker wandered about comparing the run-down places he was in to Birmingham, Alabama. Everywhere he went he picked up more tattoos.

He had stopped having lifeless ones like anchors and crossed rifles. He had a tiger and a panther on each shoulder, a cobra coiled about a torch on his chest, hawks on his thighs, Elizabeth II and Philip over where his stomach and liver were respectively. He did not care much what the subject was so long as it was colorful; on his abdomen he had a few obscenities but only because that seemed the proper place for them. Parker would be satisfied with each tattoo about a month, then something about it that had attracted him would wear off. Whenever a decent-sized mirror was available, he would get in front of it and study his overall look. The effect was not of one intricate arabesque of colors but of something haphazard and botched. A huge dissatisfaction would come over him and he would go off and find another tattooist and have another space filled up. The front of Parker was almost completely covered but there were no tattoos on his back. He had no desire for one anywhere he could not readily see it himself. As the space on the front of him for tattoos decreased, his dissatisfaction grew and became general.

After one of his furloughs, he didn't go back to the navy but remained away without official leave, drunk, in a rooming house in a city he did not know. His dissatisfaction, from being chronic and latent, had suddenly become acute and raged in him. It was as if the panther and the lion and the serpents and the eagles and the hawks had penetrated his skin and lived inside him in a raging warfare. The navy caught up with him, put him in the brig for nine months and then gave him a dishonorable discharge.

After that Parker decided that country air was the only kind fit to breathe. He rented the shack on the embankment and bought the old truck and took various jobs which he kept as long as it suited him. At the time he met his future wife, he was buying apples by the bushel and selling them for the same price by the pound to isolated homesteaders on back country roads.

"All that there," the woman said, pointing to his arm, "is no better than what a fool Indian would do. It's a heap of vanity." She seemed to have found the word she wanted. "Vanity of vanities," she said.

Well what the hell do I care what she thinks of it? Parker asked himself, but he was plainly bewildered. "I reckon you like one of these better than another anyway," he said, dallying until he thought of something that would impress her. He thrust the arm back at her. "Which you like best?"

"None of them," she said, "but the chicken is not as bad as the rest."

"What chicken?" Parker almost yelled.

She pointed to the eagle.

"That's an eagle," Parker said. "What fool would waste their time having a chicken put on themself?"

"What fool would have any of it?" the girl said and turned away. She went slowly back to the house and left him there to get going. Parker remained for almost five minutes, looking agape at the dark door she had entered.

The next day he returned with a bushel of apples. He was not one to be outdone by anything that looked like her. He liked women with meat on them, so you didn't feel their muscles, much less their old bones. When he arrived, she was sitting on the top step and the yard was full of children, all as thin and poor as herself; Parker remembered it was Saturday.

He hated to be making up to a woman when there were children around, but it was fortunate he had brought the bushel of apples off the truck. As the children approached him to see what he carried, he gave each child an apple and told it to get lost; in that way he cleared out the whole crowd.

The girl did nothing to acknowledge his presence. He might have been a stray pig or goat that had wandered into the yard and she too tired to take up the broom and send it off. He set the bushel of apples down next to her on the step. He sat down on a lower step.

"Hep yourself," he said, nodding at the basket; then he lapsed into silence.

She took an apple quickly as if the basket might disappear if she didn't make haste. Hungry people made Parker nervous. He had always had plenty to eat himself. He grew very uncomfortable. He reasoned he had nothing to say so why should he say it? He could not think now why he had come or why he didn't go before he wasted another bushel of apples on the crowd of children. He supposed they were her brothers and sisters.

She chewed the apple slowly but with a kind of relish of concentration, bent slightly but looking out ahead. The view from the porch stretched off across a long incline studded with iron weed and across the highway to a vast vista of hills and one small mountain. Long views depressed Parker. You look out into space like that and you begin to feel as if someone were after you, the navy or the government or religion.

"Who them children belong to, you?" he said at length.

"I ain't married yet," she said. "They belong to momma." She said it as if it were only a matter of time before she would be married.

Who in God's name would marry her? Parker thought.

A large barefooted woman with a wide gap-toothed face appeared in the door behind Parker. She had apparently been there for several minutes.

"Good evening," Parker said.

The woman crossed the porch and picked up what was left of the bushel of apples. "We thank you," she said and returned with it into the house.

"That your old woman?" Parker muttered.

The girl nodded. Parker knew a lot of sharp things he could have said like "You got my sympathy," but he was gloomily silent. He just sat there, looking at the view. He thought he must be coming down with something.

"If I pick up some peaches tomorrow I'll bring you some," he said.

"I'll be much obliged to you," the girl said.

Parker had no intention of taking any basket of peaches back there but the next day he found himself doing it. He and the girl had almost nothing to say to each other. One thing he did say was, "I ain't got any tattoo on my back."

"What you got on it?" the girl said.

"My shirt," Parker said. "Haw."

"Haw, haw," the girl said politely.

Parker thought he was losing his mind. He could not believe for a minute that he was attracted to a woman like this. She showed not the least interest in anything but what he brought until he appeared the third time with two cantaloups. "What's your name?" she asked.

"O. E. Parker," he said.

"What does the O. E. stand for?"

"You can just call me O. E.," Parker said. "Or Parker. Don't nobody call me by my name."

"What's it stand for?" she persisted.

"Never mind," Parker said. "What's yours?"

"I'll tell you when you tell me what them letters are the short of," she said. There was just a hint of flirtatiousness in her tone and it went rapidly to Parker's head. He had never revealed the name to any man or woman, only to the files of the navy and the government, and it was on his baptismal record which he got at the age of a month; his mother was a Methodist. When the name leaked out of the navy files, Parker narrowly missed killing the man who used it.

"You'll go blab it around," he said.

"I'll swear I'll never tell nobody," she said. "On God's holy word I swear it."

Parker sat for a few minutes in silence. Then he reached for the girl's neck, drew her ear close to his mouth and revealed the name in low voice.

"Obadiah," she whispered. Her face slowly brightened as if the name came as a sign to her. "Obadiah," she said.

The name still stank in Parker's estimation.

"Obadiah Elihue," she said in a reverent voice.

"If you call me that aloud, I'll bust your head open," Parker said. "What's yours?"

"Sarah Ruth Cates," she said.

"Glad to meet you, Sarah Ruth," Parker said.

Sarah Ruth's father was a Straight Gospel preacher but he was away, spreading it in Florida. Her mother did not seem to mind his attention to the girl so long as he brought a basket of something with him when he came. As for Sarah Ruth herself, it was plain to Parker after he had visited three times that she was crazy about him. She liked him even though she insisted that pictures on the skin were vanity of vanities and even after hearing him curse, and even after she had asked him if he was saved and he had replied that he didn't see it was anything in particular to save him from. After that, inspired, Parker had said, "I'd be saved enough if you was to kiss me."

93

She scowled. "That ain't being saved," she said.

Not long after that she agreed to take a ride in his truck. Parker parked it on a deserted road and suggested to her that they lie down together in the back of it.

"Not until after we're married," she said—just like that.

"Oh that ain't necessary," Parker said and as he reached for her, she thrust him away with such force that the door of the truck came off and he found himself flat on his back on the ground. He made up his mind then and there to have nothing further to do with her.

They were married in the County Ordinary's office because Sarah Ruth thought churches were idolatrous. Parker had no opinion about that one way or the other. The Ordinary's office was lined with cardboard file boxes and record books with dusty yellow slips of paper hanging on out of them. The Ordinary was an old woman with red hair who had held office for forty years and looked as dusty as her books. She married them from behind the iron-grill of a stand-up desk and when she finished, she said with a flourish, "Three dollars and fifty cents and till death do you part!" and yanked some forms out of a machine.

Marriage did not change Sarah Ruth a jot and it made Parker gloomier than ever. Every morning he decided he had had enough and would not return that night; every night he returned. Whenever Parker couldn't stand the way he felt, he would have another tattoo, but the only surface left on him now was his back. To see a tattoo on his own back he would have to get two mirrors and stand between them in just the correct position and this seemed to Parker a good way to make an idiot of himself. Sarah Ruth who, if she had had better sense, could have enjoyed a tattoo on his back, would not even look at the ones he had elsewhere. When he attempted to point out especial details of them, she would shut her eyes

tight and turn her back as well. Except in total darkness, she preferred Parker dressed and with his sleeves rolled down.

"At the judgement seat of God, Jesus is going to say to you, 'What you been doing all your life besides have pictures drawn all over you?' " she said.

"You don't fool me none," Parker said, "you're just afraid that hefty girl I work for'll like me so much she'll say, 'Come on, Mr. Parker, let's you and me . . .' "

"You're tempting sin," she said, "and at the judgement seat of God you'll have to answer for that too. You ought to go back to selling the fruits of the earth."

Parker did nothing much when he was at home but listen to what the judgement seat of God would be like for him if he didn't change his ways. When he could, he broke in with tales of the hefty girl he worked for. " 'Mr. Parker,' " he said she said, " 'I hired you for your brains.' " (She had added, "So why don't you use them?")

"And you should have seen her face the first time she saw me without my shirt," he said. " 'Mr. Parker,' she said, 'you're a walking panner-rammer!' " This had, in fact, been her remark but it had been delivered out of one side of her mouth.

Dissatisfaction began to grow so great in Parker that there was no containing it outside of a tattoo. It had to be his back. There was no help for it. A dim half-formed inspiration began to work in his mind. He visualized having a tattoo put there that Sarah Ruth would not be able to resist—a religious subject. He thought of an open book with HOLY BIBLE tattooed under it and an actual verse printed on the page. This seemed just the thing for a while; then he began to hear her say, "Ain't I already got a real Bible? What you think I want to read the same verse over and over for when I can read it all?" He needed something better even than the Bible! He thought about it so much that he began to lose sleep. He was already

losing flesh—Sarah Ruth just threw food in the pot and let it boil. Not knowing for certain why he continued to stay with a woman who was both ugly and pregnant and no cook made him generally nervous and irritable, and he developed a little tic in the side of his face.

Once or twice he found himself turning around abruptly as if someone were trailing him. He had had a granddaddy who had ended in the state mental hospital, although not until he was seventy-five, but as urgent as it might be for him to get a tattoo, it was just as urgent that he get exactly the right one to bring Sarah Ruth to heel. As he continued to worry over it, his eyes took on a hollow preoccupied expression. The old woman he worked for told him that if he couldn't keep his mind on what he was doing, she knew where she could find a fourteen-year-old colored boy who could. Parker was too preoccupied even to be offended. At any time previous, he would have left her then and there, saying drily, "Well, you go ahead on and get him then."

Two or three mornings later he was baling hay with the old woman's sorry baler and her broken down tractor in a large field, cleared save for one enormous old tree standing in the middle of it. The old woman was the kind who would not cut down a large old tree because it was a large old tree. She had pointed it out to Parker as if he didn't have eyes and told him to be careful not to hit it as the machine picked up hay near it. Parker began at the outside of the field and made circles inward toward it. He had to get off the tractor every now and then and untangle the baling cord or kick a rock out of the way. The old woman had told him to carry the rocks to the edge of the field, which he did when she was there watching. When he thought he could make it, he ran over them. As he circled the field his mind was on a suitable design

for his back. The sun, the size of a golf ball, began to switch regularly from in front to behind him, but he appeared to see it both places as if he had eyes in the back of his head. All at once he saw the tree reaching out to grasp him. A ferocious thud propelled him into the air, and he heard himself yelling in an unbelievably loud voice, "GOD ABOVE!"

He landed on his back while the tractor crashed upside down into the tree and burst into flame. The first thing Parker saw were his shoes, quickly being eaten by the fire; one was caught under the tractor, the other was some distance away, burning by itself. He was not in them. He could feel the hot breath of the burning tree on his face. He scrambled backwards, still sitting, his eyes cavernous, and if he had known how to cross himself he would have done it.

His truck was on a dirt road at the edge of the field. He moved toward it, still sitting, still backwards, but faster and faster; halfway to it he got up and began a kind of forward-bent run from which he collapsed on his knees twice. His legs felt like two old rusted rain gutters. He reached the truck finally and took off in it, zigzagging up the road. He drove past his house on the embankment and straight for the city, fifty miles distant.

Parker did not allow himself to think on the way to the city. He only knew that there had been a great change in his life, a leap forward into a worse unknown, and that there was nothing he could do about it. It was for all intents accomplished.

The artist had two large cluttered rooms over a chiropodist's office on a back street. Parker, still barefooted, burst silently in on him at a little after three in the afternoon. The artist, who was about Parker's own age—twenty-eight—but thin and bald, was behind a small drawing table, tracing a de-

sign in green ink. He looked up with an annoyed glance and did not seem to recognize Parker in the hollow-eyed creature before him.

"Let me see the book you got with all the pictures of God in it," Parker said breathlessly. "The religious one."

The artist continued to look at him with his intellectual, superior stare. "I don't put tattoos on drunks," he said.

"You know me!" Parker cried indignantly. "I'm O. E. Parker! You done work for me before and I always paid!"

The artist looked at him another moment as if he were not altogether sure. "You've fallen off some," he said. "You must have been in jail."

"Married," Parker said.

"Oh," said the artist. With the aid of mirrors the artist had tattooed on the top of his head a miniature owl, perfect in every detail. It was about the size of a half-dollar and served him as a show piece. There were cheaper artists in town but Parker had never wanted anything but the best. The artist went over to a cabinet at the back of the room and began to look over some art books. "Who are you interested in," he said, "saints, angels, Christs or what?"

"God," Parker said.

"Father, Son or Spirit?"

"Just God," Parker said impatiently. "Christ. I don't care. Just so it's God."

The artist returned with a book. He moved some papers off another table and put the book down on it and told Parker to sit down and see what he liked. "The up-t-date ones are in the back," he said.

Parker sat down with the book and wet his thumb. He began to go through it, beginning at the back where the up-to-date pictures were. Some of them he recognized—The Good Shepherd, Forbid Them Not, The Smiling Jesus, Jesus

the Physician's Friend, but he kept turning rapidly backwards and the pictures became less and less reassuring. One showed a gaunt green dead face streaked with blood. One was yellow with sagging purple eyes. Parker's heart began to beat faster and faster until it appeared to be roaring inside him like a great generator. He flipped the pages quickly, feeling that when he reached the one ordained, a sign would come. He continued to flip through until he had almost reached the front of the book. On one of the pages a pair of eyes glanced at him swiftly. Parker sped on, then stopped. His heart too appeared to cut off; there was absolute silence. It said as plainly as if silence were a language itself, GO BACK.

Parker returned to the picture—the haloed head of a flat stern Byzantine Christ with all-demanding eyes. He sat there trembling; his heart began slowly to beat again as if it were being brought to life by a subtle power.

"You found what you want?" the artist asked.

Parker's throat was too dry to speak. He got up and thrust the book at the artist, opened at the picture.

"That'll cost you plenty," the artist said. "You don't want all those little blocks though, just the outline and some better features."

"Just like it is," Parker said, "just like it is or nothing."

"It's your funeral," the artist said, "but I don't do that kind of work for nothing."

"How much?" Parker asked.

"It'll take maybe two days work."

"How much?" Parker said.

"On time or cash?" the artist asked. Parker's other jobs had been on time, but he had paid.

"Ten down and ten for every day it takes," the artist said.

Parker drew ten dollar bills out of his wallet; he had three left in.

"You come back in the morning," the artist said, putting the money in his own pocket. "First I'll have to trace that out of the book."

"No no!" Parker said. "Trace it now or gimme my money back," and his eyes blared as if he were ready for a fight.

The artist agreed. Anyone stupid enough to want a Christ on his back, he reasoned, would be just as likely as not to change his mind the next minute, but once the work was begun he could hardly do so.

While he worked on the tracing, he told Parker to go wash his back at the sink with the special soap he used there. Parker did it and returned to pace back and forth across the room, nervously flexing his shoulders. He wanted to go look at the picture again but at the same time he did not want to. The artist got up finally and had Parker lie down on the table. He swabbed his back with ethyl chloride and then began to outline the head on it with his iodine pencil. Another hour passed before he took up his electric instrument. Parker felt no particular pain. In Japan he had had a tattoo of the Buddha done on his upper arm with ivory needles; in Burma, a little brown root of a man had made a peacock on each of his knees using thin pointed sticks, two feet long; amateurs had worked on him with pins and soot. Parker was usually so relaxed and easy under the hand of the artist that he often went to sleep, but this time he remained awake, every muscle taut.

At midnight the artist said he was ready to quit. He propped one mirror, four feet square, on a table by the wall and took a smaller mirror off the lavatory wall and put it in Parker's hands. Parker stood with his back to the one on the table and moved the other until he saw a flashing burst of color reflected from his back. It was almost completely covered with little red and blue and ivory and saffron squares; from them he made out the lineaments of the face—a mouth,

the beginning of heavy brows, a straight nose, but the face was empty; the eyes had not yet been put in. The impression for the moment was almost as if the artist had tricked him and done the Physician's Friend.

"It don't have eyes," Parker cried out.

"That'll come," the artist said, "in due time. We have another day to go on it yet."

Parker spent the night on a cot at the Haven of Light Christian Mission. He found these the best places to stay in the city because they were free and included a meal of sorts. He got the last available cot and because he was still barefooted, he accepted a pair of secondhand shoes which, in his confusion, he put on to go to bed; he was still shocked from all that had happened to him. All night he lay awake in the long dormitory of cots with lumpy figures on them. The only light was from a phosphorescent cross glowing at the end of the room. The tree reached out to grasp him again, then burst into flame; the shoe burned quietly by itself, the eyes in the book said to him distinctly GO BACK and at the same time did not utter a sound. He wished that he were not in this city, not in this Haven of Light Mission, not in a bed by himself. He longed miserably for Sarah Ruth. Her sharp tongue and icepick eyes were the only comfort he could bring to mind. He decided he was losing it. Her eyes appeared soft and dilatory compared with the eyes in the book, for even though he could not summon up the exact look of those eyes, he could still feel their penetration. He felt as though, under their gaze, he was as transparent as the wing of a fly.

The tattooist had told him not to come until ten in the morning, but when he arrived at that hour, Parker was sitting in the dark hallway on the floor, waiting for him. He had decided upon getting up that, once the tattoo was on him, he would not look at it, that all his sensations of the day and

night before were those of a crazy man and that he would return to doing things according to his own sound judgement.

The artist began where he left off. "One thing I want to know," he said presently as he worked over Parker's back, "why do you want this on you? Have you gone and got religion? Are you saved?" he asked in a mocking voice.

Parker's throat felt salty and dry. "Naw," he said, "I ain't got no use for none of that. A man can't save his self from whatever it is he don't deserve none of my sympathy." These words seemed to leave his mouth like wraiths and to evaporate at once as if he had never uttered them.

"Then why . . ."

"I married this woman that's saved," Parker said. "I never should have done it. I ought to leave her. She's done gone and got pregnant."

"That's too bad," the artist said. "Then it's her making you have this tattoo."

"Naw," Parker said, "she don't know nothing about it. It's a surprise for her."

"You think she'll like it and lay off you a while?"

"She can't hep herself," Parker said. "She can't say she don't like the looks of God." He decided he had told the artist enough of his business. Artists were all right in their place but he didn't like them poking their noses into the affairs of regular people. "I didn't get no sleep last night," he said. "I think I'll get some now."

That closed the mouth of the artist but it did not bring him any sleep. He lay there, imagining how Sarah Ruth would be struck speechless by the face on his back and every now and then this would be interrupted by a vision of the tree of fire and his empty shoe burning beneath it.

The artist worked steadily until nearly four o'clock, not stopping to have lunch, hardly pausing with the electric in-

strument except to wipe the dripping dye off Parker's back as he went along. Finally he finished. "You can get up and look at it now," he said.

Parker sat up but he remained on the edge of the table.

The artist was pleased with his work and wanted Parker to look at it at once. Instead Parker continued to sit on the edge of the table, bent forward slightly but with a vacant look. "What ails you?" the artist said. "Go look at it."

"Ain't nothing ail me," Parker said in a sudden belligerent voice. "That tattoo ain't going nowhere. It'll be there when I get there." He reached for his shirt and began gingerly to put it on.

The artist took him roughly by the arm and propelled him between the two mirrors. "Now *look*," he said, angry at having his work ignored.

Parker looked, turned white and moved away. The eyes in the reflected face continued to look at him—still, straight, all-demanding, enclosed in silence.

"It was your idea, remember," the artist said. "I would have advised something else."

Parker said nothing. He put on his shirt and went out the door while the artist shouted, "I'll expect all of my money!"

Parker headed toward a package shop on the corner. He bought a pint of whiskey, and took it into a nearby alley and drank it all in five minutes. Then he moved on to a pool hall nearby which he frequented when he came to the city. It was a well-lighted barnlike place with a bar up one side and gambling machines on the other and pool tables in the back. As soon as Parker entered, a large man in a red and black checkered shirt hailed him by slapping him on the back and yelling, "Yeyyyyyy boy! O. E. Parker!"

Parker was not yet ready to be struck on the back. "Lay off," he said, "I got a fresh tattoo there."

"What you got this time?" the man asked and then yelled to a few at the machines. "O.E.'s got him another tattoo."

"Nothing special this time," Parker said and slunk over to a machine that was not being used.

"Come on," the big man said, "let's have a look at O.E.'s tattoo," and while Parker squirmed in their hands, they pulled up his shirt. Parker felt all the hands drop away instantly and his shirt fell again like a veil over the face. There was a silence in the pool room which seemed to Parker to grow from the circle around him until it extended to the foundations under the building and upward through the beams in the roof.

Finally someone said, "Christ!" Then they all broke into noise at once. Parker turned around, an uncertain grin on his face.

"Leave it to O.E.!" the man in the checkered shirt said. "That boy's a real card!"

"Maybe he's gone and got religion," someone yelled.

"Not on your life," Parker said.

"O.E.'s got religion and is witnessing for Jesus, ain't you, O.E.?" a little man with a piece of cigar in his mouth said wryly. "An o-riginal way to do it if I ever saw one."

"Leave it to Parker to think of a new one!" the fat man said.

"Yyeeeeeeyyyyyyy boy!" someone yelled and they all began to whistle and curse in compliment until Parker said, "Aaa shut up."

"What'd you do it for?" somebody asked.

"For laughs," Parker said. "What's it to you?"

"Why ain't you laughing then?" somebody yelled. Parker lunged into the midst of them and like a whirlwind on a summer's day there began a fight that raged amid overturned tables and swinging fists until two of them grabbed him and ran

to the door with him and threw him out. Then a calm descended on the pool hall as nerve shattering as if the long barnlike room were the ship from which Jonah had been cast into the sea.

Parker sat for a long time on the ground in the alley behind the pool hall, examining his soul. He saw it as a spider web of facts and lies that was not at all important to him but which appeared to be necessary in spite of his opinion. The eyes that were now forever on his back were eyes to be obeyed. He was as certain of it as he had ever been of anything. Throughout his life, grumbling and sometimes cursing, often afraid, once in rapture, Parker had obeyed whatever instinct of this kind had come to him—in rapture when his spirit had lifted at the sight of the tattooed man at the fair, afraid when he had joined the navy, grumbling when he had married Sarah Ruth.

The thought of her brought him slowly to his feet. She would know what he had to do. She would clear up the rest of it, and she would at least be pleased. It seemed to him that, all along, that was what he wanted, to please her. His truck was still parked in front of the building where the artist had his place, but it was not far away. He got in it and drove out of the city and into the country night. His head was almost clear of liquor and he observed that his dissatisfaction was gone, but he felt not quite like himself. It was as if he were himself but a stranger to himself, driving into a new country though everything he saw was familiar to him, even at night.

He arrived finally at the house on the embankment, pulled the truck under the pecan tree and got out. He made as much noise as possible to assert that he was still in charge here, that his leaving her for a night without word meant nothing except it was the way he did things. He slammed the

car door, stamped up the two steps and across the porch and rattled the door knob. It did not respond to his touch. "Sarah Ruth!" he yelled, "let me in."

There was no lock on the door and she had evidently placed the back of a chair against the knob. He began to beat on the door and rattle the knob at the same time.

He heard the bed springs screak and bent down and put his head to the keyhole, but it was stopped up with paper. "Let me in!" he hollered, bamming on the door again. "What you got me locked out for?"

A sharp voice close to the door said, "Who's there?"

"Me," Parker said, "O. E."

He waited a moment.

"Me," he said impatiently, "O. E."

Still no sound from inside.

He tried once more. "O. E.," he said, bamming the door two or three more times. "O. E. Parker. You know me."

There was a silence. Then the voice said slowly, "I don't know no O. E."

"Quit fooling," Parker pleaded. "You ain't got any business doing me this way. It's me, old O.E., I'm back. You ain't afraid of me."

"Who's there?" the same unfeeling voice said.

Parker turned his head as if he expected someone behind him to give him the answer. The sky had lightened slightly and there were two or three streaks of yellow floating above the horizon. Then as he stood there, a tree of light burst over the skyline.

Parker fell back against the door as if he had been pinned there by a lance.

"Who's there?" the voice from inside said and there was a quality about it now that seemed final. The knob rattled and the voice said peremptorily, "Who's there, I ast you?"

Parker bent down and put his mouth near the stuffed keyhole. "Obadiah," he whispered and all at once he felt the light pouring through him, turning his spider web soul into a perfect arabesque of colors, a garden of trees and birds and beasts.

"Obadiah Elihue!" he whispered.

The door opened and he stumbled in. Sarah Ruth loomed there, hands on her hips. She began at once, "That was no hefty blonde woman you was working for and you'll have to pay her every penny on her tractor you busted up. She don't keep insurance on it. She came here and her and me had us a long talk and I . . ."

Trembling, Parker set about lighting the kerosene lamp.

"What's the matter with you, wasting that kerosene this near daylight?" she demanded. "I ain't got to look at you."

A yellow glow enveloped them. Parker put the match down and began to unbutton his shirt.

"And you ain't going to have none of me this near morning," she said.

"Shut your mouth," he said quietly. "Look at this and then I don't want to hear no more out of you." He removed the shirt and turned his back to her.

"Another picture," Sarah Ruth growled. "I might have known you was off after putting some more trash on yourself."

Parker's knees went hollow under him. He wheeled around and cried, "Look at it! Don't just say that! *Look* at it!"

"I done looked," she said.

"Don't you know who it is?" he cried in anguish.

"No, who is it?" Sarah Ruth said. "It ain't anybody I know."

"It's him," Parker said.

"Him who?"

"God!" Parker cried.

"God? God don't look like that!"

"What do you know how he looks?" Parker moaned. "You ain't seen him."

"He don't . . . *look*," Sarah Ruth said. "He's a spirit. No man shall see his face."

"Aw listen," Parker groaned, "this is just a picture of him."

"Idolatry!" Sarah Ruth screamed. "Idolatry! Enflaming yourself with idols under every green tree! I can put up with lies and vanity but I don't want no idolator in this house!" and she grabbed up the broom and began to thrash him across the shoulders with it.

Parker was too stunned to resist. He sat there and let her beat him until she had nearly knocked him senseless and large welts had formed on the face of the tattooed Christ. Then he staggered up and made for the door.

She stamped the broom two or three times on the floor and went to the window and shook it out to get the taint of him off it. Still gripping it, she looked toward the pecan tree and her eyes hardened still more. There he was—who called himself Obadiah Elihue—leaning against the tree, crying like a baby.

## "In 1992, I had the tattoo on my arm redone . . ."

**LESLEE BECKER**

In 1992, I had the tattoo on my arm redone by a woman in Denver named Lady. The original tattoo was of a cowboy on a bucking bronco, but it really looked like an Eastern European country. A waitress in a local café asked me what my tattoo was supposed to be, and I told her it was a cowboy on a horse. "Hon," she said, "the head don't look right."

I now have a lizard on my arm, and so far, no one has questioned what it's supposed to be.

Ten years I've had this lizard, but recently went into a new parlor for a consultation and advice about getting some touch-up work on what was once a colorful design. The tattoo artist and his associates looked at me as if I might be a specimen. His shop was filled with tribes of curious young people, all of them glancing at my tattoo and letting their eyes travel up to walls filled with samples of fabulous tattoo selections. I had the feeling that I'd hurt the tattoo artist's trade that day, and that he was regarding me as someone who did not practice sound dermatological habits.

I aim to return to the tattoo artist once my cash flow and ego problems improve. I'll have him add highlights to my lizard, and maybe I can pretend I'm not at a place called Millennium, but at the tattoo parlor I visited in my youth. It was

located in an old brick building, third floor, at the end of a hallway containing a warren of abused-looking doors, behind which might've been private detectives, dentists, and fugitives. The humble sign said ARBUCKLE'S TATTOOS. Below this was another sign: ARBUCKLE'S TATTOOS REMOVED.

# Zowie

**KAROL GRIFFIN**

"You look like a knocked-up hillbilly," Savic says. I am wearing green socks, combat boots, a black sweater that hangs funny, and a pinkish brocade dress that is ankle length in the back and barely to my knees in the front. Seven months pregnant. When I cross my arms over the wriggling mound that is both me and not me, tattoos shoot out from my sleeves. This looks somehow obscene, and I find myself wondering about the absent father and his tattooed arms that are both like and not like my own. I wonder if he thinks of me when he looks at my artwork on his arms, or if he only thinks of me when he cracks his knuckles before curling his hands into fists.

Savic looks out the door of the tattoo shop at the snow blowing sideways across the parking lot, takes a long drag on his cigarette, and closes his eyes like he's getting ready for something big. "Picture it," he says. "I'm a traveling salesman and you're standing on a porch in that outfit with a Coca-Cola in one hand and a little black dog tucked under your arm. As I'm walking up the lane, you say 'Sho' is hot today.'" Savic's falsetto Appalachian impersonation fades away, and he is smiling to himself.

"Savic!" Karen looks like an angel, her beautiful face framed by cotton-candy pink hair. She's not mad at him. She's just concerned that her husband will offend someone, which he sometimes does, but usually on accident. I don't

take his daily foray into weird sex fantasies seriously. It's more outrageous than obscene. But Karen worries.

"What's the dog for?" I ask. Savic grins and lights another cigarette.

Savic is my boss at Zowie Tattoo, and I adore him, even though he is the tiniest bit scary, a whole lot moody, and prone to verbalizing lurid thoughts. His usual work uniform is this: black leather pants, a red lamé shirt, and a black leather Confederate cap with sunglasses clamped above the brim. He is from Georgia, and everyone in Wyoming who isn't wearing Wrangler jeans and a cowboy hat looks like a hillbilly of one sort or another. It's the opposite of an insult, seeing as how Savic comes from hillbilly stock himself. It's just that Wyoming isn't quite what he expected.

Shortly before Zowie Tattoo opened, the shop was burglarized. The burglars took everything—the designs off the walls, the machines, needles, ink. This was the third tattoo shop burglary in as many months, and the police didn't seem to be taking this sort of crime very seriously. Savic and Karen were determined to open the shop, no matter what. They used up the last of their savings to replace the stolen equipment, and tattoo artists across the country contributed whatever they could. Cash, flash, an autoclave. Business has been good, but not good enough. The shop rent is exorbitant, especially for a gas station turned office space in desperate need of environmental remediation. Eventually, all our best efforts won't be enough, and Savic and Karen will move bitterly back east. But for now, the big question is WHY. The shop resonates with Savic's plaintive mantra—*I just want to draw pictures on people*—which doesn't seem like too much to ask.

I knew who Savic was long before he arrived. Pick up almost any tattoo magazine, and you'll see his work. I met with Savic and Karen at the Buckhorn Bar a month before they

moved west. Sure, we agreed. Lots of clients. Lots of turn-over. A great place for a tattoo shop. My portfolio had been lost somewhere, so I spread out my meager collection of loose photos on a sticky bar table. Savic nodded approvingly.

"Why'd you quit?" he asked.

"The first time, I got married and moved to San Francisco. The second time—" There weren't really words to explain it, but Savic and Karen were looking at me expectantly. I left out the part about the absent father and chose a reason that was less personal and easier to articulate. "There's this guy who works at Mini Mart," I said. "His face has been pierced so many times that it looks as though he's had an unfortunate encounter with a Slinky. And he's got a Maori moko design tattooed on his chin."

"And?" Savic looked confused.

"He's co-opted a culture he knows nothing about," I said, "and, he's got a tattoo right in the middle of his face. Yet he looks somehow confused about why he's working the graveyard shift at a convenience store. I got tired of contributing to other people's lapses of judgment."

Savic and Karen aren't the only new folks in town. People are moving here in record numbers, tossing around city phrases like *quality of life* and *eco-tourism*. They come here hoping to escape their pasts—the crime, the pollution, and the inflated economies of urban areas—but they're looking for the West that exists more in myth than in reality. They settle in cul-de-sac arrangements of expensive city houses in neighborhoods with faux-Western names like the Buttes and Antelope Ridge. They see the possibility of inventing new, fruitful lives, but when this doesn't happen, or at least doesn't happen easily, they become overpowered by the need for a three-

dollar mocha latte. That's how it started. A coffeehouse here, a chain music store there. A subdivision on the top of the rolling hills east of Laramie, once a sacred Indian burial site. Consultants and telecommuters now outnumber ranchers and miners. Like Savic and Karen, they've all come here to settle the new West. The funny part is that I've never thought of Wyoming as a frontier. A frontier is someplace you go; this is where I live.

Laramie is tucked into a windswept Rocky Mountain basin, with the Medicine Bow and Snowy Range Mountains to the west and the Laramie Range to the east. It was built around the railroad in the late 1880s, a rough-and-tumble watering spot with frequent lynchings and many shady characters. The major industries are the railroad, the university, and an automotive technical school. The town grew east from the railroad tracks: charming tree-lined residential streets, the University of Wyoming campus, boxy modern houses covered with vinyl siding, a strip-mall assemblage of newer buildings that have been erected with little regard for form or style. The eastern edge of town is littered with car dealerships, fast-food restaurants, and our own beloved Wal-Mart.

Despite the civilizing influences of higher education, technology, and discount stores, Laramie is in the heart of the West, and this shapes the character of the town and the people more than you'd expect. I didn't notice this when I was younger, of course. At the time, I associated the West with concrete images and symbols—cowboys, Indians, rodeo, cattle—and in Laramie these are dusted off and paraded through town only once each summer.

Even though I grew up in Wyoming, most of my ideas about the spirit of the West came from books, movies, and television. My parents were quite fond of John Wayne westerns. Not the violent shoot-'em-ups so much, but the Rooster

Cogburn sort of movies with solid plots, sophisticated jokes, and sarcastic heroines. We spent quality time at the Skyline Drive-In Theatre, my sister and I dozing in the backseat of the Chrysler while a tinny audio box reverberated on the half-rolled-down window of the driver's door.

And I read. Biographies, mostly, from the children's room of the Albany County Public Library. Kit Carson, Calamity Jane, Frank and Jesse James—it went on and on, rows of safety-orange and forest-green bindings wrapped around Western lives portrayed in the best possible light.

I grew up believing that the West was a special place filled with courageous men and strong women who struggled against the hardships of isolation and nature, carving out a peculiarly Western code of ethics and morality along the way. Whenever I tried to put my life in the context of other people's versions of the West, I was usually disappointed. Even the movies that were filmed in Wyoming seemed to be about someplace else, but that didn't stop me from believing that the mythic West still existed.

I thought the West began somewhere outside the city limits, the places where my family went camping each summer, maybe, in the Middle Fork canyon, a labyrinth of evergreen overgrowth, dilapidated miners' cabins, and placer claims. I thought the West was the Two Bar Ranch, where we rode and branded every spring. When I thought about my surroundings, which wasn't often, Laramie was all about education, automobiles, boredom, and the lingering suspicion that many interesting people and things passed through town on the Union Pacific freights and the Amtrak coaches, but not much stopped or stayed.

I grew up Western without really noticing, Calamity Jane without a horse. As it turned out, I developed a connection to the place and the myth, a connection that was absolutely

seamless, so elemental that I didn't know it existed. The myth became so deeply ingrained that I couldn't have separated myself from it any more than I could have disengaged myself from a conjoined twin with whom I shared a heart. It has to do with solitude, with the connection between people and an unforgiving landscape, and optimism about what people can survive and what they might become.

"Zowie Tattoo." I answer the phone with the combination of attitude and welcome that people seem to expect when they call a tattoo shop.

"You're gonna force me to take action against you." The familiar voice of the absent father. Once this sound could almost stop my heart from sheer joy and passion. Now, my heart skips a beat and jumps into my throat. Fear. I cup my belly protectively with the hand that's not holding the phone.

"Did you know that it's an automatic aggravated assault charge when you hit a pregnant woman?" I ask like it doesn't matter one way or another. "Even without a weapon." Idle conversation. "I think it's a felony if you just hurt a pregnant woman's feelings." This spawns a new set of threats, most of them violent and all of them vivid. I hang up.

Growing up Western made it easy to become tattooed at a time when tattoos weren't especially popular. I'd gotten a good dose of the importance of expressing one's individuality at an early age, and I bought into the romantic myth of tattoos as a mark of the outlaw. I lived for a time in a tattooed West, and I was happy there.

By the time I was twenty-four, I was well on my way to becoming heavily tattooed, yet I still believed in a more tradi-

tional pursuit of the American Dream. I didn't see that these two choices would cancel each other out; this optimism was the West in me. I could drink almost anyone under the table, and I knew which fork to use for salad. I could swear like a sailor, and I could carry on a conversation about the benefits of investing in a 401K retirement plan. I never shied away from a dare, no matter how dangerous or stupid. I could rock up cocaine and bake a cherry pie, simultaneously, if need be. A fitted jacket over a modest brown skirt, and I was ready for dinner with my family and Christmas Eve church services. A black leather miniskirt and combat boots, and I was ready for a night on the town.

The differences didn't make either one better or worse. Just different. Like the differences between a waltz and flamenco, between poetry and prose.

The sunny side of the American Dream centers on a satisfying career with room for advancement. Appearance is important. Manner, etiquette, tradition. Family, future, insurance, investment. On the flip side, having fun is a higher priority. Money—sure, you need it, if you're going to have a good time. The difference might be in how it's acquired. The underside of the American Dream is a childlike place, a never-never land, where the stakes are just as high as anything you'd find on Wall Street, but the adventure is as much fun as achieving the goal. You live in the present, maybe that's the biggest difference. I have yet to hear anyone with an Individual Retirement Account utter these words: *Live fast, die young and leave a pretty corpse.*

I'm sitting in the front room at Zowie. Savic's machine is buzzing away in the distance while I wait for the next customer and flip through a tattoo magazine, not really reading.

I'm trying to decide what to tell the wriggle in my belly about its father, even though I figure I've got a good five years before it starts asking questions. Song lyrics spring to mind, pushing out more practical explanations. *He was a hardheaded man/He was brutally handsome/She was terminally pretty.* What he sang while we eluded a police chase last May. Life in the fast lane, and I love to drive. *He was the ghost of a Texas ladies' man.* What he sang in bed, naked and sweaty after the lights were out. *Wherefore art thou Romeo/You son of a bitch.* The refrain of betrayal.

I walk next door to the pool hall and buy a package of stale Slim Jims from the vending machine. Before I got pregnant, I didn't eat meat, mostly because I like the looks of cow faces. This isn't a popular sentiment in Wyoming. Plus, too, I thought it was hypocritical to eat a formerly living creature if I would not have the courage to kill it myself. Now I crave protein, especially beef. Rare steaks and huge hamburgers and ropy sticks of jerky. I eat with no remorse, even though I still lack the mettle to kill.

Tattooing at Zowie is my second job, and it seems like I'm always tired. I wonder if I should quit my day job and tattoo full-time, but then I'd lose my health insurance, so I work seven days a week instead. Seven A.M. till four, hiding my tattoos and making photocopies. Four till eleven P.M., sleeves pushed up and pushing ink. Two jobs, fourteen-hour days. I didn't think I'd ever work in a tattoo shop again, but I also didn't expect to be pregnant, pregnant alone. At night, I leave the tattoo shop in a hurry for a shower. I tuck away my tattoo money, which has become baby money. After I wash off the smell of cigarettes and antibacterial soap, I lie on the couch, exhausted but unable to sleep. I watch Lifetime: Television for Women, lots of made-for-TV movies about abused women

who eventually turn on the men who terrorized them. Sometimes I clap. Mostly I just lie on the couch, touching my belly and eating meat.

Mrs. Purdy, my sixth-grade teacher, sent me off to junior high school with a few words of advice to my parents. "Karol always roots for the underdog," she said. "It's bound to get her into trouble sooner or later." My parents weren't especially worried. I was twelve years old, and the only trouble I'd found so far was the heartache of bringing home stray animals and failed attempts at mending half-dead birds in a series of shoe boxes stuffed with toilet paper.

An innate characteristic of the Western sensibility is the appreciation of the outlaw, a romantic view that permits the elevation of criminals and eccentrics to hero status, so long as they adhere to a Western code of honor and individual freedom. Growing up in Wyoming gave me a peculiar mind-set when it came to underdogs and outlaws, and I rooted for them out of sheer appreciation of their exclusion from the mainstream.

The heartache of rooting for underdogs and outlaws became more acute as the underdogs became boys instead of stray animals, the outlaws men instead of boys. Any man I found attractive usually had a crust of rough edges and a dark side to his personality, with a flickering of goodness buried so deep that the process of finding it was a treasure hunt. It was this part, the banked coals that I could fan into a flame, to which I attached myself. Instead of falling in love with their hearts or their minds, I fell in love with their potential. I was willing to look especially hard for potential in any man who had a bad reputation, a wickedly languid smile, a penchant for

drugs or fast cars, and a few tattoos. With each one, despite my efforts, the spark of potential always flickered brightly only once, burning just long enough to extinguish itself.

The last time I tattooed was in an abandoned storefront with boarded-up windows somewhere in southern Colorado. This was before I got pregnant, back when the absent father and I acted like we thought we were Bonnie and Clyde. We were on the run from the law. More accurately, he was on the run; I was just aiding and abetting. I tattooed both his arms from shoulder to wrist, new work wrapping around jailhouse pieces and a haphazard caricature of Elvis. The NCIC wanted-fugitive report mentioned the Elvis tattoo, and the work I did was as much a disguise as anything. *People will see only fully tattooed arms,* was his rationale, *not individual pieces.*

When I started getting tattooed, a sense of kinship seemed to knit tattooed people into a colorful community. This isn't true anymore. Maybe it's because MTV has planted the seeds of tattoo desire in the fallow soil of teenage minds from coast to coast. Maybe it's because I've seen so many people rush into tattoos with little thought for design, placement, or permanence. Maybe it's because some people use tattoos more to shock others than to please themselves. Whatever the reason, I've learned two things to be true. First, one tattoo does not a tattooed person make. Second, when I see someone with a tattoo on his face or neck, I know that we are tattooed for completely different reasons, and that this is only the beginning of the differences between us.

The only tattooed people with whom I feel an inky kinship are those who are fully sleeved—tattooed from shoulder to wrist—on both arms. This speaks of a shared commitment of time and pain and dedication to an art form. Commitment and commonality breed a certain level of trust, however un-

easy; full sleeves tend to be attached to bikers, felons, and other tattoo artists. If nothing else, there's a flash of recognition and a nod of acknowledgment.

I sleeved the absent father completely. He let me tattoo whatever I wanted, wherever it would fit. I had a pretty good time and slung some nice ink, but by the time I finished, I was struck by the absurdity of tattoos as a disguise. This, after a thousand dollars' worth of tattoos in two weeks' time, power pack running off stolen electricity piped in through borrowed extension cords.

I think about some of the other things we did when he was on the run from the law, and I realize I could give him up in a heartbeat. I know, though, that I won't, any more than one of the Wild Bunch would drop a dime on a former member of the gang. Instead, I buy a gun, and an old cowboy with new tattoos teaches me to shoot it.

"Can I help you?" I smile at the three young men when they come through the door. One of them steps forward as though volunteering for an odious mission.

"Yeah." He sniffs and snorts in a manly sort of way and hitches at the crotch of his pants. "I want a tattoo." He scans the flash on the first wall and thunks a stubby finger repeatedly against a tiny Superman symbol. "How much?"

"Forty dollars."

"Let's do it." He looks to his companions for approval and the front room hums with a palpable wave of vicarious excitement. I pull the flash sheet off the wall and trace the design. "I want it in red and black, though," he says, breathing on me while I sharpen my pencil. "No yellow."

"No problem." I hold up the tracing paper. "I just need to make a stencil and we can get started."

"I don't want the *S* in it," he says as though I should have known better. "I want a *D*."

"*D*?"

"My name's Dave," he says. I erase the *S* and try to draw a satisfactory *D* inside the triangle. The tracing paper is gray and littered with eraser rubbings before I decide to call it quits.

"The only reason this symbol works graphically is because of the *S*. The *D* doesn't work," I say, surveying my efforts. "Maybe if it's a lowercase *D*—" I redraw it one more time, and hold it up.

He shakes his head. "I don't want a little *D*. I don't want to be Little Dave."

"You don't seem to mind being Duperman," I mutter, erasing until the paper rips. Eventually the big *D* is awkwardly placed in the center of the triangle, and Duperman approves it after conferring with his friends.

I belly up to Duperman, stretching his skin with my right hand and tattooing with my left. I've seen really fat tattoo artists, and I'm wondering how they manage. My elbows are lodged in the top of my stomach, and I'm anything but comfortable. Without warning, the baby kicks furiously. I lose the stretch on Duperman's arm, and even though I try to pull the tattoo machine back, the needles snag the skin. Duperman doesn't notice, but Savic does. I look down at the wide place this mistake has left in an otherwise perfect outline, and look up at Savic with dismay. We both look at my belly; I can't tattoo much longer.

A gay University of Wyoming student is brutally beaten, tied to a pole fence. Dies. This makes national headlines and causes local businesses to post signs: Violence is not a Laramie

value. Media people swarm through town, interviewing anyone who will stand still in front of a camera or tape recorder. We all agree it's a tragedy. A week later I hear my own voice on NPR, a sound bite from a barely remembered interview. *Violence is, too, a Laramie value.* What they left out was the part about Laramie's past, about the vigilante lynchings from street lamps and the trees lining Grand Avenue. They left out the part about how, now, women are the victims of Western violence most of the time, women whose bodies are dumped out in Rogers Canyon or along Happy Jack Road with surprising frequency, and how this usually rates only a small local newspaper article, not national coverage.

Savic has taken to accessorizing with a shoulder holster and semiautomatic handgun. Karen looks pinched. Business is slow, and we are all worried about money, burglars, killers.

"It starts with a bunch of maggots crawling out of my ass, and they're all wearing Shriner's caps and puking." Savic is explaining the concept for his back piece to the customer in my tattoo chair. "As the maggots come up, they get bigger and eventually turn into Shriners. The Shriners are sitting at tables in a strip club. Some of them are jacking off, and there's a hare-lipped whore giving a blow job under one of the tables. At the top, there's a stage, and on it is a one-legged stripper who's juggling flaming bowling pins. Above it all," he pauses for effect and makes an expansive gesture with both hands. "Above it all is a banner that says 'Sleep till Noon.'"

The young man in the tattoo chair looks both traumatized and impressed. He's getting a very small Tasmanian Devil on his shoulder. Earlier, when I suggested that he choose something more imaginative, he expanded upon his original idea by deciding that the Tasmanian Devil should be

making an obscene finger gesture, and there was nothing I could do to talk him out of it. I thought about refusing to tattoo him, period, but forty dollars is four packs of diapers, give or take a few.

Karen pokes her head around the doorway. "Phone call."

I pat the boy gently on the half-finished tattoo. "Break time," I say, stripping off my gloves and picking up the phone. I wish instantly that I hadn't. On the other end of the line is my once-upon-a-time favorite outlaw, the absent father. A few months ago, he was busted, extradited, heard in court. Now he's just waiting to be sentenced, but during a hefty methamphetamine binge between extradition and court, he decided that I must have been the person who tipped off the cops. It wasn't true. Even so, his hands became fleshy maces at the ends of muscular arms covered with my artwork. A blur of ink and muscle swinging toward my face, my chest, my belly. Over and over. When that wasn't enough to make me cry, he pulled out a .357 Magnum.

I cried then, begged for my life. For my child.

An unspoken Western code governs honor among outlaws, which is why I didn't press charges. That, and fear. Breaking up, though, seemed like a very good idea. I had hoped I'd heard the last of him, but he disappoints me once again.

"I didn't call to yell at you or nothing," he says. This time, it's empty promises, professed remorse, and thinly veiled demands. He and I and the baby are going to be a family, he says.

"Hey," I say. "October is National Domestic Violence Awareness Month. You going to beat up anyone special?"

He yells a few obscenities and splutters about the way he is going to kill me. He's to the part where he describes the place he plans to hide my body when I realize that I don't have to listen to this. He's making me dig my own grave

when I hang up, sit down, and close my eyes. The person I once loved more than anything has turned into a monster.

My baby hooks its feet into my ribs and bounces gaily off my bladder. I soothe it with both hands. It's getting bigger every day, and already I know what true love is really all about. "What has Wyoming come to," I ask the baby, "when tattoos have lost all meaning, and outlaws turn out to be just bad men?"

# "I got my tattoo at a time of great upheaval . . ."

**DARCEY STEINKE**

I got my tattoo at a time of great upheaval and change in my life. I wanted to demarcate this transformation and by marking myself this urge was realized. My tattoo was designed by the stained-glass artist Judith Schaechter. I wanted a sacred heart with flowers and flames but not a cartoon heart like most depictions of the sacred heart. I wanted an anatomically correct heart with veins and ventricles, filled with blood, spouting fire.

# "I'd wanted to *get one* for years . . ."

**RICK MOODY**

I'd wanted to *get one* for years, and I used to troll around a tattoo shop in Chicago, on the north side, looking at designs. But my partner, Amy, hated tattoos and attempted to curtail this ambition whenever it came up. A year or so later (1996, or thereabouts), I was in Providence at a conference on contemporary fiction with a couple of friends. I'd gone to undergraduate school there, and it was all pretty nostalgic, the three of us back for this conference as *prodigal children.* Only problem was, everybody seemed really unhappy with us. The whole vibe was poisonous and unfriendly. We decided to skip a cocktail party after a reading on the first night. Instead we went driving downtown, looking for trouble. Eventually, up on the Italian side of town, Atwells Avenue, we came upon this ghetto of tattooing parlors. A whole sequence of them. I yelled, *Stop the car!,* jumped out of the rental vehicle. Apparently, the decision had made itself, after years of waffling. I picked old-fashioned Christian imagery, namely a crucifix, and it was supposed to be in purple, in honor of my book, *Purple America,* but it sort of came out reddish. The site was (and still is) my right bicep. My friends stood outside the *surgical chamber* trying to talk me out of it. *Have you thought about hepatitis? Don't you think this is a little juvenile?* There was a moment right before the needle first hit skin when I enter-

tained some anxieties. *What if it really hurts?* But in the end the discomfort was minimal, nothing like *root canal*. Actually, I kind of liked it. I wanted to get another one almost immediately. Which I haven't done yet. Amy wept when she saw the crucifix. She was really mad. But I think she sort of likes it now.

# Tattoo Pantoum

### DENISE DUHAMEL

Best remembered for playing Tattoo,
Ricardo Montalban's chirpy sidekick on *Fantasy Island,*
Herve Villechaize was a French dwarf
who studied art in Paris before becoming an actor.

Ricardo Montalban's chirpy sidekick on *Fantasy Island*
stopped growing taller after hitting 3'9"
and studied art in Paris before becoming an actor.
Herve's own fantasy was to be a modern-day Toulouse
    Lautrec—

who also stopped growing taller after hitting 3'9"
and who was notorious when it came to women.
Herve's own fantasy was to be a modern-day Toulouse
    Lautrec,
but instead he was the evil dwarf in *The Man with the Golden
    Gun.*

James Bond was notorious when it came to women,
but not Herve who was in *Airplane II: The Sequel*
and the evil dwarf in *The Man with the Golden Gun.*
Tattoo himself had no tattoos

not even when he played a "novelty" role in *Airplane II:
    The Sequel.*

Barbie has tattoos, but they're temporary.
Tattoo himself had no tattoos
and certainly never owned a Barbie® Totally Tattoos™
    CD-ROM.

Barbie has tattoos, but they're temporary
using "hundreds of cool graphics and special effects"
that you can make on Barbie® Totally Tattoos™
    CD-ROM.
Barbie's makers are concerned about the safety of "real"
    tattoos.

Using hundreds of cool graphics and special effects,
tattoo artists are more popular than ever.
Alabama lawmakers are concerned about the safety of real
    tattoos
saying "no one with a skin infection, including a pimple,
    can get a tattoo."

Tattoo artists are more popular than ever.
Einstein, a tattoo artist in Harker Heights, TX
says "everyone, including pimply kids, should get tattoos."
Evidence of tattooing dates back to the ice age.

Einstein, a tattoo artist in Harker Heights, TX
has skulls and snakes on his Web site.
Evidence of tattooing dates back to the ice age
when brave warriors tattooed their faces.

A man with skulls and snakes on his bicep
still inspires confidence and machismo, reminding us of
when brave warriors tattooed their faces.
Some women get their makeup and eyebrows tattooed on

to inspire confidence when they're swimming or playing
    tennis.
This way they look great when they first get out of bed.
Some women get their makeup and eyebrows tattooed on
if they have shaky hands or bad eyesight.

This way they look great when they first get out of bed
and don't have to worry about smudges and mirrors.
Some women get their makeup and eyebrows tattooed on
even though they'd never sport a "real" tattoo.

They don't have to worry about smudges and mirrors
or looking tired and drawn out in hospital beds—
even though they'd never sport a "real" tattoo.
Even Jews can order Star of David temporary tattoos
    on-line.

One man who landed in a hospital bed
in a coma could be identified only by his tattoos.
Jews who order Star of David temporary tattoos on-line
may wonder if Jews with real tattoos can be buried in
    Jewish cemeteries.

A man in a coma identified only by his tattoos
was an Irishman hurt hiking in Peru.
Jews with real tattoos can be buried in Jewish cemeteries
according to Rabbi Bruce L. Gottlieb.

The Irishman hurt hiking in Peru
may have been saved by his tattoos, but Judaism teaches,
according to Rabbi Bruce L. Gottlieb,
our bodies are on loan to us.

Mutilation, scarring, and tattoos, as Judaism teaches,
are crimes against nature, as is plastic surgery.
Our bodies are on loan to us
which is why permanent lipstick and areola repigmentation

are, like plastic surgery, crimes against nature,
but not as bad a crime as suicide—
permanent lipstick and areola repigmentation
are nothing compared to shooting yourself or being married
    three times.

*Fantasy Island* knew of sadness, especially a star's suicide.
Herve Villechaize was a French dwarf
who in 1993 fatally shot himself. Married three times,
he's best remembered for playing Tattoo.

# It Only Hurts a Little

**SETH MNOOKIN**

A little over a year ago—last June—I got my first tattoo. I went to Artistic Tattooing in Providence, on my friend Dave's recommendation.

At that time, however, I had not yet discovered my fascination with, and appreciation for, pain. I was scared. As I walked into Artistic Tattooing, I tried to force an expression of indifference onto my face, hoping that no one would notice my badly shaking hands. I was fighting a losing battle: The quiet drone of the electric needle made me queasy, and I could hear my voice tremble as I asked Rusty, AT's master craftsman, if there was anything to which I could compare the sensation of getting a tattoo.

Rusty was not sympathetic. After more than twenty years in the business, he was no longer interested in soothing some virgin punk's jangled nerves. He looked up at me through the blue haze of his cigarette smoke and murmured with a sadistic glint in his eye and a slight leer on his lips, "Ever get hit by a car?"

No, in fact, I hadn't, and I quickly scurried into the street, seeking out a quiet corner in which to vomit. Ten minutes later, I was back, shaken but ready. "All right," I shouted as I walked back in. The sound of my voice alarmed me; whereas before I could discern the tremble on my breath, now I seemed to be shouting in an effort to muster up all the

machismo I could. "Do it. Smack that little whale right on my ankle."

It was over before I could really start whimpering, although at one point, when my leg began to shake, Rusty reminded me that "every time you move, it stays with you for the rest of your life." As I lay there, sweat pouring down my face, I kept repeating a twisted mantra over and over to myself. *This is my choice. No one is making me do this.* I remembered that Dave had said that when he got his tattoo—a sun on his ankle—Rusty had paused in the middle of the process and leaned in close to Dave.

"So, how's it feel?" Rusty asked.

"Well, uh, it kind of hurts," Dave answered.

Rusty leaned in a little closer, and, almost whispering, asked:

"Feels kind of good, doesn't it . . . ?"

This exchange served as an epiphany for Dave into the appeal of tattooing. It hurts, but you're choosing the pain. This realization is intoxicating. And pain isn't always a bad thing. Getting a tattoo feels pretty much like what you'd expect having a needle jammed into your skin hundreds of times a minute would feel like. Worse than a flu shot, but not as bad as getting your arm broken. And, because it's not unbearable, it does almost feel good.

So as I limped into the street, I felt no small sense of accomplishment. Damn straight, I got a tattoo. And Rusty said the ankle hurts more than most places—more bone for the needle to dig into.

On my next two trips to Artistic Tattooing, I liked to think that Rusty and I bonded. Maybe we did . . . probably not, though. I sure as hell was damn more excited about knowing Rusty's name than he was about knowing mine.

———

But Rusty didn't fit into my plans one Thursday night. Days before classes were set to begin, I had been assigned to write a piece about tattooing for *Fifteen Minutes,* the weekly magazine of *The Harvard Crimson,* and the burly, almost mute inker seemed too guarded to be the subject of some serious writing. Dan, Dave, Nick, and I met at the Carpenter Center. As we drove off, my head was clear and I was full of hubris and energy. I could march into any tattoo parlor around and say exactly what I wanted and get it. I decided to go to Electric Ink Tattooing, in East Providence, just to prove my fearlessness. Everything was good. Or so I thought.

Looking back, as soon as I walked into Electric Ink I should have known something was wrong. There was no one there but the tattoo artists; no line of waiting customers, like at Artistic Tattooing. And Electric Ink was at the end of a dimly lit street, no other stores in sight. Three men were in the shop, eating pizza and looking hungry for some fresh meat. There was a strange glint in their eyes. Artistic Tattooing was much more professional—Rusty didn't like any fucking around. That did not seem to be the case here.

The guys who worked at Electric Ink were friendly—too friendly, in retrospect. Nervous-friendly. They felt compelled to joke with me as much as I did with them. This was bad. I might have had something to prove, but they certainly shouldn't have. This was their territory. No matter how much tattooists need the business, they always act (or should) like you need them, while they couldn't give a shit if you dropped dead or not.

And once you're in, you do need them. They hold your ticket to change. After you get a tattoo, you will never be exactly the same. You carry away more than just some ink injected into your fat. Because of this, tattoo artists wield a power not totally unlike that of doctors. If they're good, they

can make you better (or at least make you look better). But if they fuck up, it's still your body. This realization breeds a certain cockiness on the artist's, as well as the customer's, part, a forced nonchalance, an affected disregard for the body and flesh. No one is supposed to care too much, but no one better make a mistake. So when the long-haired, bearded man behind the desk at Electric Ink joked that "you can always tell a Harvard man, but you can't tell him much," and they laughed a little too quickly and loudly, I felt my stomach tighten. At the time, I associated this with pre-ink jitters—I had decided that instead of an inkless FM logo, I was going to get a snake wrapped around my ankle, covering my whale.

There was no need to be nervous, I thought, in an unsuccessful effort to calm myself. Electric Ink was pretty much what I had come to expect at tattoo parlors. Lots of big black binders offering the parlor's options, full of naked women and mythic beasts, some tribal stuff, and a couple of flowers and birds, "for the chicks," the guy behind the desk explained. "And lots of frat guys like Tasmanian Devils on their asses." And this parlor, like others, was brightly lit. The artists, after all, need the light.

Indeed, Electric Ink seemed pretty standard, as far as tattoo parlors go. Except I had this nagging thought in the back of my mind that Electric Ink's artists seemed overly friendly. Thinking back to my last time at Artistic Tattooing, I realized how different this place was. Rusty was never big on jokes; in fact, he didn't seem to be too keen on conversation in general. When I had gotten my tangoers, I had tried in vain to make some small talk with Rusty to keep my mind off of the needle.

"So, how many customers you get a day?" I had asked.

"Depends."

"Business usually pretty good?"

"Sometimes."

"How long have you been tattooing?"

At this point, Rusty had stopped, turned off his needle, and looked me in the eye. He leaned in a little, and, in a tone that was barely audible, asked:

"What are you, writing a book?"

Nothing else was said. I never asked about the picture of him with Willie Nelson on the wall.

But at Electric Ink, things were different. One of the guys asked me if I knew a local tattoo artist who works underground, out of Cambridge. I did. They asked me who had done my other tattoos. Rusty, I said. They knew him. They seemed impressed. This wasn't good. And when they quoted me a price of one hundred dollars for an hour's work—cheap by tattoo standards—I couldn't help thinking of a sign Rusty had on the wall in Artistic Tattooing: "We're not cheap but we're good. Other shops charge less, but they know what their work is worth."

The more things progressed, the more the vibe spun out of control. As Scott, my artist, began to explain to me that his first tattoo was of a velociraptor from *Jurassic Park,* I did some quick calculations. *Jurassic Park* came out in June. Not much time had passed since then for him to perfect his craft.

Still, I had already bought my ticket; now I had to take the ride. Scott began to shave my ankle, and before he was halfway around, had sliced me three times. Another guy who worked there joked about Scott's famed "velvety touch." Ha-ha. Blood was dripping down my ankle, and Dan seemed to be getting nervous. He came up next to me and muttered something about leaving to take a walk.

Great. Now our car was gone, and we were stranded on a quiet street in East Providence. I had known that Dan was the wild card, but I hadn't counted on his deserting us. By this

time, Scott had added another slice into my ankle and was liberally applying rubbing alcohol to my open wounds.

Desperate to regain control of the situation, I began talking with the guy who seemed to know some people in Cambridge. He said something about having been in Boston over the weekend to get tickets for a Bad Religion concert, but I couldn't quite make out what it was he was trying to say. But I wasn't really listening; I was too busy watching Scott flub his first attempt at applying a stencil of the snake to my ankle. "Oh, really?" I mumbled absentmindedly, vaguely recalling that Bad Religion was some horrendous hard-core band.

Apparently, this was the wrong response. "Yeah, really, huh," the guy barked back at me. Great. Now there was one goon up front, one freak making a mess out of my ankle, and one combative dude, pissed that I had apparently misheard him. My sweat was growing stale, and my leg had started to shake a little. Dave looked over at me, apparently trying to figure out if everything was okay. And Scott was still fumbling with the now tattered stencil.

Finally, after three strangely botched attempts at applying the stencil, Scott whipped out a Magic Marker, ready to sketch a snake on my ankle. Several shaky, disjointed lines later, I inquired as to his intentions. Surely, I asked, he was not planning on working from only his deranged lines?

By this point, he was sweating too, and probably wishing I had never come in. He was certainly wishing that Nick and Dave would stop taking pictures of his incompetence. As he tried to explain that he was, indeed, going to work from his sketched lines, I asked frantically how he was planning to incorporate the design within the snake. "I'll figure it out once I start," he said, cleaning his tattoo gun.

My head started to spin. As I looked around, I realized

that one of the other guys was resterilizing needles and stapling them into packets marked "Hospital Sterilization." Very different from Artistic, where they use new needles for every customer. That was it. I wanted out.

Eyeing the door, I began trying to determine the quickest and most effective escape route. I had to work fast. Things had become decidedly uncool, and I didn't want anything with so much negative potential on my body for the rest of my life. Explaining my tangoers was fun. I have only the fondest memories of good 'ol reticent Rusty even when I almost passed out. But this was different.

What happened next was a blur of adrenaline and energy. As Scott began cleaning the needle and preparing the black ink, I jumped up, exclaiming that I did not have enough money and needed to get to a cash machine. Waving my hands frantically and clutching my wallet, pulling out press passes and old IDs, I told him I'd be right back.

It would have gone off without a hitch, except Dave and Nick weren't biting. First they offered to lend me some money, and then, when I finally succeeded in dragging them outside, they insisted that I go back in and explain that I was taking off. Maybe I should even offer Scott some money, they suggested.

At this point, Dan pulled up in the Volvo and, looking slightly confused, said he hadn't been planning on coming back for an hour, and what were we doing out so early. Suddenly, it seemed that Scott and the boys at Electric Ink were the least of my problems. I had lured Dan and Nick and Dave down to Providence with the promise of blood and needles, of twisted expressions of pain that they could document in

the interests of Journalism. Now we were running off with our tails between our legs. They weren't going to give up so easily.

Eventually, I agreed to go back in. Although I certainly didn't feel that I owed any explanations—after all, Scott was about to ineptly mutilate my body—my three companions disagreed. I even ended up giving Scott twenty bucks. I guess that's the going rate for leg mutilation.

The final scene was as uncomfortable and unsatisfying as the end of a love affair in which no one had done anything wrong, but nothing had worked, either. Walking over to Scott, I tried to remind myself that the fact that he was incompetent did not reflect poorly on me. Still, I couldn't help feeling bad. "Look, I don't think I'm gonna do this today. Why don't I give you some money for the work you've done so far."

Instead of being angry, Scott appeared equally uneasy. "Sure, why don't you give me twenty bucks." Done. I couldn't help feeling like I had come out on top.

As we drove off, we were all silent. The boys at Electric Ink had gathered by the window and were doing their best to glare at us, but they knew they hadn't played their parts well. I couldn't help thinking that they looked a little ridiculous.

# Tattoos

**J. D. MCCLATCHY**

### I. CHICAGO, 1969

Three boots from Great Lakes stumble arm-in-arm
      Past the hookers
    And winos on South State
To a tat shack. Pissed on mai tais, what harm
    Could come from the bright slate
Of flashes on the scratcher's corridor
Wall, or the swagger of esprit de corps?

Tom, the freckled Hoosier farmboy, speaks up
      And shyly points
    To a four-inch eagle
High over the Stars and Stripes at sunup.
    A stormy upheaval
Inside—a seething felt first in the groin—
Then shoves its stubby subconscious gunpoint

Into the back of his mind. The eagle's beak
      Grips a banner
    Waiting for someone's name.
Tom mumbles that he'd like the space to read
    FELIX, for his small-framed
Latino bunkmate with the quick temper.
Felix hears his name and starts to stammer—

He's standing there beside Tom—then all three
        Nervously laugh
    Outloud, and the stencil
Is taped to Tom's chest. The needle's low-key
    Buzzing fusses until,
Oozing rills of blood like a polygraph's
Lines, there's a scene that for years won't come off.

Across the room, facedown on his own cot,
        Stripped to the waist,
    Felix wants Jesus Christ
Crucified on his shoulder blade, but not
    The heart-broken, thorn-spliced
Redeemer of punk East Harlem jailbait.
He wants light streaming from the wounds, a face

Staring right back at those who've betrayed him,
        Confident, strong,
    With a dark blue crewcut.
Twelve shading needles work around the rim
    Of a halo, bloodshot
But lustrous, whose pain is meant to prolong
His sudden resolve to fix what's been wrong.

(Six months later, a swab in Vietnam,
        He won't have time
    To notice what's been inked
At night onto the sky's open hand—palms
    Crawling with Cong. He blinks.
Bullets slam into him. He tries to climb
A wooden cross that roses now entwine.)

And last, the bookish, acned college grad
	From Tucson, Steve,
	Who's downed an extra pint
Of cut-price rye and, misquoting Conrad
	On the fate of the mind,
Asks loudly for the whole nine yards, a "sleeve,"
An arm's-length pattern of motives that weave

And eddy around shoals of muscle or bone.
	Back home he'd signed
	On for a Navy hitch
Because he'd never seen what he's since grown
	To need, an *ocean* which . . .
But by now he's passed out, and left its design
To the old man, whose eyes narrow, then shine.

By dawn, he's done. By dawn, the others too
	Have paid and gone.
	Propped on a tabletop,
Steve's grappling with a hangover's thumbscrew.
	The bandages feel hot.
The old man's asleep in a chair. Steve yawns
And makes his way back, shielded by clip-ons.

In a week he'll unwrap himself. His wrist,
	A scalloped reef,
	Could flick an undertow
Up through the tangled swash of glaucous cyst
	And tendon kelp below
A vaccination scallop's anchored seaweed,
The swelling billow his bicep could heave

For twin dolphins to ride toward his shoulder's
        Coppery cliffs
     Until the waves, all flecked
With a glistening spume, climb the collar-
    Bone and break on his neck.
When he raises his arm, the tide's adrift
With his dreams, all his watery what-ifs,

And ebbs back down under the sheet, the past,
        The uniform.
     His skin now seems colder.
The surface of the world, he thinks, is glass,
    And the body's older,
Beckoning life shines up at us transformed
At times, moonlit, colorfast, waterborne.

2.

Figuring out the body starts with the skin,
    Its boundary, its edgy go-between,
The scarred, outspoken witness at its trials,
    The monitor of its memories,
Pleasure's flushed archivist and death's pale herald.
    But skin is general-issue, a blank
Identity card until it's been filled in
    Or covered up, in some way disguised
To set us apart from the beasts, whose aspects
   Are given, not chosen, and the gods
Whose repertoire of change—from shower of gold
    To carpenter's son—is limited.
We need above all to distinguish ourselves
    From one another, and ornament

Is particularity, elevating
  By the latest bit of finery,
Pain, wardrobe, extravagance or privation
  Each above the common human herd.
The panniered skirt, dicky, ruff and powdered wig,
  Beauty mole, Mohawk, or nipple ring,
The penciled eyebrow above Fortuny pleats,
  The homeless addict's stolen parka,
Face lift, mukluk, ponytail, fez, dirndl, ascot,
  The starlet's lucite stiletto heels,
The billboard model with his briefs at half-mast,
  The geisha's obi, the gigolo's
Espadrilles, the war widow's décolletage . . .
  Any arrangement elaborates
A desire to mask that part of the world
  One's body is. Nostalgia no more
Than anarchy laces up the secondhand
  Myths we dress our well-fingered goods in.
Better still perhaps to change the body's shape
  With rings to elongate the neck, shoes
To bind the feet, lead plates wrapped to budding breasts,
  The Sadhu's penis-weights and plasters,
The oiled, pumped-up torsos at Muscle Beach,
  Or corsets cinched so tightly the ribs
Protrude like a smug, rutting pouter pigeon's.
  They serve to remind us we are not
Our own bodies but anagrams of their flesh,
  And pain not a feeling but a thought.
But best of all, so say fellow travelers
  In the fetish clan, is the tattoo,
Because not merely molded or worn awhile
  But exuded from the body's sense

Of itself, the story of its conjuring
    A means defiantly to round on
Death's insufferably endless emptiness.
    If cave men smeared their bones with ochre,
The color of blood and first symbol of life,
    Then people ever since—Egyptian
Priestesses, Mayan chieftains, woady Druids,
    Sythian nomads and Hebrew slaves,
Praetorian guards and Kabuki actors,
    Hell's Angels, pilgrims, monks and convicts—
Have marked themselves or been forcibly branded
    To signify that they are members
Of a group apart, usually above
    But often below the rest of us.
The instruments come effortlessly to hand:
    Fish bone, razor blade, bamboo sliver,
Thorn, glass, shell shard, nail or electric needle.
    The canvas is pierced, the lines are drawn,
The colors suffuse a pattern of desire.
    The Eskimos pull a charcoaled string
Beneath the skin, and seadogs used to cover
    The art with gunpowder and set fire
To it. The explosion drove the colors in.
    Teddy boys might use matchtip sulfur
Or caked shoe polish mashed with spit. In Thailand
    The indigo was once a gecko.
In mall parlors here, India ink and tabs
    Of pigment cut with grain alcohol
Patch together tribal grids, vows, fantasies,
    Frescoes, planetary signs, pinups,
Rock idols, bar codes, all the insignia
    Of the brave face and the lonely heart.

The reasons are both remote and parallel.
     The primitive impulse was to join,
The modern to detach oneself from the world.
     The hunter's shadowy camouflage,
The pubescent girl's fertility token,
     The warrior's lurid coat of mail,
The believer's entrée to the afterlife—
     The spiritual practicality
Of our ancestors remains a source of pride.
     Yielding to sentimentality,
Later initiates seek to dramatize
     Their jingoism, their Juliets
Or Romeos. They want to fix a moment,
     Some port of call, a hot one-night stand,
A rush of mother-love or Satan worship.
     Superstition prompts the open eye
On the sailor's lid, the fish on his ankle.
     The biker makes a leather jacket
Of his soft beerbelly and nailbitten hands.
     The call girl's strategic butterfly
Or calla lily attracts and focuses
     Her client's interest and credit card.
But whether encoded or flaunted, there's death
     At the bottom of every tattoo.
The mark of Cain, the stigma to protect him
     From the enemy he'd created,
Must have been a skull. Once incorporated,
     Its spell is broken, its mortal grip
Loosened or laughed at or fearlessly faced down.
     A Donald Duck with drooping forelock
And swastikas for eyes, the sci-fi dragon,
     The amazon's griffon, the mazy

Yin-yang dragnets, the spiders on barbed-wire webs,
    The talismanic fangs and jesters,
Ankhs and salamanders, scorpions and dice
    All are meant to soothe the savage breast
Or back beneath whose dyed flesh there beats something
    That will stop. Better never to be
Naked again than not disguise what time will
    Press like a flower in its notebook,
Will score and splotch, rot, erode and finish off.
    Ugly heads are raised against our end.
If others are unnerved, why not death itself?
    If unique, then why not immortal?
Protected by totem animals that perch
    Or coil in strategic locations—
A lizard just behind the ear, a tiger's
    Fangs seeming to rip open the chest,
An eagle spreading its wings across the back—
    The body at once both draws death down
And threatens its dominion. The pain endured
    To thwart the greater pain is nothing
Next to the notion of nothingness.
    Is that what I see in the mirror?
The vacancy of everything behind me,
    The eye that now takes so little in,
The unmarked skin, the soul without privileges . . .
    Everything's exposed to no purpose.
The tears leave no trace of their grief on my face.
    My gifts are never packaged, never
Teasingly postponed by the need to undo
    The puzzled perfections of surface.
All over I am open to whatever
    You may make of me, and death soon will,

Its unmarked grave the shape of things to come,
   The page there was no time to write on.

### 3. NEW ZEALAND, 1890

Because he was the chieftain's eldest son
         And so himself
     Destined one day to rule,
The great meetinghouse was garishly strung
      With smoked heads and armfuls
Of flax, the kiwi cloak, the lithograph
Of Queen Victoria, seated and stiff,

Oil lamps, the greenstone clubs and treasure box
         Carved with demons
      In polished attitudes
That held the tribal feathers and ear drops.
      Kettles of fern root, stewed
Dog, mulberry, crayfish and yam were hung
To wait over the fire's spluttering tongues.

The boy was led in. It was the last day
         Of his ordeal.
      The tenderest sections—
Under his eyes, inside his ears—remained
      To be cut, the maze run
To its dizzying ends, a waterwheel
Lapping his flesh the better to reveal

Its false-face of unchanging hostility,
        A feeding tube
    Was put between his lips.
His arms and legs were held down forcibly.
        Resin and lichen, mixed
With pigeon fat and burnt to soot, was scooped
Into mussel shells. The women withdrew.

By then the boy had slowly turned his head,
        Whether to watch
    Them leave or keep his eye
On the stooped, grayhaired cutter who was led
    In amidst the men's cries
Of ceremonial anger at each
Of the night's cloudless hours on its path

Through the boy's life. The cutter knelt beside
        The boy and stroked
    The new scars, the smooth skin.
From his set of whalebone chisels he tied
    The shortest one with thin
Leather thongs to a wooden handle soaked
In rancid oil. Only his trembling throat

Betrayed the boy. The cutter smiled and took
        A small mallet,
    Laid the chisel along
The cheekbone, and tapped so a sharpness struck
    The skin like a bygone
Memory of other pain, other threats.
Someone dabbed at the blood. Someone else led

A growling chant about their ancestors.
          Beside the eye's
     Spongy marshland a frond
Sprouted, a jagged gash to which occurs
     A symmetrical form,
While another chisel pecks in the dye,
A blue the deep furrow intensifies.

The boy's eyes are fluttering now, rolling
          Back in his head.
     The cutter stops only
To loop the blade into a spiralling,
     Puckered, thick filigree
Whose swollen tracery, it seems, has led
The boy beyond the living and the dead.

He can feel the nine Nothings drift past him
          In the dark: Night,
     The Great Night, the Choking
Night, the All-Brightening Night and the Dim,
     The Long Night, the Floating
Night, the Empty Night and with the first light
A surging called the War Canoe of Night—

Which carries Sky Father and Earth Mother,
          Their six sons borne
     Inside the airless black
The two make, clasped only to each other.
     Turning onto his back,
The eldest son struggles with all his force,
Shoulder to sky, straining until it's torn

Violently away from the bleeding earth.
        He sets four beams,
     Named for the winds, to keep
His parents apart. They're weeping, the curve
       Of loneliness complete
Between them now. The old father's tears gleam
Like stars, then fall as aimlessly as dreams

To earth, which waits for them all to return.
        Hers is the care
     Of the dead, and his tears
Seep into her folds like a dye that burns.
      One last huge drop appears
Hanging over the boy's head. Wincing, scared,
He's put his hand up into the cold air.

# *from* Typee

## HERMAN MELVILLE

In one of my strolls with Kory-Kory, in passing along the border of a thick growth of bushes, my attention was arrested by a singular noise. On entering the thicket I witnessed for the first time the operation of tattooing as performed by these islanders.

I beheld a man extended flat upon his back on the ground, and, despite the forced composure of his countenance, it was evident that he was suffering agony. His tormentor bent over him, working away for all the world like a stone-cutter with mallet and chisel. In one hand he held a short slender stick, pointed with a shark's tooth, on the upright end of which he tapped with a small hammer-like piece of wood, thus puncturing the skin, and charging it with the coloring matter in which the instrument was dipped. A cocoa-nut shell containing this fluid was placed upon the ground. It is prepared by mixing with a vegetable juice the ashes of the 'armor,' or candle-nut, always preserved for the purpose. Beside the savage, and spread out upon a piece of soiled tappa, were a great number of curious black-looking little implements of bone and wood, used in the various divisions of his art. A few terminated in a single fine point, and, like very delicate pencils, were employed in giving the finishing touches, or in operating upon the more sensitive portions of the body, as was the case in the present instance. Others presented several points

distributed in a line, somewhat resembling the teeth of a saw. These were employed in the coarser parts of the work, and particularly in pricking in straight marks. Some presented their points disposed in small figures, and being placed upon the body, were, by a single blow of the hammer, made to leave their indelible impression. I observed a few the handles of which were mysteriously curved, as if intended to be introduced into the orifice of the ear, with a view perhaps of beating the tattoo upon the tympanum. Altogether, the sight of these strange instruments recalled to mind that display of cruel-looking mother-of-pearl-handled things which one sees in their velvet-lined cases at the elbow of a dentist.

The artist was not at this time engaged on an original sketch, his subject being a venerable savage, whose tattooing had become somewhat faded with age and needed a few repairs, and accordingly he was merely employed in touching up the works of some of the old masters of the Typee school, as delineated upon the human canvas before him. The parts operated upon were the eyelids, where a longitudinal streak, like the one which adorned Kory-Kory, crossed the countenance of the victim.

In spite of all the efforts of the poor old man, sundry twitchings and screwings of the muscles of the face denoted the exquisite sensibility of these shutters to the windows of his soul, which he was now having repainted. But the artist, with a heart as callous as that of an army surgeon, continued his performance, enlivening his labors with a wild chant, tapping away the while as merrily as a woodpecker.

So deeply engaged was he in his work, that he had not observed our approach, until, after having enjoyed an unmolested view of the operation, I chose to attract his attention. As soon as he perceived me, supposing that I sought him in his professional capacity, he seized hold of me in a paroxysm

of delight, and was all eagerness to begin the work. When, however, I gave him to understand that he had altogether mistaken my views, nothing could exceed his grief and disappointment. But recovering from this, he seemed determined not to credit my assertion, and grasping his implements, he flourished them about in fearful vicinity to my face, going through an imaginary performance of his art, and every moment bursting into some admiring exclamation at the beauty of his designs.

Horrified at the bare thought of being rendered hideous for life if the wretch were to execute his purpose upon me, I struggled to get away from him, while Kory-Kory, turning traitor, stood by, and besought me to comply with the outrageous request. On my reiterated refusals the excited artist got half beside himself, and was overwhelmed with sorrow at losing so noble an opportunity of distinguishing himself in his profession.

The idea of engrafting his tattooing upon my white skin filled him with all a painter's enthusiasm: again and again he gazed into my countenance, and every fresh glimpse seemed to add to the vehemence of his ambition. Not knowing to what extremities he might proceed, and shuddering at the ruin he might inflict upon my figure-head, I now endeavored to draw off his attention from it, and holding out my arm in a fit of desperation, signed to him to commence operations. But he rejected the compromise indignantly, and still continued his attack on my face, as though nothing short of that would satisfy him. When his fore-finger swept across my features, in laying out the borders of those parallel bands which were to encircle my countenance, the flesh fairly crawled upon my bones. At last, half wild with terror and indignation, I succeeded in breaking away from the three savages, and fled towards old Marheyo's house, pursued by the indomitable

artist, who ran after me, implements in hand. Kory-Kory, however, at last interfered, and drew him off from the chace.

This incident opened my eyes to a new danger: and I now felt convinced that in some luckless hour I should be disfigured in such a manner as never more to have the *face* to return to my countrymen, even should an opportunity offer.

These apprehensions were greatly increased by the desire which King Mehevi and several of the inferior chiefs now manifested that I should be tattooed. The pleasure of the king was first signified to me some three days after my casual encounter with Karky the artist. Heavens! what imprecations I showered upon that Karky! Doubtless he had plotted a conspiracy against me and my countenance, and would never rest until his diabolical purpose was accomplished. Several times I met him in various parts of the valley, and, invariably, whenever he descried me, he came running after me with his mallet and chisel, flourishing them about my face as if he longed to begin. What an object he would have made of me!

When the king first expressed his wish to me, I made known to him my utter abhorrence of the measure, and worked myself into such a state of excitement, that he absolutely stared at me in amazement. It evidently surpassed his majesty's comprehension how any sober-minded and sensible individual could entertain the least possible objection to so beautifying an operation.

Soon afterwards he repeated his suggestion, and meeting with a like repulse, showed some symptoms of displeasure at my obduracy. On his third time renewing his request, I plainly perceived that something must be done, or my visage was ruined for ever; I therefore screwed up my courage to the sticking point, and declared my willingness to have both arms tattooed from just above the wrist to the shoulder. His majesty was greatly pleased at the proposition, and I was congratulat-

ing myself with having thus compromised the matter, when he intimated that as a thing of course my face was first to undergo the operation. I was fairly driven to despair; nothing but the utter ruin of my 'face divine,' as the poets call it, would, I perceived, satisfy the inexorable Mehevi and his chiefs, or rather, that infernal Karky, for he was at the bottom of it all.

The only consolation afforded me was a choice of patterns: I was at perfect liberty to have my face spanned by three horizontal bars, after the fashion of my serving-man's; or to have as many oblique stripes slanting across it; or if, like a true courtier, I chose to model my style on that of royalty, I might wear a sort of freemason badge upon my countenance in the shape of a mystic triangle. However, I would have none of these, though the king most earnestly impressed upon my mind that my choice was wholly unrestricted. At last, seeing my unconquerable repugnance, he ceased to importune me.

But not so some other of the savages. Hardly a day passed but I was subjected to their annoying requests, until at last my existence became a burden to me; the pleasures I had previously enjoyed no longer afforded me delight, and all my former desire to escape from the valley now revived with additional force.

———

Not . . . shy of exhibiting her charms was the Island Queen herself, the beauteous wife of Mowanna, the king of Nukuheva. Between two and three years after the adventures recorded in this volume, I chanced, while aboard of a man-of-war, to touch at these islands. The French had then held possession of the Marquesas some time, and already prided themselves upon the beneficial effects of their jurisdiction, as discernible in the deportment of the natives. To be sure, in

one of their efforts at reform they had slaughtered about a hundred and fifty of them at Whitihoo—but let that pass. At the time I mention, the French squadron was rendezvousing in the bay of Nukuheva, and during an interview between one of their captains and our worthy Commodore, it was suggested by the former, that we, as the flag-ship of the American squadron, should receive, in state, a visit from the royal pair. The French officer likewise represented, with evident satisfaction, that under their tuition the king and queen had imbibed proper notions of their elevated station, and on all ceremonious occasions conducted themselves with suitable dignity. Accordingly, preparations were made to give their majesties a reception on board in a style corresponding with their rank.

One bright afternoon, a gig, gaily bedizened with streamers, was observed to shove off from the side of one of the French frigates, and pull directly for our gangway. In the stern sheets reclined Mowanna and his consort. As they approached, we paid them all the honors due to royalty;—manning our yards, firing a salute, and making a prodigious hubbub.

They ascended the accommodation ladder, were greeted by the Commodore, hat in hand, and passing along the quarterdeck, the marine guard presented arms, while the band struck up 'The king of the Cannibal Islands.' So far all went well. The French officers grimaced and smiled in exceedingly high spirits, wonderfully pleased with the discreet manner in which these distinguished personages behaved themselves.

Their appearance was certainly calculated to produce an effect. His majesty was arrayed in a magnificent military uniform, stiff with gold lace and embroidery, while his shaven crown was concealed by a hugh chapeau bras, waving with ostrich plumes. There was one slight blemish, however, in his

appearance. A broad patch of tattooing stretched completely across his face, in a line with his eyes, making him look as if he wore a huge pair of goggles; and royalty in goggles suggested some ludicrous ideas. But it was in the adornment of the fair person of his dark complexioned spouse that the tailors of the fleet had evinced the gaiety of their national taste. She was habited in a gaudy tissue of scarlet cloth, trimmed with yellow silk, which, descending a little below the knees, exposed to view her bare legs, embellished with spiral tattooing, and somewhat resembling two miniature Trajan's columns. Upon her head was a fanciful turban of purple velvet, figured with silver sprigs, and surmounted by a tuft of variegated feathers.

The ship's company crowding into the gangway to view the sight, soon arrested her majesty's attention. She singled out from their number an old salt, whose bare arms and feet, and exposed breast were covered with as many inscriptions in India ink as the lid of an Egyptian sarcophagus. Notwithstanding all the sly hints and remonstrances of the French officers, she immediately approached the man, and pulling further open the bosom of his duck frock, and rolling up the leg of his wide trowsers, she gazed with admiration at the bright blue and vermilion pricking, thus disclosed to view. She hung over the fellow, caressing him, and expressing her delight in a variety of wild exclamations and gestures. The embarrassment of the polite Gauls at such an unlooked-for occurrence may be easily imagined; but picture their consternation, when all at once the royal lady, eager to display the hieroglyphics on her own sweet form, bent forward for a moment, and turning sharply round, threw up the skirts of her mantle, and revealed a sight from which the aghast Frenchmen retreated precipitately, and tumbling into their boat, fled the scene of so shocking a catastrophe.

# *from* 7 Tattoos

**PETER TRACHTENBERG**

*The living being is only a species of the dead,
and a very rare species.*

NIETZSCHE, *The Gay Science*

In the fall of 1991 I went to Borneo. What happened was I'd
saved some money and I decided to go to the wildest place I
could think of. I suppose I was going through a nostalgic
phase then, and the thing I was feeling nostalgic for was my
younger self. At the time I called this "controlled regression,"
and one result of regressing in this controlled manner was that
I found myself trying to realize the *fantasy* of wildness, of
wilderness, that I'd had as a ten-year-old boy in upper Man-
hattan. I wanted to be an explorer, a guy with a pith helmet
and a good jawline hacking his way through a rank, humid,
dripping rain forest with all sorts of fauna making ominous
background roars and hoots and that weird cackle I associate
with no creature I know of but that you always hear in jungle
movies and that I actually did hear, years later, in a village on
the Mahakam River. I swear on my father's grave. Whatever
it is that lives out there really makes that sound.

The other reason I picked Borneo was because of tattoos.
I thought I'd find tattooed people there, bowl-coiffed Dayaks
who still wore those geometric tattoos, the black, looping,
barbed lines and spirals that they call "tribal" on St. Mark's
Place. If you go to a tattooist and ask him for a tribal piece,

what you'll get will be an imitation of a Bornean, that is to say a Dayak, tattoo. The piece I have on my collarbone—it looks kind of like a set of antlers—is actually adapted from an Iban Dayak pattern from Sarawak, in North Borneo. It was my first tattoo. I'd gotten it a year or so before I went over, and I wanted to see its original, so to speak.

Getting tattooed is one of the few impulses I've ever delayed acting on. Back in the late seventies I was all set to have a forearm piece that was going to be a crucifix made of a pair of syringes wrapped in barbed wire. But the trouble was I didn't know any tattooists then, and by the time I did I had changed my way of life and I no longer cared to advertise my bad habits. I still wanted a tattoo, but everyone kept telling me not to make any major decisions in the beginning. So I waited one year, and then another and another, like somebody in a fairy tale, until almost five years had passed since the last time I'd thought of decorating myself with a picture of crossed syringes. And I figured, What the heck. Live a little.

I got my first tattoo in Amsterdam, where I used to live, from one of the world's all-time great tattooists. His name is Henk Schiffmacher, but he works under the name Hanky Panky. He is one of tattooing's stars—a red giant, I'd call him, a big hot presence at the trade's conventions and in the pages of its glossy magazines, whose photos of freshly decorated body parts have the lush sheen of pornography. Hanky Panky is also an archivist of tattoos, and he's traveled all over the world, hanging out with Hell's Angels in the States and Yakuza in Japan and these big, spooky Samoan guys who do their work with gigantic harpoons that have been known to go right through the skin and puncture spleens and kidneys. His shop was in the Red Light District, overlooking a canal, and it had a little tattoo museum that reminded me of the museums of human oddities they used to have around Times

Square when I was a kid: It had that same soothing, musty kind of gruesomeness. The first thing I saw when I came in for my appointment was a glass display case. And inside the case was an entire tattooed human skin from Japan that had been cured like a big sheet of beef jerky and stretched so that you could see its images clearly. And I must have been re-gressing on all cylinders then, because I wasn't grossed out at all: I thought it was cool.

The next thing I know there's a guy lumbering toward me. He looks like a biker. He's thick all over, not fat, but thick, slabby; he could crush me like a Styrofoam packing peanut, and he's got shoulder-length hair and a beard and his thick, pestle-shaped forearms are covered with very precise, almost dainty patterns that from a distance might almost be knocked off from a Ralph Lauren bedspread. And I'm wait-ing for him to sneer at me, since what am I but a frail, clean-shaven, unmarked *tourist,* who in all his thirty-six years has done nothing more remarkable to his body than get his ear-lobe pierced a couple of times? But Hanky Panky is Dutch, and the Dutch are always polite, even when they despise you, and instead he says, in that clipped Dutch accent that's almost impossible to place: "Well. What is it you are looking for, exactly?"

I show Hanky Panky the design that I adapted from a photo in a book of Dayak art, and he has me take off my shirt and he sketches the design on my collarbone with a grease pencil. Then he calls over an assistant to shave my chest. Now, under other circumstances, this could be kind of a turn-on. But in Hanky Panky's tattoo parlor it just reminds me of the shaving I had to undergo before some surgery I once had in the groin region. That one, much to my initial disappointment, had been performed by a male nurse, al-though I *did* see the wisdom of having a man for the job at

around the time he began to whisk the razor around my balls. "Hey, be careful. Please!" I begged. And my male nurse answered, "Don't worry, buddy. I'll handle 'em like they were my own."

People are always asking me whether getting tattooed hurts; it's one of the Seven Stupid Questions of the World. True, after a while your endorphins kick in and the sensation of spreading numbness becomes oddly pleasurable, kind of like some Heroin Lite. But in the beginning being tattooed is like being scratched with a safety pin—over and over and over and over. It's irritating and it's boring. And because I'm bored and because it makes me very anxious to sit half-naked with a stranger looming over my prickling flesh, I ask Hanky Panky all these questions: "Say, where did this kooky practice start? Why was it so big with sailors? Can I get AIDS from this?"

When I ask him about AIDS, Hanky Panky glances up from his needle and gives me a cold, gray, gunmetal look. "You should have asked me that earlier." Total, withering disapproval. "I have been working on you for two hours." I turn white. I'm thinking what an indescribable bummer it's going to be to have survived all those years of shooting dope and getting up to all sorts of monkey business in the carnal department only to be killed by a cosmetic procedure. I can just imagine what my father would say if he were still alive: "So, what else did you expect, getting tattooed like some goy sailor?" To my father, there would have been no difference between my getting AIDS from a tattoo gun and my getting it from a syringe I'd shared with half the junkies on Clinton Street. As far as I know, Judaism has no line at all on heroin, while it's got plenty to say about tattoos. At that moment, I remember something my father once told me. I couldn't have been more than five, and he caught me picking my nose. He

said, "You know what happens if you stick your finger up there? You want to know what happens, *shmeggege*? The bacteria bores up"—*bores up,* he's saying—"it bores up into your brain and the next thing you know you're dead from infection." And, look, it turned out he was right.

Hanky Panky chuckles. "I am making a joke, heh-heh. We use only new needles. This is Holland, you know." Because of course Holland is the country where hygiene was invented.

Two hours later I get up and I look at myself in the mirror. And there, on that chest that was just a chest, on those shoulders that were just shoulders, is a beautiful, undulant black labyrinth of slender, hooked lines. It's incredibly crisp, the way new tattoos are, and the antibiotic ointment makes it shiny. This is my body, and it's been transfigured. The word that comes to mind is *lithe.* I'm lithe and I'm powerful and I'm wild. This tattoo has turned me into a jungle thing, into a head-hunting Dayak motherfucker. Gone are the timidity, the caution, the doubt, the sniveling Heepish *niceness,* the excruciating self-consciousness that have encysted me since the day I first knew I was an "I," that I dragged around with me through my childhood like some unwanted twin, that I spent twenty years trying to talk away with therapy and wash away with booze and shoot away with dope and fuck away with any woman who was gracious enough to recognize my handicap or dumb enough not to see it, and *look*—it's gone. Four hours under a tattooist's needle and for the first time in my life I can look in the mirror and actually like what I see.

Amazing things, endorphins.

Now, before we get to Borneo, I need to mention that the other reason I'd been so late in getting tattooed was my fa-

ther. First off, my father was Jewish, and Leviticus 19 says everything there is to say about Jews and tattoos: "Ye shall not make any cuttings in your flesh for the dead, nor print any marks upon you: I am the Lord." That "I am the Lord," I'm convinced, is there as a sort of peevish afterthought, just in case you should have any questions about the basis for these injunctions. It's like one of those T-shirts that says BECAUSE I'M THE MOMMY, THAT'S WHY.

Because he was a nominally observant Jew, my father had no tattoos, but his mother and several other relatives had gotten them when they were herded into Auschwitz. Tattooing had been the Germans' way of keeping track of the Jews they were killing in such huge numbers with such witless method and ingenuity. The only way I can imagine what the Nazis had in mind is to envision an empire of idiot savants who've made it their national project to count to infinity by ones. At the railroad sidings, at the camp entrances, outside the gas chambers and the crematoria, they count and they count. And they tick off each "one" with a number on the wrist, because they don't want to make any mistakes in their idiot progress toward infinity; they want to keep track of all those corpses and those corpses-to-be, of all those "I"s who are about to be transformed into inanimate "its." Because what is a corpse but an I that has become an it?

My father wasn't tattooed, but I grew up among tattooed people. I remember being at a family reunion when I was little and staring at the wrist of my father's cousin S—"S" for Sam or Shmuel or Sandor, the exact name doesn't matter. There, peeking out from under his shirt cuff, are some spidery numbers stitched in blurred blue ink; they look like an old laundry mark. And I was fascinated. Most of the time my father answered questions quickly, in irritated bursts: "What the hell do you mean by asking me anything so stupid?" But

when I asked him about his cousin's numbers, my father paused. And he actually thought for a while. I suppose he was wondering what sort of answer would be appropriate for an eight-year-old. And then he said, in that Russian accent that had not yet become so embarrassing to me: "They did that to him in the camps."

So I'm sure that subconscious thoughts of my father had played some part in my earlier hesitation about getting a tattoo. Otherwise it's quite likely that I'd now be talking about a crucifix made of syringes. And the moment I got back from Europe, I fell into a depression. I stepped off the plane in Baltimore and—WHAM!—that old familiar gloom of mine was bludgeoning me like a two-by-four. Because in the back of my mind I was sure I'd betrayed my father and trampled on the memory of the Holocaust. As usual, my depression manifests itself in my body image. Which sucks. Mornings I stand before the mirror and stare at myself for an hour at a time. I turn in profile. I wring the fat on my waist. I tilt from side to side, checking my love handles. Every woman I've ever gone with has mistaken this custom for some charming vanity, but it's really self-disgust, disgust at the self that is my body. The tattoo? The tattoo changes nothing. No, the tattoo is a beautiful addition to my hideous body, that squat, hairy, clay-colored body that aches and trembles and sweats and shits and stinks. The tattoo is something new for me to feel unworthy of.

But I wouldn't call it a mistake. Or else, the very fact that it *is* a mistake is what makes it so successful. My tattoo may be the first mistake I've ever made that I can't take back. Because up till now I've taken back everything. I was a loving child and I turned my back on my mother and father. I renounced jobs and apartments. I loved people and reneged on them. I got married and divorced so fast it was like something out of

*The Time Machine*: Whoops, there goes the Industrial Revolution, there goes the wife! Even drugs and booze, the two great loyalties of my life—I turned my back on them, too, and if you look at me today, you won't see a sign of those abusive love affairs on my entire body. It could be a Mormon who's telling you this. Or at least a lifelong vegetarian.

But isn't this how it's supposed to be for us Americans? For what is the American dream if not the expectation that every shady episode of your life can be erased? Horse-thief uncles, illegitimate kids, old rap sheets—all you have to do is change your zip code and they're history. At the very worst, you hire a media consultant and get him to apply a little spin. You can be driven from the White House in disgrace on national television, but if you wait five years, *Time* magazine will hail you as an elder statesman. I don't know what America Nathaniel Hawthorne lived in, but it sure wasn't the America of Richard Nixon and Oprah Winfrey. Because if Hester Prynne were walking around today with a scarlet *A* on her dress, people would think it stood for Armani.

So what I like about my tattoo is that at last there is some evidence in my life. It may be what I originally meant it to be or it may just be an advertisement of my terminal confusion, like the international symbol for DANGER: BRIDGE OUT. But either way, my tattoo—all my tattoos—is a mistake I can't correct by any means short of laser surgery.

# Embellishments

**VIRGINIA CHASE SUTTON**

Mother called it mutilation.
  As the needle swirled across the template
shooting gaudy Christmas color,

I knew it was right. Consider the pain.
  Never mind the fine curl of silvered needles,
clean, sterile. The bite and stain forever

on the skin. Or staring men who fan behind
  the artist's tints, his colors pulled from mixing
bowls and pans, primary hues of all his longing.

Whiteness. Deep bitter blue veins. My breasts.
  A slur of candied red, darkly green apple,
a smudge of summer yellow over black corners

already sketched. All that desire: rows of men
  watching my naked breasts, their pocketed hands,
rub of hips in unison, my steady gleam under

a lamp's small focus. I grow beneath his touch.
  Spilled circles increase their glow, pale pink
raspberries, erupting nipples after the crush

of his hands. To be wanted by so many men.
  To long for shifting hands, the body tightens,
fine lines tallied before the gushing glut

of color that filled each individual petal
  and leaf. As a child, I saw Mother rise
over a stranger's back. Her legs opened

and cracked as she stretched behind him
  on his motorcycle's slippery bench. They
embraced, her manicured fingers twined about

his waist. No smile or wave. Just a straight line
  to the corner. Twisted in ornate darkness, the scent
of night-blooming flowers and a bit of air stirred.

Afterward, she limped to the kitchen and buttered
  the new burn on her right leg. It was
a perfect circle, a cookie cutter cutout

forever melted into skin. She stroked butter
  back and forth, trapped heat way down.
Raised bubbles, little kisses,

boiled to the top. She was marked by that
  translucent ride with a stranger through
an empty town. Her skin took it all, healed

dark, blossoms of red and pink dripping brown
  and yellow. Tattoos scab, and when mine was picked
away, colors were raw, sharper than a scar.

Is it a pierce, stain, wound, cut, slices
  of body dragged into a scar or scab?
Mother never said which touch is truest. We're

so alike. I still tingle to those tiny kisses,
  explosions turned to oil, spoiled skin, permanent heat
all the way down to the bone.

# Tattoo Thoughts

### DZVINIA ORLOWSKY

Because of lightning
on a young waiter's bicep
I lied and said I forgot my sweater,
left my family with our menus,
followed after him, outside,
into the parking lot,

rain coming down,
a few cars, one tree with ugly branches,
clouds tensing into pig shapes
then releasing—I waited for him.
I've thought about the long vine
that like a motorcycle

on an open road
would begin at my shoulder—
*I do anything I want*—
how words like *chrysalis*
squirm into blossom,
how a body willingly

takes on its own unnatural blue—
bare winter breasts,
veins like phone wires
beneath my wrist.

Yes, tattoo thoughts.
Yes, better than another small dog.

Once, a woman flinched
when I touched her skin
lightly with my finger.
She must've sensed
the entire small fires in me—
stranger heart,

barbed wire,
*Sweet Jesus,*
looking buckshot into her eyes—
like I knew she was
going to miss me,
like I'd already left.

# The Fifteen-Dollar Eagle

## SYLVIA PLATH

There are other tattoo shops in Madigan Square, but none of them a patch on Carmey's place. He's a real poet with the needle and dye, an artist with a heart. Kids, dock bums, the out-of-town couples in for a beer put on the brakes in front of Carmey's, nose to the window, one and all. You got a dream, Carmey says, without saying a word, you got a rose on the heart, an eagle in the muscle, you got the sweet Jesus himself, so come in to me. Wear your heart on your skin in this life, I'm the man can give you a deal. Dogs, wolves, horses and lions for the animal lover. For the ladies, butter-flies, birds of paradise, baby heads smiling or in tears, take your choice. Roses, all sorts, large, small, bud and full bloom, roses with name scrolls, roses with thorns, roses with Dresden-doll heads sticking up in dead center, pink petal, green leaf, set off smart by a lead-black line. Snakes and dragons for Frankenstein. Not to mention cowgirls, hula girls, mermaids and movie queens, ruby-nippled and bare as you please. If you've got a back to spare, there's Christ on the cross, a thief at either elbow and angels overhead to right and left holding up a scroll with "Mount Calvary" on it in Old English script, close as yellow can get to gold.

Outside they point at the multicolored pictures plastered on Carmey's three walls, ceiling to floor. They mutter like a mob scene, you can hear them through the glass:

"Honey, take a looka those peacocks!"

"That's crazy, paying for tattoos. I only paid for one I got, a panther on my arm."

"You want a heart, I'll tell him where."

I see Carmey in action for the first time courtesy of my steady man, Ned Bean. Lounging against a wall of hearts and flowers, waiting for business, Carmey is passing the time of day with a Mr. Tomolillo, an extremely small person wearing a wool jacket that drapes his nonexistent shoulders without any attempt at fit or reformation. The jacket is patterned with brown squares the size of cigarette packs, each square boldly outlined in black. You could play tick-tack-toe on it. A brown fedora hugs his head just above the eyebrows like the cap on a mushroom. He has the thin, rapt, triangular face of a praying mantis. As Ned introduces me, Mr. Tomolillo snaps over from the waist in a bow neat as the little moustache hairlining his upper lip. I can't help admiring this bow because the shop is so crowded there's barely room for the four of us to stand up without bumping elbows and knees at the slightest move.

The whole place smells of gunpowder and some fumey antiseptic. Ranged along the back wall from left to right are: Carmey's worktable, electric needles hooked to a rack over a Lazy Susan of dye pots, Carmey's swivel chair facing the show window, a straight customer's chair facing Carmey's chair, a waste bucket, and an orange crate covered with scraps of paper and pencil stubs. At the front of the shop, next to the glass door, there is another straight chair, with the big placard of Mount Calvary propped on it, and a cardboard file drawer on a scuffed wooden table. Among the babies and daisies on the wall over Carmey's chair hang two faded sepia daguerreotypes of a boy from the waist up, one front view, one back. From the distance he seems to be wearing a long-sleeved,

skintight black lace shirt. A closer look shows he is stark naked, covered only with a creeping ivy of tattoos.

In a jaundiced clipping from some long-ago rotogravure, these Oriental men and women are sitting cross-legged on tasseled cushions, back to the camera and embroidered with seven-headed dragons, mountain ranges, cherry trees and waterfalls. "These people have not a stitch of clothing on," the blurb points out. "They belong to a society in which tattoos are required for membership. Sometimes a full job costs as much as $300." Next to this, a photograph of a bald man's head with the tentacles of an octopus just rounding the top of the scalp from the rear.

"Those skins are valuable as many a painting, I imagine," says Mr. Tomolillo. "If you had them stretched on a board."

But the Tattooed Boy and those clubby Orientals have nothing on Carmey, who is himself a living advertisement of his art—a schooner in full sail over a rose-and-holly-leaf ocean on his right biceps, Gypsy Rose Lee flexing her muscled belly on the left, forearms jammed with hearts, stars and anchors, lucky numbers and name scrolls, indigo edges blurred so he reads like a comic strip left out in a Sunday rainstorm. A fan of the Wild West, Carmey is rumored to have a bronco reared from navel to collarbone, a thistle-stubborn cowboy stuck to its back. But that may be a mere fable inspired by his habit of wearing tooled leather cowboy boots, finely heeled, and a Bill Hickock belt studded with red stones to hold up his black chino slacks. Carmey's eyes are blue. A blue in no way inferior to the much-sung about skies of Texas.

"I been at it sixteen years now," Carmey says, leaning back against his picturebook wall, "and you might say I'm still learning. My first job was in Maine, during the war. They heard I was a tattooist and called me out to this station of Wacs . . ."

"To tat*too* them?" I ask.

"To tattoo their numbers on, nothing more or less."

"Weren't some of them *scared*?"

"Oh, sure, sure. But some of them came back. I got two Wacs in one day for a tattoo. Well, they hemmed. And they hawed. 'Look,' I tell them, 'you came in the other day and you knew which one you wanted, what's the trouble?' "

" 'Well, it's not what we want but where we want it,' one of them pipes up. 'Well, if that's all it is you can trust me,' I say. 'I'm like a doctor, see? I handle so many women it means nothing.' 'Well, I want three roses,' this one says: 'one on my stomach and one on each cheek of my butt.' So the other one gets up courage, you know how it is, and asks for one rose . . ."

"Little ones or big ones?" Mr. Tomolillo won't let a detail slip.

"About like that up there." Carmey points to a card of roses on the wall, each bloom the size of a Brussels sprout. "The biggest going. So I did the roses and told them: 'Ten dollars off the price if you come back and show them to me when the scab's gone.' "

"Did they come?" Ned wants to know.

"You bet they did." Carmey blows a smoke ring that hangs wavering in the air a foot from his nose, the blue, vaporous outline of a cabbage rose.

"You wanta know," he says, "a crazy law? I could tattoo you anywhere," he looks me over with great care, "anywhere at all. Your back. Your rear." His eyelids droop, you'd think he was praying. "Your breasts. Anywhere at all but your face, hands and feet."

Mr. Tomolillo asks: "Is that a *Fed*eral law?"

Carmey nods. "A Federal law. I got a blind." He juts a thumb at the dusty-slatted venetian blind drawn up in the

display window. "I let that blind down, and I can do privately any part of the body. Except face, hands and feet."

"I bet it's because they *show*," I say.

"Sure. Take in the Army, at drill. The guys wouldn't look right. Their faces and hands would stand out, they couldn't cover up."

"However that may be," Mr. Tomolillo says, "I think it is a shocking law, a totalitarian law. There should be a freedom about personal adornment in any democracy. I mean, if a lady *wants* a rose on the back of her hand, I should think . . ."

"She should *have* it," Carmey finishes with heat. "People should have what they want, regardless. Why, I had a little lady in here the other day." Carmey levels the air with the flat of his hand not five feet from the floor. "So high. Wanted Calvary, the whole works, on her back, and I gave it to her. Eighteen hours it took."

I eye the thieves and angels on the poster of Mount Calvary with some doubt. "Didn't you have to shrink it down a bit?"

"Nope."

"Or leave off an angel?" Ned wonders. "Or a bit of the foreground?"

"Not a bit of it. A thirty-five-dollar job in full color, thieves, angels, Old English—the works. She went out of the shop proud as punch. It's not every little lady's got all Calvary in full color on her back. Oh, I copy photos people bring in, I copy movie stars. Anything they want, I do it. I've got some designs I wouldn't put up on the wall on account of offending some of the clients. I'll show you." Carmey opens the cardboard file drawer on the table at the front of the shop. "The wife's got to clean this up," he says. "It's a terrible mess."

"Does your wife help you?" I ask with interest.

"Oh, Laura, she's in the shop most of the day." For some reason Carmey sounds all at once solemn as a monk on Sunday. I wonder, does he use her for a come-on: Laura, the Tattooed Lady, a living masterpiece, sixteen years in the making. Not a white patch on her, ladies and gentlemen—look all you want to. "You should drop by and keep her company, she likes talk." He is rummaging around in the drawer, not coming up with anything, when he stops in his tracks and stiffens like a pointer.

This big guy is standing in the doorway.

"What can I do for you?" Carmey steps forward, the maestro he is.

"I want that eagle you showed me."

Ned and Mr. Tomolillo and I flatten ourselves against the side walls to let the guy into the middle of the room. He'll be a sailor out of uniform in his peajacket and plaid wool shirt. His diamond-shaped head, width all between the ears, tapers up to a narrow plateau of cropped black hair.

"The nine-dollar or the fifteen?"

"The fifteen."

Mr. Tomolillo sighs in gentle admiration.

The sailor sits down in the chair facing Carmey's swivel, shrugs out of his peajacket, unbuttons his right shirt cuff and begins slowly to roll up the sleeve.

"You come right in here," Carmey says to me in a low, promising voice, "where you can get a good look. You've never seen a tattooing before." I squinch up and settle on the crate of papers in the corner at the left of Carmey's chair, careful as a hen on eggs.

Carmey flicks through the cardboard file again and this time digs out a square piece of plastic. "Is this the one?"

The sailor looks at the eagle pricked out on the plastic. Then he says: "That's right," and hands it back to Carmey.

"Mmmm," Mr. Tomolillo murmurs in honor of the sailor's taste.

Ned says: "That's a fine eagle."

The sailor straightens with a certain pride. Carmey is dancing round him now, laying a dark-stained burlap cloth across his lap, arranging a sponge, a razor, various jars with smudged-out labels and a bowl of antiseptic on his work-table—finicky as a priest whetting his machete for the fatted calf. Everything has to be just so. Finally he sits down. The sailor holds out his right arm and Ned and Mr. Tomolillo close in behind his chair, Ned leaning over the sailor's right shoulder and Mr. Tomolillo over his left. At Carmey's elbow I have the best view of all.

With a close, quick swipe of the razor, Carmey clears the sailor's forearm of its black springing hair, wiping the hair off the blade's edge and onto the floor with his thumb. Then he anoints the area of bared flesh with vaseline from a small jar on top of his table. "You ever been tattooed before?"

"Yeah." The sailor is no gossip. "Once." Already his eyes are locked in a vision of something on the far side of Carmey's head, through the walls and away in the thin air beyond the four of us in the room.

Carmey is sprinkling a black powder on the face of the plastic square and rubbing the powder into the pricked holes. The outline of the eagle darkens. With one flip, Carmey presses the plastic square powder-side against the sailor's greased arm. When he peels the plastic off, easy as skin off an onion, the outline of an eagle, wings spread, claws hooked for action, frowns up from the sailor's arm.

"Ah!" Mr. Tomolillo rocks back on his cork heels and casts a meaning look at Ned. Ned raises his eyebrows in approval. The sailor allows himself a little quirk of the lip. On him it is as good as a smile.

"Now," Carmey takes down one of the electric needles, pitching it rabbit-out-of-the-hat, "I am going to show you how we make a nine-dollar eagle a fifteen-dollar eagle."

He presses a button on the needle. Nothing happens.

"Well," he sighs, "it's not working."

Mr. Tomolillo groans. "Not again?"

Then something strikes Carmey and he laughs and flips a switch on the wall behind him. This time when he presses the needle it buzzes and sparks blue. "No connection, that's what it was."

"Thank heaven," says Mr. Tomolillo.

Carmey fills the needle from a pot of black dye on the Lazy Susan. "This same eagle," Carmey lowers the needle to the eagle's right wingtip, "for nine dollars is only black and red. For fifteen dollars you're going to see a blend of four colors." The needle steers along the lines laid by the powder. "Black, green, brown and red. We're out of blue at the moment or it'd be five colors." The needle skips and backtalks like a pneumatic drill but Carmey's hand is steady as a surgeon's. "How I *love* eagles!"

"I believe you *live* on Uncle Sam's eagles," says Mr. Tomolillo.

Black ink seeps over the curve of the sailor's arm and into the stiff, stained butcher's-apron canvas covering his lap, but the needle travels on, scalloping the wing feathers from tip to root. Bright beads of red are rising through the ink, heart's-blood bubbles smearing out into the black stream.

"The guys complain," Carmey singsongs. "Week after week I get the same complaining: What have you got new? We don't want the same type eagle, red and black. So I figure out this blend. You wait. A solid color eagle."

The eagle is losing itself in a spreading thundercloud of black ink. Carmey stops, sloshes his needle in the bowl of an-

tiseptic, and a geyser of white blooms up to the surface from the bowl's bottom. Then Carmey dips a big, round cinnamon-colored sponge in the bowl and wipes away the ink from the sailor's arm. The eagle emerges from its hood of bloodied ink, a raised outline on the raw skin.

"Now you're gonna see something." Carmey twirls the Lazy Susan till the pot of green is under his thumb and picks another needle from the rack.

The sailor is gone from behind his eyes now, off somewhere in Tibet, Uganda or Barbados, oceans and continents away from the blood drops jumping in the wake of the wide green swaths Carmey is drawing in the shadow of the eagle's wings.

About this time I notice an odd sensation. A powerful sweet perfume is rising from the sailor's arm. My eyes swerve from the mingling red and green and I find myself staring intently into the waste bucket by my left side. As I watch the calm rubble of colored candy wrappers, cigarette buffs and old wads of muddily stained Kleenex, Carmey tosses a tissue soaked with fresh red onto the heap. Behind the silhouetted heads of Ned and Mr. Tomolillo the panthers, roses and red-nippled ladies wink and jitter. If I fall forward or to the right, I will jog Carmey's elbow and make him stab the sailor and ruin a perfectly good fifteen-dollar eagle, not to mention disgracing my sex. The only alternative is a dive into the bucket of bloody papers.

"I'm doing the brown now," Carmey sings out a mile away, and my eyes rivet again on the sailor's blood-sheened arm. "When the eagle heals, the colors will blend right into each other, like on a painting."

Ned's face is a scribble of black India ink on a seven-color crazy quilt.

"I'm going . . ." I make my lips move, but no sound comes out.

Ned starts toward me but before he gets there the room switches off like a light.

The next thing is, I am looking into Carmey's shop from a cloud with the X-ray eyes of an angel and hearing the tiny sound of a bee spitting blue fire.

"The blood get her?" It is Carmey's voice, small and far.

"She looks all white," says Mr. Tomolillo. "And her eyes are funny."

Carmey passes something to Mr. Tomolillo. "Have her sniff that." Mr. Tomolillo hands something to Ned. "But not too much."

Ned holds something to my nose.

I sniff, and I am sitting in the chair at the front of the shop with Mount Calvary as a backrest. I sniff again. Nobody looks angry, so I have not bumped Carmey's needle. Ned is screwing the cap on a little flask of yellow liquid. Yardley's smelling salts.

"Ready to go back?" Mr. Tomolillo points kindly to the deserted orange crate.

"Almost." I have a strong instinct to stall for time. I whisper in Mr. Tomolillo's ear, which is very near to me, he is so short, "Do *you* have any tattoos?"

Under the mushroom brim of his fedora Mr. Tomolillo's eyes roll heavenward. "My gracious, no! I'm only here to see about the springs. The springs in Mr. Carmichael's machine have a way of breaking in the middle of a customer."

"How annoying."

"That's what I'm here for. We're testing out a new spring now, a much heavier spring. You know how distressing it is when you're in the dentist's chair and your mouth is full of what-not . . ."

"Balls of cotton and little metal siphons . . . ?"

"Precisely. And in the middle of this the dentist turns away," Mr. Tomolillo half-turns his back in illustration and makes an evil, secretive face, "and buzzes about in the corner for ten minutes with the machinery, you don't know what." Mr. Tomolillo's face smooths out like linen under a steam iron. "That's what I'm here to see about, a stronger spring. A spring that won't let the customer down."

By this time I am ready to go back to my seat of honor on the orange crate. Carmey has just finished with the brown and in my absence the inks have indeed blended into one another. Against the shaven skin, the lacerated eagle is swollen in tri-colored fury, claws curved sharp as butcher's hooks.

"I think we could redden the eye a little?"

The sailor nods, and Carmey opens the lid on a pot of dye the color of tomato ketchup. As soon as he stops working with the needle, the sailor's skin sends up its blood beads, not just from the bird's black outline now, but from the whole rasped, rainbowed body.

"Red," Carmey says, "really picks things up."

"Do you save the blood?" Mr. Tomolillo asks suddenly.

"I should think," says Ned, "you might well have some arrangement with the Red Cross."

"With a blood bank!" The smelling salts have blown my head clear as a blue day on Monadnock. "Just put a little basin on the floor to catch the drippings."

Carmey is picking out a red eye on the eagle. "We vampires don't share our blood." The eagle's eye reddens but there is now no telling blood from ink. "You never heard of a vampire do that, did you?"

"Nooo . . ." Mr. Tomolillo admits.

Carmey floods the flesh behind the eagle with red and

the finished eagle poises on a red sky, born and baptized in the blood of its owner.

The sailor drifts back from parts unknown.

"Nice?" With his sponge Carmey clears the eagle of the blood filming its colors the way a sidewalk artist might blow the pastel dust from a drawing of the White House, Liz Taylor or Lassie-Come-Home.

"I always say," the sailor remarks to nobody in particular, "when you get a tattoo, get a good one. Nothing but the best." He looks down at the eagle, which has begun in spite of Carmey's swabbing to bleed again. There is a little pause. Carmey is waiting for something and it isn't money. "How much to write Japan under that?"

Carmey breaks into a pleased smile. "One dollar."

"Write Japan, then."

Carmey marks out the letters on the sailor's arm, an extra flourish to the *J*'s hook, the loop of the *P*, and the final *N*, a love letter to the eagle-conquered Orient. He fills the needle and starts on the *J*.

"I under*stand*," Mr. Tomolillo observes in his clear, lecturer's voice, "Japan is a center of tattooing."

"Not when *I* was there," the sailor says. "It's banned."

"Banned!" says Ned. "What for?"

"Oh, they think it's *bar*barous nowadays." Carmey doesn't lift his eyes from the second *A,* the needle responding like a broken-in bronc under his masterly thumb. "There are operators, of course. Sub rosa. There always are." He puts the final curl on the *N* and sponges off the wellings of blood which seem bent on obscuring his artful lines. "That what you wanted?"

"That's it."

Carmey folds a wad of Kleenex into a rough bandage and

lays it over the eagle and Japan. Spry as a shopgirl wrapping a gift package he tapes the tissue into place.

The sailor gets up and hitches into his peajacket. Several schoolboys, lanky, with pale, pimply faces, are crowding the doorway, watching. Without a word the sailor takes out his wallet and peels sixteen dollar bills off a green roll. Carmey transfers the cash to his wallet. The schoolboys fall back to let the sailor pass into the street.

"I hope you didn't mind my getting dizzy."

Carmey grins. "Why do you think I've got those salts so close at hand? I have big guys passing out cold. They get egged in here by their buddies and don't know how to get out of it. I got people getting sick to their ears in that bucket."

"She's never got like that before," Ned says. "She's seen all sorts of blood. Babies born. Bull fights. Things like that."

"You was all worked up." Carmey offers me a cigarette, which I accept, takes one himself, and Ned takes one, and Mr. Tomolillo says no-thank-you. "You was all tensed, that's what did it."

"How much is a heart?"

The voice comes from a kid in a black leather jacket in the front of the shop. His buddies nudge each other and let out harsh, puppy-barks of laughter. The boy grins and flushes all at once under his purple stripple of acne. "A heart with a scroll under it and a name on the scroll."

Carmey leans back in his swivel chair and digs his thumbs into his belt. The cigarette wobbles on his bottom lip. "Four dollars," he says without batting an eye.

"Four dollars?" The boy's voice swerves up and cracks in shrill disbelief. The three of them in the doorway mutter among themselves and shuffle back and forth.

"Nothing here in the heart line under three dollars."

Carmey doesn't kow-tow to the tight-fisted. You want a rose, you want a heart in this life, you pay for it. Through the nose.

The boy wavers in front of the placards of hearts on the wall, pink, lush hearts, hearts with arrows through them, hearts in the center of buttercup wreaths. "How much," he asks in a small, craven voice, "for just a name?"

"One dollar." Carmey's tone is strictly business.

The boy holds out his left hand. "I want Ruth." He draws an imaginary line across his left wrist. "Right here . . . so I can cover it up with a watch if I want to."

His two friends guffaw from the doorway.

Carmey points to the straight chair and lays his half-smoked cigarette on the Lazy Susan between two dye pots. The boy sits down, schoolbooks balanced on his lap.

"What happens," Mr. Tomolillo asks of the world in general, "if you choose to change a name? Do you just cross it off and write the next above it?"

"You could," Ned suggests, "wear a watch over the old name so only the new name showed."

"And then another watch," I say, "over that, when there's a third name."

"Until your arm," Mr. Tomolillo nods, "is up to the shoulder with watches."

Carmey is shaving the thin scraggly growth of hairs from the boy's wrist. "You're taking a lot of ragging from somebody."

The boy stares at his wrist with a self-conscious and unsteady smile, a smile that is maybe only a public substitute for tears. With his right hand he clutches his schoolbooks to keep them from sliding off his knee.

Carmey finishes marking *R-U-T-H* on the boy's wrist and holds the needle poised. "She'll bawl you out when she sees this." But the boy nods him to go ahead.

"Why?" Ned asks. "Why should she bawl him out?"

"'Gone and got yourself tattooed!'" Carmey mimics a mincing disgust. "'And with just a name! Is *that* all you think of me?'—She'll be wanting roses, birds, butterflies . . .'" The needle sticks for a second and the boys flinches like a colt. "And if you *do* get all that stuff to please her—roses . . .'"

"Birds and butterflies," Mr. Tomolillo puts in.

". . . she'll say, sure as rain at a ball game: 'What'd you want to go and spend all that *money* for?'" Carmey whizzes the needle clean in the bowl of antiseptic. "You can't beat a woman." A few meager blood drops stand up along the four letters—letters so black and plain you can hardly tell it's a tattoo and not just inked in with a pen. Carmey tapes a narrow bandage of Kleenex over the name. The whole operation lasts less than ten minutes.

The boys fishes a crumpled dollar bill from his back pocket. His friends cuff him fondly on the shoulder and the three of them crowd out the door, all at the same time, nudging, pushing, tripping over their feet. Several faces, limpet-pale against the window, melt away as Carmey's eye lingers on them.

"No wonder he doesn't want a heart, that kid, he wouldn't know what to do with it. He'll be back next week asking for a Betty or a Dolly or some such, you wait." He sighs, and goes to the cardboard file and pulls out a stack of those photographs he wouldn't put on the wall and passes them around. "One picture I would like to get," Carmey leans back in the swivel chair and props his cowboy boots on a little carton, "the butterfly. I got pictures of the rabbit hunt. I got pictures of ladies with snakes winding up their legs and into them, but I could make a lot of sweet dough if I got a picture of the butterfly on a woman."

"Some queer kind of butterfly nobody wants?" Ned

peers in the general direction of my stomach as at some high-grade salable parchment.

"It's not what, it's where. One wing on the front of each thigh. You know how butterflies on a flower make their wings flutter, ever so little? Well, any move a woman makes, these wings look to be going in and out, in and out. I'd like a photograph of that so much I'd practically do a butterfly for free."

I toy, for a second, with the thought of a New Guinea Golden, wings extending from hipbone to kneecap, ten times life size, but drop it fast. A fine thing if I got tired of my own skin sooner than last year's sack.

"Plenty of women *ask* for butterflies in that particular spot," Carmey goes on, "but you know what, not one of them will let a photograph be taken after the job's done. Not even from the waist down. Don't imagine I haven't asked. You'd think everybody over the whole United States would recognize them from the way they carry on when it's even mentioned."

"Couldn't," Mr. Tomolilo ventures shyly, "the wife oblige? Make it a little family affair?"

Carmey's face skews up in a pained way. "Naw." He shakes his head, his voice weighted with an old wonder and regret. "Naw, Laura won't hear of the needle. I used to think the idea of it'd grow on her after a bit, but nothing doing. She makes me feel, sometimes, what do I see in it all. Laura's white as the day she was born. Why, she *hates* tattoos."

Up to this moment I have been projecting, fatuously, intimate visits with Laura at Carmey's place. I have been imaging a lithe, supple Laura, a butterfly poised for flight on each breast, roses blooming on her buttocks, a gold-guarding dragon on her back and Sinbad the Sailor in six colors on her belly, a woman with Experience written all over her, a

woman to learn from in this life. I should have known better.

The four of us are slumped there in a smog of cigarette smoke, not saying a word, when a round, muscular woman comes into the shop, followed closely by a greasy-haired man with a dark, challenging expression. The woman is wrapped to the chin in a woolly electric-blue coat; a fuchsia kerchief covers all but the pompadour of her glinting blond hair. She sits down in the chair in front of the window regardless of Mount Calvary and proceeds to stare fixedly at Carmey. The man stations himself next to her and keeps a severe eye on Carmey too, as if expecting him to bolt without warning.

There is a moment of potent silence.

"Why," Carmey says pleasantly, but with small heart, "here's the wife now."

I take a second look at the woman and rise from my comfortable seat on the crate at Carmy's elbow. Judging from his watchdog stance, I gather the strange man is either Laura's brother or her bodyguard or a low-class private detective in her employ. Mr. Tomolillo and Ned are moving with one accord toward the door.

"We must be running along," I murmur, since nobody else seems inclined to speak.

"Say hello to the people, Laura," Carmey begs, back to the wall. I can't help but feel sorry for him, even a little ashamed. The starch is gone out of Carmey now, and the gay talk.

Laura doesn't say a word. She is waiting with the large calm of a cow for the three of us to clear out. I imagine her body, death-lily-white and totally bare—the body of a woman immune as a nun to the eagle's anger, the desire of the rose. From Carmey's wall the world's menagerie howls and ogles at her alone.

# Herstory

**MADAME CHINCHILLA**

The Tattooed Woman used to live in stone caves, under animal skin shelters, in igloos, mud-packed dwellings, and under palm-thatched huts. She crouched near fire-pits collecting inky-black soot for her tattoos. She roamed naked and barefoot, proud and fearless upon the earth, collecting red berries and roots to grind into paste to tattoo herself. She would bow to the four directions—an elemental vibration resounding through the centuries. She was the Goddess, the Medicine Woman, the Woman of Pleasure, the Worker. She was the Mother.

Missionaries trespassed her lands, and shamed her into covering her nakedness, cutting her hair, and not praying to her animist gods. They shamed her into ceasing her "pagan ways" and marking her body with tattoos. She chewed strong roots and chanted while undergoing the tribal ritual of being tattooed for her passage into womanhood. She hid her tattoos behind black veils, silenced her tongue, but her soul was wild as ever.

She was tattooed by the shaman or tribal elder, with sharpened obsidian, bones, fish teeth, or metal. Ritual drums and chanting laced the night air. She was marked with symbols referring to her function in the tribe, as a basket maker, storyteller, medicine woman. She was marked when she was

twelve and her menses began to flow, and again when they ceased.

In Gujarat, India, women were tattooed with vermilion inked dots at the corners of their eyes and face. Vermilion is the color of blood, and of the flames which will consume her body after death. Her tattoos were a rite of passage securing her safe journey into the afterworld amongst the wandering tribes.

In the fifties the tattooed woman was brazen, rebellious, often drunk and rowdy. She lingered in smoky bars with her tattooed shoulder exposed, and rode on the back of Harleys with her leather-encased legs clasped tightly around her man's hips. She smoked cigarettes, and drank beer, whiskey, and wine, and still does. Her laughter echoes the centuries of her oppression. Her body dances the dance of all women in the slow and sensual undulations, in dusky atmospheres. She sucks from life urgently, like it's going out of style.

The tattooed woman may be seen sitting demurely on a high stool in a nightclub, crossing one slim ankle over the other, a tattoo barely visible through her dark silk stockings. She may be seen wearing a tattoo where her breast used to be. She can be seen lingering in static poses on the covers of CDs and fashion magazines.

The tattooed woman lives in ghettos, condos, in the streets . . . sleeps on newspapers. She bathes in rivers and in claw-foot tubs, uses a hole in the ground or a bidet. She can be seen sitting behind a desk with a computer mouse at her command, pushing a broom across smooth wooden floors, or dropping the children off at daycare. She works in a bank, the fields, or in a crumbling government building. She holds a scalpel, wrench, spatula, hammer, blow-dryer, or a tattoo machine. The tattooed woman's archetype is diverse. She is an

artist, housewife, teacher, or secretary. She is a Christian, Buddhist, Jew, Quaker, or Hindu. She is a Republican, Democrat, socialist, or an anarchist. She is a vegan or she is omnivorous.

She is the aroma of amber, Egyptian musk, jasmine, patchouli or Chanel. Her hair is braided, permed, or shaved. It is blond, henna or purple, and perfumed by wood smoke or fragrant oils. She wears an orchid in her French twist. She wears moccasins, Converse high-tops, high heels, or Birkenstocks. Her dress is leather, cotton, fur, hemp, silk, or polyester. She wears black opals, raw pearls, rhinestones, or seashells around her neck.

Her flame is vibrant. She swims within her soup of hormones. The magnetism of the moon pulls her psyche. She encompasses the universal truths of all women . . . in all centuries . . . in varied states of consciousness. She rides the waves of her life with difficulty and grace.

We are all part of the Tribe of Women, beautiful and empowered by our tattooed symbols. We wear an eclectic mix of universal marks which are bizarre, traditional, artistic, and graceful. They are disturbing and curious. With a feeling of revelation, we are sisters, dancing through the fire of ancient rituals, richly embellished, transformed forever, back into our lovers' arms, carrying within our hearts, as well as under our tattooed skins, an exquisite sameness . . . back into the world.

# "I bring my book—
# prepared to wait . . ."

**CHERISE WYNEKEN**

I bring my book—prepared to wait. And wait I do—in stages. First to register—then down the hall to the waiting room. A quick detour through a cubbyhole where I take off my blouse and bra, don a dark blue gown, and settle in—to wait.

At last I hear my name being called (mangled as usual) along with directions to Room 1. The attendant directs me to lie on a stretcherlike table. Measurements are made. My breast is marked with blue pencil. The tattoo is etched between them. A mark for future reference. Radiation begins.

# *from* Tree

## DEENA METZGER

SUNDAY, AUGUST I, 1977

I am no longer afraid of mirrors where I see the sign of the amazon, the one who shoots arrows. There is a fine red line across my chest where a knife entered, but now a branch winds about the scar and travels from arm to heart. Green leaves cover the branch, grapes hang there and a bird appears. What grows in me now is vital and does not cause me harm. I think the bird is singing. When he finished his work, the tattooist drank a glass of wine with me. I have relinquished some of the scars. I have designed my chest with the care given to an illuminated manuscript. I am no longer ashamed to make love. In the night, a hand caressed my chest and once again I came to life. Love is a battle I can win. I have the body of a warrior who does not kill or wound. On the book of my body, I have permanently inscribed a tree.

All the forms I know originate in the heart. The tree which grows in the heart depends on community. We cannot do anything alone. I am well because you take care of me. Ariel is also alive because we took care of him. A woman brought

me a feather. When I caught her eye, she acknowledged it was a political act.

I am no longer ashamed of what I know, nor the scars I suffered to gain that knowledge. I am not afraid of the power which is in us. I am not afraid of the dawn, of being alone, of making love, of announcing myself as a part of the revolution.

# Becoming Bird

### BOB HICOK

It began with a tattoo gun to his back.
Face down, he sniffed the skin of dead men
on an execution table the artist bought
from a guard who pinched it from the trash

at Jackson Prison. It was to be one feather
outside each scapula, an idea
that arrived while he flipped *Art
Through the Ages* past the side view

of *Kristos Boy,* who without arms and confined
to the appetite of marble, still seemed
poised for air, to lift through the roof
of the Acropolis Museum into the polluted sky

of Athens, bound for translucence. But healed,
turning left, right in a sandwich of mirrors,
the lonely feathers asked to be plucked,
the black ink grew from a root of dusk

to charcoal tip, they'd have fluttered
if wind arrived, reflex to join the rush,
but alone seemed less symbolic than forgotten.
So he returned to the *Cunning Needle,*

to Martha of pierced tongue and navel, said
wings and she slapped the table, added
coverts and scapulars, secondaries
and tertials, for a year needles chewed

his skin closer to hawk, to dove, injected
acrylic through tiny pearls of blood.
Then with a back that belonged to the sky
he couldn't stop, sprouted feathers

to collarline, down thighs, past knees
and his feet became scaled, claws gripped
the tops of his toes, she turned him over
for the fine work of down, he laid, arms

on the syringe-wings of the table,
a model of crucifixion dreaming flight
through the pricks. So now, by day's end
he can barely hold back the confidence

of his wings. At home, naked with eyes
closed, he feels wind as music
and dreams his body toward a mouse
skimming the woven grass, not considering

but inhabiting the attack, falling hard
as hunger teasing the reach of land,
while from the ink of the first tattoo
a real feather grows, useless but patient.

# Designing a Bird from Memory in Jack's Skin Kitchen

### ELIOT WILSON

We hated everything below us.
We'd come to hate the ground itself,
to dread the heavy ropes of gravity
drawing us down from blue
to a brooding green
which would billow in tan dust
like waves of fistic clouds.

We'd come to kill
the afternoons, to evade
the blanket heat by flying out of rifle reach
and dropping mortar rounds through the clouds and
    trees.

I would come to forget Isaac,
our Arab gunner with his shell carton filled with baklava,
and just how mixed he was
bearded, but awash in after-shave,
dropping incendiary bombs and Hershey bars at the
    same time,
Viet S'mores we called it.

How he could shoot his .50 caliber,
stoned on hash,
as accurate as fate itself,
shoot children and dogs,
but not women or birds. *Bad luck,*
he said. *Even when they are dead,*
*women and birds remember.*

I would forget how we found him later in Song Ngan
    Valley
mixed with the ground and chopper,
repatriated, tangled like a lover,
his broken hand up and open
as if feeling for rain,
or patiently expecting some small gratuity,
the visor of his helmet shining the same
blue-black iridescence
as the glass of Chartres cathedral.

*Right here,* I tell the tattoo man
giving him my arm,
*A blue bird, that certain blue, with black eyes*
*and rising.*

# Second Skin

**BRUCE BOND**

We imagined my uncle's tattoos
as shell shock and rice wine
surfacing on Asian nights.
My mother told us not to stare,
though his arms were the typhoid streets.
He would have loved them for life,
the women with diminutive names
and strong hands needled
into his skin: their high-heeled
initials, the blue florets.
I still see him in the showers
by the city pool, lathering up
the thorns on his thigh.
Foam streams over his shoulders,
the broken skiff blazing
into his chest. And where
there's fire, the thin fury
of hair. As each blue cell
flakes off, the next comes up
blue, faithful, as though
the color were his gene's amnesia,
and marriageable women
would shun him now for fear

their children would be tough
and blue, the fool thicket
of roses fixing its stale kiss
on their thighs, their nipples.
They would wear their family's
blue, recurrent dream, a cold
fire surfacing between them.

# Portrait

**KIRSTEN RYBCZYNSKI**

My father is tall. He looks even taller than he is because I am so small. He is so thin and gangly, all sharp angles, elbows, bony shoulders. His long hair is brown, thick and unkempt. He has a beard. For some reason his teeth were pulled. Maybe all or maybe just the top or just the bottom. He leaves his dentures in Vietnam and doesn't get new ones when he comes back. The beard hides this but his voice gives it away. He sounds like there's something wrong with him.

He wears T-shirts and blue jeans. He wears glasses. His arm, legs, chest are covered with tattoos. Jesus on his chest. Two angels on either side. A crown of thorns. Blood. A teardrop on his cheek that disappeared after he got knifed in the face. A panther. A tiger. A toadstool, yellow and orange on his ankle. An old man with a white beard on his other ankle. A brightly colored parrot. A spider on his shoulder. I looked at it when he was in the bathtub and I touched it. A flower on his finger. I can see it when he lifts me up. Two dice with a banner that reads "Saturday night's alright for fightin.' " A man, pulling down one eyelid with a finger. Over his head the words "I've got this crazy feeling."

When I am six, my father has his own tattoo business called Captain John's. He gives me his drawings on white paper and tells me to color them in with markers. A naked lady. A goat with horns sitting on a throne. I color the pan-

thers black with red for the eyes and yellow for the claws. I take my coloring seriously. I am careful and precise. My father uses the colored drawings to show his customers.

When I get my only tattoo at twenty-three, the owner of Papillon's remembers my father.

He was crazy, he says with a laugh. Whatever happened to him?

He died, I say.

Too bad, he was a good guy. But man was he crazy.

My father smells like beer or vodka, which they say doesn't have a smell but it does. Especially when it's been in you so long that it oozes from your pores. He smells like tobacco, not like cigarettes, but fresh tobacco—sweet and fragrant. The combination is so male, so heady. I put my face into his shirt and breathe the smells of my father.

He is quick to tell a joke, to laugh, to lie, to steal. He doesn't hit me. But I hear him explode outside a door, banging, yelling.

He lives on the street or at the Hartford Hotel, a flophouse. When I am a teenager, an article is written about the people who live at the hotel. My father gets his picture in the local paper. He sits in his room with a window behind him. He has his shirt off. His tattoos are vivid and distracting against the pale white of his skin. He is skinny but his belly is distended. He is not smiling. He sits with his legs apart, a cocky pose. He glares at the camera.

There is an interview with the picture. The reporter wants to know how my father got to this place, why he lives here.

I got no other place to go, he says.

The Hartford Hotel was torn down after my father moved out. When he died, I thought about the article and the picture and wondered how he looked to people reading

the paper. I wondered how they saw him. A drunk, a wasted, smelly bum. A sorry excuse for a human being. A wide-eyed, longhaired freak. A joker, a curio.

That picture in the paper cannot make my father any more real to me. I close my eyes and see his long nose and skinny neck. I remember the fragile things about him. His ribs through a white T-shirt, his bony wrists.

# "When I muse about tattoos . . ."

**JOY WILLIAMS**

When I muse about tattoos, I think of Kafka's Harrow in his
story "In the Penal Colony." This monstrous device with its
long needles shuttles back and forth on a ribbon of steel and
effects the ultimate in tattoos for it inscribes upon each indi-
vidual's body that individual's "sentence." Enlightenment is
presumed to come in the twelfth hour of the great Harrow's
work when, just at life's end, the doomed one begins to com-
prehend the transfiguring justice of his dilemma.

I think too of Wendy Williams, the Plasmatic rocker who
committed suicide a few years ago. She had a number of satis-
factory tattoos but wanted a truly grand one. She moved in
with a tattoo artist, the best in town, which in this case hap-
pened to be, perhaps unfortunately, Manchester, Connecti-
cut. She wanted leopard spots but he couldn't figure out how
to do it. He commenced doing something else. It wasn't
working, she hated it, it ran up and down her arms, this de-
sign that she could not comprehend, that was not her. Wendy
O. Williams. She wore long-sleeved shirts to conceal it, she
was unhappy with this ambitious, muddled unfinished tattoo,
very unhappy, unhappy unto death.

# In the Penal Colony

**FRANZ KAFKA**

*Translated by Willa and Edwin Muir*

"It's a remarkable piece of apparatus," said the officer to the explorer and surveyed with a certain air of admiration the apparatus which was after all quite familiar to him. The explorer seemed to have accepted merely out of politeness the Commandant's invitation to witness the execution of a soldier condemned to death for disobedience and insulting behavior to a superior. Nor did the colony itself betray much interest in this execution. At least, in the small sandy valley, a deep hollow surrounded on all sides by naked crags, there was no one present save the officer, the explorer, the condemned man, who was a stupid-looking, wide-mouthed creature with bewildered hair and face, and the soldier who held the heavy chain controlling the small chains locked on the prisoner's ankles, wrists, and neck, chains that were themselves attached to each other by communicating links. In any case, the condemned man looked so like a submissive dog that one might have thought he could be left to run free on the surrounding hills and would only need to be whistled for when the execution was due to begin.

The explorer did not much care about the apparatus and walked up and down behind the prisoner with almost visible indifference while the officer made the last adjustments, now creeping beneath the structure, which was bedded deep in the earth, now climbing a ladder to inspect its upper parts.

These were tasks that might well have been left to a mechanic, but the officer performed them with great zeal, whether because he was a devoted admirer of the apparatus or because of other reasons the work could be entrusted to no one else. "Ready now!" he called at last and climbed down from the ladder. He looked uncommonly limp, breathed with his mouth wide open, and had tucked two fine ladies' handkerchiefs under the collar of his uniform. "These uniforms are too heavy for the tropics, surely," said the explorer, instead of making some inquiry about the apparatus, as the officer had expected. "Of course," said the officer, washing his oily and greasy hands in a bucket of water that stood ready, "but they mean home to us; we don't want to forget about home. Now just have a look at this machine," he added at once, simultaneously drying his hands on a towel and indicating the apparatus. "Up till now a few things still had to be set by hand, but from this moment it works all by itself." The explorer nodded and followed him. The officer, anxious to secure himself against all contingencies, said: "Things sometimes go wrong, of course; I hope that nothing goes wrong today, but we have to allow for the possibility. The machinery should go on working continuously for twelve hours. But if anything does go wrong it will only be some small matter that can be set right at once.

"Won't you take a seat?" he asked finally, drawing a cane chair out from among a heap of them and offering it to the explorer, who could not refuse it. He was now sitting at the edge of a pit, into which he glanced for a fleeting moment. It was not very deep. On one side of the pit the excavated soil had been piled up in a rampart, on the other side of it stood the apparatus. "I don't know," said the officer, "if the Commandant has already explained this apparatus to you." The explorer waved one hand vaguely; the officer asked for noth-

ing better, since now he could explain the apparatus himself. "This apparatus," he said, taking hold of a crank handle and leaning against it, "was invented by our former Commandant. I assisted at the very earliest experiments and had a share in all the work until its completion. But the credit of inventing it belongs to him alone. Have you ever heard of our former Commandant? No? Well, it isn't saying too much if I tell you that the organization of the whole penal colony is his work. We who were his friends knew even before he died that the organization of the colony was so perfect that his successor, even with a thousand new schemes in his head, would find it impossible to alter anything, at least for many years to come. And our prophecy has come true; the new Commandant has had to acknowledge its truth. A pity you never met the old Commandant!—But," the officer interrupted himself, "I am rambling on, and here stands his apparatus before us. It consists, as you see, of three parts. In the course of time each of these parts has acquired a kind of popular nickname. The lower one is called the 'Bed,' the upper one the 'Designer,' and this one here in the middle that moves up and down is called the 'Harrow.'" "The Harrow?" asked the explorer. He had not been listening very attentively, the glare of the sun in the shadeless valley was altogether too strong, it was difficult to collect one's thoughts. All the more did he admire the officer, who in spite of his tight-fitting full-dress uniform coat, amply befrogged and weighed down by epaulettes, was pursuing his subject with such enthusiasm and, besides talking, was still tightening a screw here and there with a spanner. As for the soldier, he seemed to be in much the same condition as the explorer. He had wound the prisoner's chain around both his wrists, propped himself on his rifle, let his head hang, and was paying no attention to anything. That did not surprise the explorer, for the officer was

speaking French, and certainly neither the soldier nor the prisoner understood a word of French. It was all the more remarkable, therefore, that the prisoner was nonetheless making an effort to follow the officer's explanations. With a kind of drowsy persistence he directed his gaze wherever the officer pointed a finger, and at the interruption of the explorer's question he, too, as well as the officer, looked around.

"Yes, the Harrow," said the officer, "a good name for it. The needles are set in like the teeth of a harrow and the whole thing works something like a harrow, although its action is limited to one place and contrived with much more artistic skill. Anyhow, you'll soon understand it. On the Bed here the condemned man is laid—I'm going to describe the apparatus first before I set it in motion. Then you'll be able to follow the proceedings better. Besides, one of the cogwheels in the Designer is badly worn; it creaks a lot when it's working; you can hardly hear yourself speak; spare parts, unfortunately, are difficult to get here.—Well, here is the Bed, as I told you. It is completely covered with a layer of cotton wool; you'll find out why later. On this cotton wool the condemned man is laid, face down, quite naked, of course; here are straps for the hands, here for the feet, and here for the neck, to bind him fast. Here at the head of the Bed, where the man, as I said, first lays down his face, is this little gag of felt, which can be easily regulated to go straight into his mouth. It is meant to keep him from screaming and biting his tongue. Of course the man is forced to take the felt into his mouth, for otherwise his neck would be broken by the strap." "Is that cotton wool?" asked the explorer, bending forward. "Yes, certainly," said the officer, with a smile, "feel it for yourself." He took the explorer's hand and guided it over the Bed. "It's specially prepared cotton wool, that's why it looks so different; I'll tell you presently what it's for." The explorer

already felt a dawning interest in the apparatus; he sheltered his eyes from the sun with one hand and gazed up at the structure. It was a huge affair. The Bed and the Designer were of the same size and looked like two dark wooden chests. The Designer hung about two meters above the Bed; each of them was bound at the corners with four rods of brass that almost flashed out rays in the sunlight. Between the chests shuttled the Harrow on a ribbon of steel.

The officer had scarcely noticed the explorer's previous indifference, but he was now well aware of his dawning interest; so he stopped explaining in order to leave a space of time for quiet observation. The condemned man imitated the explorer; since he could not use a hand to shelter his eyes he gazed upwards without shade.

"Well, the man lies down," said the explorer, leaning back in his chair and crossing his legs.

"Yes," said the officer, pushing his cap back a little and passing one hand over his heated face, "now listen! Both the Bed and the Designer have an electric battery each; the Bed needs one for itself, the Designer for the Harrow. As soon as the man is strapped down, the Bed is set in motion. It quivers in minute, very rapid vibrations, both from side to side and up and down. You will have seen similar apparatus in hospitals; but in our Bed the movements are all precisely calculated; you see, they have to correspond very exactly to the movements of the Harrow. And the Harrow is the instrument for the actual execution of the sentence."

"And how does the sentence run?" asked the explorer.

"You don't know that either?" said the officer in amazement, and bit his lips. "Forgive me if my explanations seem rather incoherent. I do beg your pardon. You see, the Commandant always used to do the explaining; but the new Commandant shirks this duty; yet that such an important vis-

itor"—the explorer tried to deprecate the honor with both hands; the officer, however, insisted—"that such an important visitor should not even be told about the kind of sentence we pass is a new development, which—" He was just on the point of using strong language but checked himself and said only: "I was not informed, it is not my fault. In any case, I am certainly the best person to explain our procedure, since I have here"—he patted his breast pocket—"the relevant drawings made by our former Commandant."

"The Commandant's own drawings?" asked the explorer. "Did he combine everything in himself, then? Was he soldier, judge, mechanic, chemist, and draughtsman?"

"Indeed he was," said the officer, nodding assent, with a remote, glassy look. Then he inspected his hands critically; they did not seem clean enough to him for touching the drawings; so he went over to the bucket and washed them again. Then he drew out a small leather wallet and said: "Our sentence does not sound severe. Whatever commandment the prisoner has disobeyed is written upon his body by the Harrow. This prisoner, for instance"—the officer indicated the man—"will have written on his body: HONOR THY SUPERIORS!"

The explorer glanced at the man; he stood, as the officer pointed him out, with bent head, apparently listening with all his ears in an effort to catch what was being said. Yet the movement of his blubber lips, closely pressed together, showed clearly that he could not understand a word. Many questions were troubling the explorer, but at the sight of the prisoner he asked only: "Does he know his sentence?" "No," said the officer, eager to go on with his exposition, but the explorer interrupted him: "He doesn't know the sentence that has been passed on him?" "No," said the officer again, pausing a moment as if to let the explorer elaborate his ques-

tion, and then said: "There would be no point in telling him. He'll learn it on his body." The explorer intended to make no answer, but he felt the prisoner's gaze turned on him; it seemed to ask if he approved such goings-on. So he bent forward again, having already leaned back in his chair and put another question: "But surely he knows that he has been sentenced?" "Nor that either," said the officer, smiling at the explorer as if expecting him to make further surprising remarks. "No," said the explorer, wiping his forehead, "then he can't know either whether his defense was effective?" "He has had no chance of putting up a defense," said the officer, turning his eyes away as if speaking to himself and so sparing the explorer the shame of hearing self-evident matters explained. "But he must have had some chance of defending himself," said the explorer, and rose from his seat.

The officer realized that he was in danger of having his exposition of the apparatus held up for a long time; so he went up to the explorer, took him by the arm, waved a hand toward the condemned man, who was standing very straight now that he had so obviously become the center of attention—the soldier had also given the chain a jerk—and said: "This is how the matter stands. I have been appointed judge in this penal colony. Despite my youth. For I was the former Commandant's assistant in all penal matters and know more about the apparatus than anyone. My guiding principle is this: Guilt is never to be doubted. Other courts cannot follow that principle, for they consist of several opinions and have higher courts to scrutinize them. That is not the case here, or at least, it was not the case in the former Commandant's time. The new man has certainly shown some inclination to interfere with my judgments, but so far I have succeeded in fending him off and will go on succeeding. You wanted to have the case explained; it is quite simple, like all of them. A captain

reported to me this morning that this man, who had been assigned to him as a servant and sleeps before his door, had been asleep on duty. It is his duty, you see, to get up every time the hour strikes and salute the captain's door. Not an exacting duty, and very necessary, since he has to be a sentry as well as a servant, and must be alert in both functions. Last night the captain wanted to see if the man was doing his duty. He opened the door as the clock struck two and there was his man curled up asleep. He took his riding whip and lashed him across the face. Instead of getting up and begging pardon, the man caught hold of his master's legs, shook him, and cried: 'Throw that whip away or I'll eat you alive.'—That's the evidence. The captain came to me an hour ago; I wrote down his statement and appended the sentence to it. Then I had the man put in chains. That was all quite simple. If I had first called the man before me and interrogated him, things would have got into a confused tangle. He would have told lies, and had I exposed these lies he would have backed them up with more lies, and so on and so forth. As it is, I've got him and I won't let him go.—Is that quite clear now? But we're wasting time, the execution should be beginning and I haven't finished explaining the apparatus yet." He pressed the explorer back into his chair, went up again to the apparatus, and began: "As you see, the shape of the Harrow corresponds to the human form; here is the harrow for the torso, here are the harrows for the legs. For the head there is only this one small spike. Is that quite clear?" He bent amiably forward toward the explorer, eager to provide the most comprehensive explanations.

The explorer considered the Harrow with a frown. The explanation of the judicial procedure had not satisfied him. He had to remind himself that this was in any case a penal colony where extraordinary measures were needed and that

military discipline must be enforced to the last. He also felt that some hope might be set on the new Commandant, who was apparently of a mind to bring in, although gradually, a new kind of procedure which the officer's narrow mind was incapable of understanding. This train of thought prompted his next question: "Will the Commandant attend the execution?" "It is not certain," said the officer, wincing at the direct question, and his friendly expression darkened. "That is just why we have to lose no time. Much as I dislike it, I shall have to cut my explanations short. But of course tomorrow, when the apparatus has been cleaned—its one drawback is that it gets so messy—I can recapitulate all the details. For the present, then, only the essentials.—When the man lies down on the Bed and it begins to vibrate, the Harrow is lowered onto his body. It regulates itself automatically so that the needles barely touch his skin; once contact is made the steel ribbon stiffens immediately into a rigid band. And then the performance begins. An ignorant onlooker would see no difference between one punishment and another. The Harrow appears to do its work with uniform regularity. As it quivers, its points pierce the skin of the body which is itself quivering from the vibration of the Bed. So that the actual progress of the sentence can be watched, the Harrow is made of glass. Getting the needles fixed in the glass was a technical problem, but after many experiments we overcame the difficulty. No trouble was too great for us to take, you see. And now anyone can look through the glass and watch the inscription taking form on the body. Wouldn't you care to come a little nearer and have a look at the needles?"

The explorer got up slowly, walked across, and bent over the Harrow. "You see," said the officer, "there are two kinds of needles arranged in multiple patterns. Each long needle has a short one beside it. The long needle does the writing,

and the short needle sprays a jet of water to wash away the blood and keep the inscription clear. Blood and water together are then conducted here through small runnels into this main runnel and down a waste pipe into the pit." With his finger the officer traced the exact course taken by the blood and water. To make the picture as vivid as possible he held both hands below the outlet of the waste pipe as if to catch the outflow, and when he did this the explorer drew back his head and feeling behind him with one hand sought to return to his chair. To his horror he found that the condemned man too had obeyed the officer's invitation to examine the Harrow at close quarters and had followed him. He had pulled forward the sleepy soldier with the chain and was bending over the glass. One could see that his uncertain eyes were trying to perceive what the two gentlemen had been looking at, but since he had not understood the explanation he could not make head or tail of it. He was peering this way and that way. He kept running his eyes along the glass. The explorer wanted to drive him away, since what he was doing was probably culpable. But the officer firmly restrained the explorer with one hand and with the other took a clod of earth from the rampart and threw it at the soldier. He opened his eyes with a jerk, saw what the condemned man had dared to do, let his rifle fall, dug his heels into the ground, dragged his prisoner back so that he stumbled and fell immediately, and then stood looking down at him, watching him struggling and rattling in his chains. "Set him on his feet!" yelled the officer, for he noticed that the explorer's attention was being too much distracted by the prisoner. In fact he was even leaning right across the Harrow, without taking any notice of it, intent only on finding out what was happening to the prisoner. "Be careful with him!" cried the officer again. He ran around the apparatus, himself caught the condemned

man under the shoulders, and with the soldier's help got him up on his feet, which kept slithering from under him.

"Now I know all about it," said the explorer as the officer came back to him. "All except the most important thing," he answered, seizing the explorer's arm and pointing upwards: "In the Designer are all the cogwheels that control the movements of the Harrow, and this machinery is regulated according to the inscription demanded by the sentence. I am still using the guiding plans drawn by the former Commandant. Here they are"—he extracted some sheets from the leather wallet—"but I'm sorry I can't let you handle them, they are my most precious possessions. Just take a seat and I'll hold them in front of you like this, then you'll be able to see everything quite well." He spread out the first sheet of paper. The explorer would have liked to say something appreciative, but all he could see was a labyrinth of lines crossing and recrossing each other, which covered the paper so thickly that it was difficult to discern the blank spaces between them. "Read it," said the officer. "I can't," said the explorer. "Yet it's clear enough," said the officer. "It's very ingenious," said the explorer evasively, "but I can't make it out." "Yes," said the officer with a laugh, putting the paper away again, "it's no calligraphy for school children. It needs to be studied closely. I'm quite sure that in the end you would understand it too. Of course the script can't be a simple one; it's not supposed to kill a man straight off, but only after an interval of, on an average, twelve hours; the turning point is reckoned to come at the sixth hour. So there have to be lots and lots of flourishes around the actual script; the script itself runs around the body only in a narrow girdle; the rest of the body is reserved for the embellishments. Can you appreciate now the work accomplished by the Harrow and the whole apparatus?—Just watch it!" He ran up the ladder, turned a wheel, called down:

"Look out, keep to one side!" and everything started working. If the wheel had not creaked, it would have been marvelous. The officer, as if surprised by the noise of the wheel, shook his fist at it, then spread out his arms in excuse to the explorer, and climbed down rapidly to peer at the working of the machine from below. Something perceptible to no one save himself was still not in order; he clambered up again, did something with both hands in the interior of the Designer, then slid down one of the rods, instead of using the ladder, so as to get down quicker, and with the full force of his lungs, to make himself heard at all in the noise, yelled in the explorer's ear: "Can you follow it? The Harrow is beginning to write; when it finishes the first draft of the inscription on the man's back, the layer of cotton wool begins to roll and slowly turns the body over, to give the Harrow fresh space for writing. Meanwhile the raw part that has been written on lies on the cotton wool, which is specially prepared to staunch the bleeding and so makes all ready for a new deepening of the script. Then these teeth at the edge of the Harrow, as the body turns further around, tear the cotton wool away from the wounds, throw it into the pit, and there is more work for the Harrow. So it keeps on writing deeper and deeper for the whole twelve hours. The first six hours the condemned man stays alive almost as before, he suffers only pain. After two hours the felt gag is taken away, for he has no longer strength to scream. Here, into this electrically heated basin at the head of the Bed, some warm rice pap is poured, from which the man, if he feels like it, can take as much as his tongue can lap. Not one of them ever misses the chance. I can remember none, and my experience is extensive. Only about the sixth hour does the man lose all desire to eat. I usually kneel down here at that moment and observe what happens. The man rarely swallows his last mouthful, he only rolls it around his mouth

and spits it out into the pit. I have to duck just then or he would spit it in my face. But how quiet he grows at just about the sixth hour! Enlightenment comes to the most dull-witted. It begins around the eyes. From there it radiates. A moment that might tempt one to get under the Harrow one-self. Nothing more happens than that the man begins to understand the inscription, he purses his mouth as if he were listening. You have seen how difficult it is to decipher the script with one's eyes; but our man deciphers it with his wounds. To be sure, that is a hard task; he needs six hours to accomplish it. By that time the Harrow has pierced him quite through and casts him into the pit, where he pitches down upon the blood and water and the cotton wool. Then the judgment has been fulfilled, and we, the soldier and I, bury him."

The explorer had inclined his ear to the officer and with his hands in his jacket pockets watched the machine at work. The condemned man watched it too, but uncomprehend-ingly. He bent forward a little and was intent on the moving needles when the soldier, at a sign from the officer, slashed through his shirt and trousers from behind with a knife, so that they fell off; he tried to catch at his falling clothes to cover his nakedness, but the soldier lifted him into the air and shook the last remnants from him. The officer stopped the machine, and in the sudden silence the condemned man was laid under the Harrow. The chains were loosened and the straps fastened on instead; in the first moment that seemed almost a relief to the prisoner. And now the Harrow was adjusted a little lower, since he was a thin man. When the needle points touched him a shudder ran over his skin; while the soldier was busy strapping his right hand, he flung out his left hand blindly; but it happened to be in the direction toward where the explorer was standing. The officer kept

watching the explorer sideways, as if seeking to read from his face the impression made on him by the execution, which had been at least cursorily explained to him.

The wrist strap broke; probably the soldier had drawn it too tight. The officer had to intervene, the soldier held up the broken piece of strap to show him. So the officer went over to him and said, his face still turned toward the explorer: "This is a very complex machine, it can't be helped that things are breaking or giving way here and there; but one must not thereby allow oneself to be diverted in one's general judgment. In any case, this strap is easily made good; I shall simply use a chain; the delicacy of the vibrations for the right arm will of course be a little impaired." And while he fastened the chains, he added: "The resources for maintaining the machine are now very much reduced. Under the former Commandant I had free access to a sum of money set aside entirely for this purpose. There was a store, too, in which spare parts were kept for repairs of all kinds. I confess I have been almost prodigal with them, I mean in the past, not now as the new Commandant pretends, always looking for an excuse to attack our old way of doing things. Now he has taken charge of the machine money himself, and if I send for a new strap they ask for the broken old strap as evidence, and the new strap takes ten days to appear and then is of shoddy material and not much good. But how I am supposed to work the machine without a strap, that's something nobody bothers about."

The explorer thought to himself: It's always a ticklish matter to intervene decisively in other people's affairs. He was neither a member of the penal colony nor a citizen of the state to which it belonged. Were he to denounce this execution or actually try to stop it, they could say to him: You are a foreigner, mind your own business. He could make no an-

swer to that, unless he were to add that he was amazed at himself in this connection, for he traveled only as an observer, with no intention at all of altering other people's methods of administering justice. Yet here he found himself strongly tempted. The injustice of the procedure and the inhumanity of the execution were undeniable. No one could suppose that he had any selfish interest in the matter, for the condemned man was a complete stranger, not a fellow countryman or even at all sympathetic to him. The explorer himself had recommendations from high quarters, had been received here with great courtesy, and the very fact that he had been invited to attend the execution seemed to suggest that his views would be welcome. And this was all the more likely since the Commandant, as he had heard only too plainly, was no upholder of the procedure and maintained an attitude almost of hostility to the officer.

At that moment the explorer heard the officer cry out in rage. He had just, with considerable difficulty, forced the felt gag into the condemned man's mouth when the man in an irresistible access of nausea shut his eyes and vomited. Hastily the officer snatched him away from the gag and tried to hold his head over the pit; but it was too late, the vomit was running all over the machine. "It's all the fault of that Commandant!" cried the officer, senselessly shaking the brass rods in front, "the machine is befouled like a pigsty." With trembling hands he indicated to the explorer what had happened. "Have I not tried for hours at a time to get the Commandant to understand that the prisoner must fast for a whole day before the execution. But our new, mild doctrine thinks otherwise. The Commandant's ladies stuff the man with sugar candy before he's led off. He has lived on stinking fish his whole life long and now he has to eat sugar candy! But it could still be possible, I should have nothing to say against it,

but why won't they get me a new felt gag, which I have been begging for the last three months. How should a man not feel sick when he takes a felt gag into his mouth which more than a hundred men have already slobbered and gnawed in their dying moments?"

The condemned man had laid his head down and looked peaceful, the soldier was busy trying to clean the machine with the prisoner's shirt. The officer advanced toward the explorer who in some vague presentiment fell back a pace, but the officer seized him by the hand, and drew him to one side. "I should like to exchange a few words with you in confidence," he said, "may I?" "Of course," said the explorer, and listened with downcast eyes.

"This procedure and method of execution, which you are now having the opportunity to admire, has at the moment no longer any open adherents in our colony. I am its sole advocate, and at the same time the sole advocate of the old Commandant's tradition. I can no longer reckon on any further extension of the method, it takes all my energy to maintain it as it is. During the old Commandant's lifetime the colony was full of his adherents; his strength of conviction I still have in some measure, but not an atom of his power; consequently the adherents have skulked out of sight, there are still many of them but none of them will admit it. If you were to go into the teahouse today, on execution day, and listen to what is being said, you would perhaps hear only ambiguous remarks. These would all be made by adherents, but under the present Commandant and his present doctrines they are of no use to me. And now I ask you: because of this Commandant and the women who influence him, is such a piece of work, the work of a lifetime"—he pointed to the machine—"to perish? Ought one to let that happen? Even if one has only come as a stranger to our island for a few days?

But there's no time to lose, an attack of some kind is impending on my function as judge; conferences are already being held in the Commandant's office from which I am excluded; even your coming here today seems to me a significant move; they are cowards and use you as a screen, you, a stranger.— How different an execution was in the old days! A whole day before the ceremony the valley was packed with people; they all came only to look on; early in the morning the Commandant appeared with his ladies; fanfares roused the whole camp; I reported that everything was in readiness; the assembled company—no high official dared to absent himself— arranged itself around the machine; this pile of cane chairs is a miserable survival from that epoch. The machine was freshly cleaned and glittering, I got new spare parts for almost every execution. Before hundreds of spectators—all of them standing on tiptoe as far as the heights there—the condemned man was laid under the Harrow by the Commandant himself. What is left today for a common soldier to do was then my task, the task of the presiding judge, and was an honor for me. And then the execution began! No discordant noise spoiled the working of the machine. Many did not care to watch it but lay with closed eyes in the sand; they all knew: Now justice is being done. In the silence one heard nothing but the condemned man's sighs, half-muffled by the felt gag. Nowadays the machine can no longer wring from anyone a sigh louder than the felt gag can stifle; but in those days the writing needles let drop an acid fluid, which we're no longer permitted to use. Well, and then came the sixth hour! It was impossible to grant all the requests to be allowed to watch it from nearby. The Commandant in his wisdom ordained that the children should have the preference; I, of course, because of my office had the privilege of always being at hand; often enough I would be squatting there with a small child in either

arm. How we all absorbed the look of transfiguration on the face of the sufferer, how we bathed our cheeks in the radiance of that justice, achieved at last and fading so quickly! What times these were, my comrade!" The officer had obviously forgotten whom he was addressing; he had embraced the explorer and laid his head on his shoulder. The explorer was deeply embarrassed, impatiently he stared over the officer's head. The soldier had finished his cleaning job and was now pouring rice pap from a pot into the basin. As soon as the condemned man, who seemed to have recovered entirely, noticed this action he began to reach for the rice with his tongue. The soldier kept pushing him away, since the rice pap was certainly meant for a later hour, yet it was just as unfitting that the soldier himself should thrust his dirty hands into the basin and eat out of it before the other's avid face.

The officer quickly pulled himself together. "I didn't want to upset you," he said, "I know it is impossible to make those days credible now. Anyhow, the machine is still working and it is still effective in itself. It is effective in itself even though it stands alone in this valley. And the corpse still falls at the last into the pit with an incomprehensibly gentle wafting motion, even though there are not hundreds of people swarming around like flies as formerly. In those days we had to put a strong fence around the pit, it has long since been torn down."

The explorer wanted to withdraw his face from the officer and looked around him at random. The officer thought he was surveying the valley's desolation; so he seized him by the hands, turned him around to meet his eyes, and asked: "Do you realize the shame of it?"

But the explorer said nothing. The officer left him alone for a little; with legs apart, hands on hips, he stood very still, gazing at the ground. Then he smiled encouragingly at the

explorer and said: "I was quite near you yesterday when the Commandant gave you the invitation. I heard him giving it. I know the Commandant. I divined at once what he was after. Although he is powerful enough to take measures against me, he doesn't dare to do it yet, but he certainly means to use your verdict against me, the verdict of an illustrious foreigner. He has calculated it carefully: this is your second day on the island, you did not know the old Commandant and his ways, you are conditioned by European ways of thought, perhaps you object on principle to capital punishment in general and to such mechanical instruments of death in particular, besides you will see that the execution has no support from the public, a shabby ceremony—carried out with a machine already somewhat old and worn—now, taking all that into consideration, would it not be likely (so thinks the Commandant) that you might disapprove of my methods? And if you disapprove, you wouldn't conceal the fact (I'm still speaking from the Commandant's point of view), for you are a man to feel confidence in your own well-tried conclusions. True, you have seen and learned to appreciate the peculiarities of many peoples, and so you would not be likely to take a strong line against our proceedings, as you might do in your own country. But the Commandant has no need of that. A casual, even an unguarded remark will be enough. It doesn't even need to represent what you really think, so long as it can be used speciously to serve his purpose. He will try to prompt you with sly questions, of that I am certain. And his ladies will sit around you and prick up their ears; you might be saying something like this: 'In our country we have a different criminal procedure,' or 'In our country the prisoner is interrogated before he is sentenced,' or 'We haven't used torture since the Middle Ages.' All these statements are as true as they seem natural to you, harmless remarks that pass no judgment

on my methods. But how would the Commandant react to them? I can see him, our good Commandant, pushing his chair away immediately and rushing onto the balcony, I can see his ladies streaming out after him, I can hear his voice—the ladies call it a voice of thunder—well, and this is what he says: 'A famous Western investigator, sent out to study criminal procedure in all the countries of the world, has just said that our old tradition of administering justice is inhumane. Such a verdict from such a personality makes it impossible for me to countenance these methods any longer. Therefore from this very day I ordain . . .' and so on. You may want to interpose that you never said any such thing, that you never called my methods inhumane, on the contrary your profound experience leads you to believe they are most humane and most in consonance with human dignity, and you admire the machine greatly—but it will be too late; you won't even get onto the balcony, crowded as it will be with ladies; you may try to draw attention to yourself, you may want to scream out; but a lady's hand will close your lips—and I and the work of the old Commandant will be done for."

The explorer had to suppress a smile; so easy, then, was the task he had felt to be so difficult. He said evasively: "You overestimate my influence; the Commandant has read my letters of recommendation, he knows that I am no expert in criminal procedure. If I were to give an opinion, it would be as a private individual, an opinion no more influential than that of any ordinary person, and in any case much less influential than that of the Commandant, who, I am given to understand, has very extensive powers in this penal colony. If his attitude to your procedure is as definitely hostile as you believe, then I fear the end of your tradition is at hand, even without any humble assistance from me."

Had it dawned on the officer at last? No, he still did not

understand. He shook his head emphatically, glanced briefly around at the condemned man and the soldier, who both flinched away from the rice, came close up to the explorer, and without looking at his face but fixing his eye on some spot on his coat said in a lower voice than before: "You don't know the Commandant; you feel yourself—forgive the expression—a kind of outsider so far as all of us are concerned; yet, believe me, your influence cannot be rated too highly. I was simply delighted when I heard that you were to attend the execution all by yourself. The Commandant arranged it to aim a blow at me, but I shall turn it to my advantage. Without being distracted by lying whispers and contemptuous glances—which could not have been avoided had a crowd of people attended the execution—you have heard my explanations, seen the machine, and are now in course of watching the execution. You have doubtless already formed your own judgment; if you still have some small uncertainties the sight of the execution will resolve them. And now I make this request to you: help me against the Commandant!"

The explorer would not let him go on. "How could I do that," he cried, "it's quite impossible. I can neither help nor hinder you."

"Yes, you can," the officer said. The explorer saw with a certain apprehension that the officer had clenched his fists. "Yes, you can," repeated the officer, still more insistently. "I have a plan that is bound to succeed. You believe your influence is insufficient. I know that it is sufficient. But even granted that you are right, is it not necessary, for the sake of preserving this tradition, to try even what might prove insufficient? Listen to my plan, then. The first thing necessary for you to carry it out is to be as reticent as possible today regarding your verdict on these proceedings. Unless you are asked a direct question you must say nothing at all; but what you do

say must be brief and general; let it be remarked that you would prefer not to discuss the matter, that you are out of patience with it, that if you are to let yourself go you would use strong language. I don't ask you to tell any lies; by no means; you should only give curt answers, such as: 'Yes, I saw the execution,' or 'Yes, I had it explained to me.' Just that, nothing more. There are grounds enough for any impatience you betray, although not such as will occur to the Commandant. Of course, he will mistake your meaning and interpret it to please himself. That's what my plan depends on. Tomorrow in the Commandant's office there is to be a large conference of all the high administrative officials, the Commandant presiding. Of course the Commandant is the kind of man to have turned these conferences into public spectacles. He has had a gallery built that is always packed with spectators. I am compelled to take part in the conferences, but they make me sick with disgust. Now, whatever happens, you will certainly be invited to this conference; if you behave today as I suggest, the invitation will become an urgent request. But if for some mysterious reason you're not invited, you'll have to ask for an invitation; there's no doubt of your getting it then. So tomorrow you're sitting in the Commandant's box with the ladies. He keeps looking up to make sure you're there. After various trivial and ridiculous matters, brought in merely to impress the audience—mostly harbor works, nothing but harbor works!—our judicial procedure comes up for discussion too. If the Commandant doesn't introduce it, or not soon enough, I'll see that it's mentioned. I'll stand up and report that today's execution has taken place. Quite briefly, only a statement. Such a statement is not usual, but I shall make it. The Commandant thanks me, as always, with an amiable smile, and then he can't restrain himself, he seizes the excellent opportunity. 'It has just been reported,' he will say, or words to that

effect, 'that an execution has taken place. I should like merely to add that this execution was witnessed by the famous explorer who has, as you all know, honored our colony so greatly by his visit to us. His presence at today's session of our conference also contributes to the importance of this occasion. Should we not now ask the famous explorer to give us his verdict on our traditional mode of execution and the procedure that leads up to it?' Of course there is loud applause, general agreement, I am more insistent than anyone. The Commandant bows to you and says: 'Then in the name of the assembled company, I put the question to you.' And now you advance to the front of the box. Lay your hands where everyone can see them, or the ladies will catch them and press your fingers.—And then at last you can speak out. I don't know how I'm going to endure the tension of waiting for that moment. Don't put any restraint on yourself when you make your speech, publish the truth aloud, lean over the front of the box, shout, yes indeed, shout your verdict, your unshakable conviction, at the Commandant. Yet perhaps you wouldn't care to do that, it's not in keeping with your character, in your country perhaps people do these things differently, well, that's all right too, that will be quite as effective, don't even stand up, just say a few words, even in a whisper, so that only the officials beneath you will hear them, that will be quite enough, you don't even need to mention the lack of public support for the execution, the creaking wheel, the broken strap, the filthy gag of felt, no, I'll take all that upon me, and, believe me, if my indictment doesn't drive him out of the conference hall, it will force him to his knees to make the acknowledgment: Old Commandant, I humble myself before you.—That is my plan; will you help me to carry it out? But of course you are willing, what is more, you must."
And the officer seized the explorer by both arms and gazed,

breathing heavily, into his face. He had shouted the last sentence so loudly that even the soldier and the condemned man were startled into attending; they had not understood a word but they stopped eating and looked over at the explorer, chewing their previous mouthfuls.

From the very beginning the explorer had no doubt about what answer he must give; in his lifetime he had experienced too much to have any uncertainty here; he was fundamentally honorable and unafraid. And yet now, facing the soldier and the condemned man, he did hesitate, for as long as it took to draw one breath. At last, however, he said, as he had to: "No." The officer blinked several times but did not turn his eyes away. "Would you like me to explain?" asked the explorer. The officer nodded wordlessly. "I do not approve of your procedure," said the explorer then, "even before you took me into your confidence—of course I shall never in any circumstances betray your confidence—I was already wondering whether it would be my duty to intervene and whether my intervention would have the slightest chance of success. I realized to whom I ought to turn: to the Commandant, of course. You have made that fact even clearer, but without having strengthened my resolution, on the contrary, your sincere conviction has touched me, even though it cannot influence my judgment."

The officer remained mute, turned to the machine, caught hold of a brass rod, and then, leaning back a little, gazed at the Designer as if to assure himself that all was in order. The soldier and the condemned man seemed to have come to some understanding; the condemned man was making signs to the soldier, difficult though his movements were because of the tight straps; the soldier was bending down to him; the condemned man whispered something and the soldier nodded.

The explorer followed the officer and said: "You don't know yet what I mean to do. I shall tell the Commandant what I think of the procedure, certainly, but not at a public conference, only in private; nor shall I stay here long enough to attend any conference; I am going away early tomorrow morning, or at least embarking on my ship."

It did not look as if the officer had been listening. "So you did not find the procedure convincing," he said to himself and smiled, as an old man smiles at childish nonsense and yet pursues his own meditations behind the smile.

"Then the time has come," he said at last, and suddenly looked at the explorer with bright eyes that held some challenge, some appeal for cooperation. "The time for what?" asked the explorer uneasily, but got no answer.

"You are free," said the officer to the condemned man in the native tongue. The man did not believe it at first. "Yes, you are set free," said the officer. For the first time the condemned man's face woke to real animation. Was it true? Was it only a caprice of the officer's, that might change again? Had the foreign explorer begged him off? What was it? One could read these questions on his face. But not for long. Whatever it might be, he wanted to be really free if he might, and he began to struggle so far as the Harrow permitted him.

"You'll burst my straps," cried the officer, "lie still! We'll soon loosen them." And signing the soldier to help him, he set about doing so. The condemned man laughed wordlessly to himself, now he turned his face left toward the officer, now right toward the soldier, nor did he forget the explorer.

"Draw him out," ordered the officer. Because of the Harrow this had to be done with some care. The condemned man had already torn himself a little in the back through his impatience.

From now on, however, the officer paid hardly any atten-

tion to him. He went up to the explorer, pulled out the small leather wallet again, turned over the papers in it, found the one he wanted, and showed it to the explorer. "Read it," he said. "I can't," said the explorer, "I told you before that I can't make out these scripts." "Try taking a close look at it," said the officer and came quite near to the explorer so that they might read it together. But when even that proved useless, he outlined the script with his little finger, holding it high above the paper as if the surface dared not be sullied by touch, in order to help the explorer to follow the script in that way. The explorer did make an effort, meaning to please the officer in this respect at least, but he was quite unable to follow. Now the officer began to spell it, letter by letter, and then read out the words. "'BE JUST!' is what is written there," he said, "surely you can read it now." The explorer bent so close to the paper that the officer feared he might touch it and drew it farther away; the explorer made no remark, yet it was clear that he still could not decipher it. "'BE JUST!' is what is written there," said the officer once more. "Maybe," said the explorer, "I am prepared to believe you." "Well, then," said the officer, at least partly satisfied, and climbed up the ladder with the paper; very carefully he laid it inside the Designer and seemed to be changing the disposition of all the cog-wheels; it was a troublesome piece of work and must have involved wheels that were extremely small, for sometimes the officer's head vanished altogether from sight inside the Designer, so precisely did he have to regulate the machinery.

The explorer, down below, watched the labor uninterruptedly, his neck grew stiff and his eyes smarted from the glare of sunshine over the sky. The soldier and the condemned man were now busy together. The man's shirt and trousers, which were already lying in the pit, were fished out by the point of the soldier's bayonet. The shirt was abom-

inably dirty and its owner washed it in the bucket of water. When he put on the shirt and trousers both he and the soldier could not help guffawing, for the garments were of course slit up behind. Perhaps the condemned man felt it incumbent on him to amuse the soldier, he turned around and around in his slashed garments before the soldier, who squatted on the ground beating his knees with mirth. All the same, they presently controlled their mirth out of respect for the gentlemen.

When the officer had at length finished his task aloft, he surveyed the machinery in all its details once more, with a smile, but this time shut the lid of the Designer, which had stayed open till now, climbed down, looked into the pit and then at the condemned man, noting with satisfaction that the clothing had been taken out, then went over to wash his hands in the water bucket, perceived too late that it was disgustingly dirty, was unhappy because he could not wash his hands, in the end thrust them into the sand—this alternative did not please him, but he had to put up with it—then stood upright and began to unbutton his uniform jacket. As he did this, the two ladies' handkerchiefs he had tucked under his collar fell into his hands. "Here are your handkerchiefs," he said, and threw them to the condemned man. And to the explorer he said in explanation: "A gift from the ladies."

In spite of the obvious haste with which he was discarding first his uniform jacket and then all his clothing, he handled each garment with loving care, he even ran his fingers caressingly over the silver lace on the jacket and shook a tassel into place. This loving care was certainly out of keeping with the fact that as soon as he had a garment off he flung it at once with a kind of unwilling jerk into the pit. The last thing left to him was his short sword with the sword belt. He drew it out of the scabbard, broke it, then gathered all together, the

bits of the sword, the scabbard, and the belt, and flung them so violently down that they clattered into the pit.

Now he stood naked there. The explorer bit his lips and said nothing. He knew very well what was going to happen, but he had no right to obstruct the officer in anything. If the judicial procedure which the officer cherished were really so near its end—possibly as a result of his own intervention, as to which he felt himself pledged—then the officer was doing the right thing; in his place the explorer would not have acted otherwise.

The soldier and the condemned man did not understand at first what was happening, at first they were not even looking on. The condemned man was gleeful at having got the handkerchiefs back, but he was not allowed to enjoy them for long, since the soldier snatched them with a sudden, unexpected grab. Now the condemned man in turn was trying to twitch them from under the belt where the soldier had tucked them, but the soldier was on his guard. So they were wrestling, half in jest. Only when the officer stood quite naked was their attention caught. The condemned man especially seemed struck with the notion that some great change was impending. What had happened to him was now going to happen to the officer. Perhaps even to the very end. Apparently the foreign explorer had given the order for it. So this was revenge. Although he himself had not suffered to the end, he was to be revenged to the end. A broad, silent grin now appeared on his face and stayed there all the rest of the time.

The officer, however, had turned to the machine. It had been clear enough previously that he understood the machine well, but now it was almost staggering to see how he managed it and how it obeyed him. His hand had only to approach the Harrow for it to rise and sink several times till it was adjusted to the right position for receiving him; he

233

touched only the edge of the Bed and already it was vibrating; the felt gag came to meet his mouth, one could see that the officer was really reluctant to take it but he shrank from it only a moment, soon he submitted and received it. Everything was ready, only the straps hung down at the sides, yet they were obviously unnecessary, the officer did not need to be fastened down. Then the condemned man noticed the loose straps, in his opinion the execution was incomplete unless the straps were buckled, he gestured eagerly to the soldier and they ran together to strap the officer down. The latter had already stretched out one foot to push the lever that started the Designer; he saw the two men coming up; so he drew his foot back and let himself be buckled in. But now he could not reach the lever; neither the soldier nor the condemned man would be able to find it, and the explorer was determined not to lift a finger. It was not necessary; as soon as the straps were fastened the machine began to work; the Bed vibrated, the needles flickered above the skin, the Harrow rose and fell. The explorer had been staring at it quite a while before he remembered that a wheel in the Designer should have been creaking; but everything was quiet, not even the slightest hum could be heard.

Because it was working so silently the machine simply escaped one's attention. The explorer observed the soldier and the condemned man. The latter was the more animated of the two, everything in the machine interested him, now he was bending down and now stretching up on tiptoe, his forefinger was extended all the time pointing out details to the soldier. This annoyed the explorer. He was resolved to stay till the end, but he could not bear the sight of these two. "Go back home," he said. The soldier would have been willing enough, but the condemned man took the order as a punish-

ment. With clasped hands he implored to be allowed to stay, and when the explorer shook his head and would not relent, he even went down on his knees. The explorer saw that it was no use merely giving orders, he was on the point of going over and driving them away. At that moment he heard a noise above him in the Designer. He looked up. Was that cogwheel going to make trouble after all? But it was something quite different. Slowly the lid of the Designer rose up and then clicked wide open. The teeth of a cogwheel showed themselves and rose higher, soon the whole wheel was visible, it was as if some enormous force were squeezing the Designer so that there was no longer room for the wheel, the wheel moved up till it came to the very edge of the Designer, fell down, rolled along the sand a little on its rim, and then lay flat. But a second wheel was already rising after it, followed by many others, large and small and indistinguishably minute, the same thing happened to all of them, at every moment one imagined the Designer must now really be empty, but another complex of numerous wheels was already rising into sight, falling down, trundling along the sand, and lying flat. This phenomenon made the condemned man completely forget the explorer's command, the cogwheels fascinated him, he was always trying to catch one and at the same time urging the soldier to help, but always drew back his hand in alarm, for another wheel always came hopping along which, at least on its first advance, scared him off.

The explorer, on the other hand, felt greatly troubled; the machine was obviously going to pieces; its silent working was a delusion; he had a feeling that he must now stand by the officer, since the officer was no longer able to look after himself. But while the tumbling cogwheels absorbed his whole attention he had forgotten to keep an eye on the rest of the

machine; now that the last cogwheel had left the Designer, however, he bent over the Harrow and had a new and still more unpleasant surprise. The Harrow was not writing, it was only jabbing, and the Bed was not turning the body over but only bringing it up quivering against the needles. The explorer wanted to do something, if possible, to bring the whole machine to a standstill, for this was no exquisite torture such as the officer desired, this was plain murder. He stretched out his hands. But at that moment the Harrow rose with the body spitted on it and moved to the side, as it usually did only when the twelfth hour had come. Blood was flowing in a hundred streams, not mingled with water, the water jets too had failed to function. And now the last action failed to fulfill itself, the body did not drop off the long needles, streaming with blood it went on hanging over the pit without falling into it. The Harrow tried to move back to its old position, but as if it had itself noticed that it had not yet got rid of its burden it stuck after all where it was, over the pit. "Come and help!" cried the explorer to the other two, and himself seized the officer's feet. He wanted to push against the feet while the others seized the head from the opposite side and so the officer might be slowly eased off the needles. But the other two could not make up their minds to come; the condemned man actually turned away; the explorer had to go over to them and force them into position at the officer's head. And here, almost against his will, he had to look at the face of the corpse. It was as it had been in life; no sign was visible of the promised redemption; what the others had found in the machine the officer had not found; the lips were firmly pressed together, the eyes were open, with the same expression as in life, the look was calm and convinced, through the forehead went the point of the great iron spike.

———

As the explorer, with the soldier and the condemned man behind him, reached the first houses of the colony, the soldier pointed to one of them and said: "There is the teahouse."

In the ground floor of the house was a deep, low, cavernous space, its walls and ceiling blackened with smoke. It was open to the road all along its length. Although this teahouse was very little different from the other houses of the colony, which were all very dilapidated, even up to the Commandant's palatial headquarters, it made on the explorer the impression of a historic tradition of some kind, and he felt the power of past days. He went near to it, followed by his companions, right up between the empty tables that stood in the street before it, and breathed the cool, heavy air that came from the interior. "The old man's buried here," said the soldier, "the priest wouldn't let him lie in the churchyard. Nobody knew where to bury him for a while, but in the end they buried him here. The officer never told you about that, for sure, because of course that's what he was most ashamed of. He even tried several times to dig the old man up by night, but he was always chased away." "Where is the grave?" asked the explorer, who found it impossible to believe the soldier. At once both of them, the soldier and the condemned man, ran before him pointing with outstretched hands in the direction where the grave should be. They led the explorer right up to the back wall, where guests were sitting at a few tables. They were apparently dock laborers, strong men with short, glistening, full black beards. None had a jacket, their shirts were torn, they were poor, humble creatures. As the explorer drew near, some of them got up, pressed close to the wall, and stared at him. "It's a foreigner," ran the whisper around him, "he wants to see the grave." They pushed one of the tables aside, and under it there was really a gravestone. It was a simple stone, low enough to be covered by a table.

There was an inscription on it in very small letters, the explorer had to kneel down to read it. This was what it said: "Here rests the old Commandant. His adherents, who now must be nameless, have dug this grave and set up this stone. There is a prophecy that after a certain number of years the Commandant will rise again and lead his adherents from this house to recover the colony. Have faith and wait!" When the explorer had read this and risen to his feet he saw all the bystanders around him smiling, as if they too had read the inscription, had found it ridiculous, and were expecting him to agree with them. The explorer ignored this, distributed a few coins among them, waiting till the table was pushed over the grave again, quitted the teahouse, and made for the harbor.

The soldier and the condemned man had found some acquaintances in the teahouse, who detained them. But they must have soon shaken them off, for the explorer was only halfway down the long flight of steps leading to the boats when they came rushing after him. Probably they wanted to force him at the last minute to take them with him. While he was bargaining below with a ferryman to row him to the steamer, the two of them came headlong down the steps, in silence, for they did not dare to shout. But by the time they reached the foot of the steps the explorer was already in the boat, and the ferryman was just casting off from the shore. They could have jumped into the boat, but the explorer lifted a heavy knotted rope from the floor boards, threatened them with it, and so kept them from attempting the leap.

# Convict K00457

**ROBERT C. ALLEN**

Both of my arms have bands just above the elbows. My left arm has a chain (one link accidentally done wrong), my right arm has barbed wire (done at separate times by different people, so it had to be done with the effect of tearing through the flesh). Above the chain is a collage of candles, demons, elves, ten calendar years, a skeleton judge, rotting flesh, and flames. Above the barbed wire, on the inside of my arm, I have a pair of praying hands. On the outside, my Savior on the cross, with the words *Jesus Saves* on either side.

The tattoo on my collar is four words. The words *Jesus Saves* are legible, going from left to right across the width of my chest. Under those words, going in the opposite direction, upside down and backwards, are the words *Evil Ways*. I decided to get this because I always saw myself stuck between good and evil. The words are done in a beautiful script, and the tattoo is only tip-shaded. By the way, the collar area is not as sensitive as everyone makes it out to be.

The tattoo on the lower left half of my back is a demon I found in a book of demons and mythology. I was looking for something to help even out the motif I was going for, a balance of good and evil. His name is Eurynome, and he is said to conjure up the murdering tendencies in people. He is incredibly ugly, with long claws on his fingers and toes. On his

back he wears the skin of a goat for a cape. Yet, as ugly as he is, it is a beautiful tattoo. Very much worth the pain.

The tattoo on my back right shoulder is a Celtic knot-work cross, with an eyeball at the top, a flaming heart at the foot, and a complex knot in the center. The eyeball represents the spiritual third eye that guides me. The heart represents the burning heart of my Savior. And the complex knot represents everything. The idea for this tattoo was mine. I thought of it after watching a movie with a priest that had a tattoo of a huge knot-work cross in the center of his back.

The tattoo on the lower right half of my back is an old frontiersman. He's leaning back with his rifle laying on his lap, the only thing at ease with him being his beard. His coat has those old, wide-eyed clasps from the Civil War era, and his gun has great detail, betraying its age. I got the pattern from a card my mom sent me because the guy looks a lot like my uncle. But the tattoo isn't done, because the man doing the work sliced someone's throat.

# Mando

**STEVE VENDER**

Even after all these years, I still love going to jail. A lot of the criminal defense investigators I know hate it, but they burned out long ago, having heard one too many stories with the same sad line.

"Man, you know I didn't do it."

"Who did?"

"Dude. It was Dude done did it. Not me."

I hear the same line, but it never bothers me. In fact, I don't even ask my guy if he committed the crime he's charged with unless it's absolutely necessary. Citizens don't seem to understand this, but my job is to provide the best possible defense, and that defense usually begins in jail. Of course I never know what's going to happen when I go to the jail. That's the hook.

Tonight I'm here to see Mando, and it's going to take some time because he's in Ad Seg (Administrative Segregation), caged in a cell half the size of a bathroom. It'll take time to cuff and chain him, and then get extra deputies to escort him to the interview room where I'm waiting. Past experience dictates that Mando can never, and that is never, come into contact with any of the other inmates.

While waiting for Mando, I stand outside the interview room and look down the long tier of the mainline. The noise in jail is overwhelming. Inmates are yelling at each other

241

through the bars on each side of the tier. I can hear a hustle going on between B-1 and C-1. Somebody in B-2 is loudly dissing a rival in C-2. There are threats amidst laughter, lame come-ons, everybody pent up and crazed from being locked down day and night. Imagine a hundred radios at full volume all tuned to a different station, and you get some sense of the noise level. It's ear-splitting, nerve-jangling, the most demented cacophony you'll ever hear.

Mando is different, though, he doesn't need to raise his voice or get into the mix. His tattoos say it all. They speak volumes.

I remember the first time I came to see him, when he was still on the mainline in the general population, wearing orange sweats instead of the red ones that the Ad Segers wear. There was Mando, sauntering down the line to the big locked gate that separated us, his head completely shaved and tattooed with a 49er's football helmet, logos on each side, with smaller tattoos covering his neck. Tip of the iceberg.

Mando had been charged with First Degree Murder and two counts of Attempted, and there was no possible way that anyone could say Dude did that one, with the surviving victims all too willing to point the finger at Mando. There were so many charges in the Criminal Complaint that it looked like a small booklet instead of the two or three pages you usually get.

Mando was a Norteño gang member, upper tier in rank and one of their best killers. He had attacked three Sureños who had foolishly crossed into Norteño territory, stabbing all three of them and killing one man. Mando just loved the knife. The two daggers he had tattooed on each side of his

neck, with drops of blood dripping from the tips, told the world the knife was his weapon of choice.

I had worked cases involving a few of Mando's homies, so Mando had heard about me. He knew I defended Sureños, too, but it was never a point of contention between us. Mando understood. It was just business. He might call me a *gavacho,* a white man, and he knew I didn't live *la vida loca* like he did, but he had respect for anyone who worked in the streets like I did. For him, that took heart. I had *corazón,* and he appreciated that, enough so to give us room to work together.

As for his case, well, you either have room to work or you don't, and with Mando there was hardly any room to wiggle. Mando would take the hit, no matter what. It was just a question of how hard that hit would be. The only way we could go was with self-defense. Hey, *tres* stuck Sureños, and one dead guy named "Dreamer" who was fingering a loaded 9mm when the police rolled him over, were mitigating factors, no matter how faint the light seemed. And then there were Mando's meds, reports from San Francisco General Hospital documenting a history of being shot, stabbed, and assaulted with bats, sticks, clubs, bottles, pipes, and anything else that might have been handy. Mando's meds were thick as a phone book. They would show why he needed to stab three guys and snuff one man's dreams. And, so, with that little light, we went to work.

When you're doing criminal defense, the first interview is crucial. You establish a rapport, or you don't. Your guy knows he can trust you, or he can't. It sounds simple, but when you're sitting across from someone who's committed a horrendous crime, and this person is very bright, and what's more you find yourself liking him on some level, well, it can

get complex. The smart guys know how to exploit this tension, and that's when mental chess begins on the Masters level. I'd danced to that first-interview number hundreds of times, and nothing much bothered me anymore, but that 49er's helmet tattooed on Mando's head threw me. Of course it would be the 'Niners. They wore red, Norteño colors, while the Sureños, their archenemies, wore blue. And then throw in those tattoos on his neck and it made it difficult to concentrate. Was it the tombstone with *RIP* on his Adam's apple, forever mourning the death of his "primo"? Or maybe it was those daggers. Either way, it was hard not to look.

I managed to get the trust I wanted from that first interview despite the noise that Mando's tattoos made in that cramped interview room. And make no mistake about it, tattoos are all about sound. They are never silent. They announce, but what's more they pronounce. They tell the world what kind of man stands before it. Tattoos not only provide identity, they do much more. They provide a look at the inside of a man, sometimes showing you things you just don't want to see.

Since we were going with self-defense, I wanted to document Mando's history. I made the necessary arrangements to photograph his wounds when I went to see him the second time. As I readied the camera to shoot the scars, Mando slipped the sweatshirt over his muscular shoulders. That's when I heard one long nightmarish wail.

Mando's body was covered with tattoos from his waist to his neck, a canvas painted by a lunatic, a road map to hell. His torso was a city with no zoning laws, full of weird structures erected by crazed builders whacked out on bad speed. There were billboards everywhere, full of spiders and cobwebs, bats and snakes, skulls and bones, the Grim Reaper presiding over it

all. Above his left breast was a Janus face, half laughing, half crying. Above the right one was a woman with long hair, a river of tears falling from her eyes. In the center of his chest a huge Jesus offered absolution. Thorns and chains ran along his sides, continuing above the faces on his breast, and in the middle of his stomach was the word *Excelsior* done in Old English lettering, telling the world that was the section of San Francisco where Mando ruled. Some of the tattoos I could read; some of them I couldn't. The spiders and cobwebs were for the time he'd done. The laughing and crying faces were for his happy and sad life. The crying woman meant someone, somewhere on the outside was waiting for him. One look and I knew those tears would continue to fall, the wait would be long.

I worked on Mando's case for the better part of a year, right through the preliminary hearing and into trial preparation, documenting his history, preparing to bring the citizens who would sit on his jury into *la violencia,* the absolutely brutal killing that never seemed to end. And then, it was over. We had always been paddling upstream, trying to make someone understand why Mando would do such a thing, but in one brief moment Mando threw his paddle over the side and headed in the direction he was always meant to go, no matter what anyone did to keep things on course.

Up until this point, Mando had been doing his county jail time without any incidents. The sheriff's deputies who ran the jails were hip to the war on the streets. Just because Norteños and Sureños were locked up didn't mean the hostilities ceased, so they usually kept the gangs segregated. But in an environment like county jail, a boiling pot full of killers, torture lovers, baby rapers, amped-up dopers, gangbangers and every known variety of psycho in the catalog, there are bound to be fuckups.

Shortly before trial, when Mando was walking the main-line one day, somebody fucked up and let a Sureño out at the same time. Just as the man passed, Mando grabbed him by the hair and pulled him backward. In a second, Mando cut the man's throat from ear to ear with a jail blade fashioned from pilfered safety razors. As the man fell, clutching at his neck and desperately gasping for air, Mando stood over him, arms aloft, laughing maniacally.

Miraculously, the man survived. A week later I saw the photos taken by the Sheriff's Department as part of the Discovery package provided by the DA's office. It was Mando's new case.

Mando comes out of Ad Seg, cuffed and chained, into the interview room, and we look at the photos together. When we're finished, I go straight to the bar across the street from the jail and drink steadily for two hours, continuing to look at the photographs. I can't stop looking at that cut, the jagged red gully that was carved into the man's throat. It looks like an aerial photo of a clear-cut forest, an obscene violence blighting the landscape. I try counting the stitches, but I'm either too drunk or there are too many and I lose count.

When I get home that night, I begin thinking about all of the bangers who look at themselves as soldiers in a war. Then I think about all of the books I've read on gangs and poverty, disintegrating families, overcrowding and alienation. But what keeps coming back to me is the look in Mando's eyes when I showed him the photographs. I'd been looking at Mando's tattoos all during the time I worked on his case, and they certainly told me things about him, but now I understood that Mando never needed those tattoos. He had his

eyes. That look was all he needed to wear, a look that took you to the bottom of the ocean, a place so cold and so dark that only the most hideous creatures could survive there. The silence in that look had me spooked far more than any of the sounds that ever came from his tattoos.

# The News

### TONY HOAGLAND

The big country beat the little country up
like a schoolyard bully,
so an even bigger country stepped in
and knocked it on its ass to make it nice,
which reminds me of my Uncle Bob's
                              philosophy of parenting.

It's August, I'm sitting on the porch swing,
touching the sores inside my mouth
with the tip of my tongue, watching the sun
go down in the west like a sinking ship,
from which a flood of stick orange bleeds out.

It's the hour of meatloaf perfume emanating from the
    houses.
It's the season of Little League practice
and atonal high school band rehearsals.
You can't buy a beach umbrella in the stores till next year.
The summer beauty pageants are all over,
and no one I know won the swimsuit competition.

This year illness just flirted with me,
picking me up and putting me down
like a cat with a ball of yarn,
so I walked among the living like a tourist,

and I wore my health uneasily, like a borrowed shirt,
knowing I would probably have to give it back.

There are the terrible things that happen to you
and the terrible things that you yourself make happen,
like Frank, who gave his favorite niece
a little red sports car
for her to smash her life to pieces in.

And the girl on the radio sings,
*You know what I'm talking about. Bawhoop, awhoop.*

This year it seems like everyone is getting tattoos—
Great White sharks and Chinese characters,
hummingbirds and musical notes—
but the only tattoo I would want to get
is of a fist and a rose.

But I can't tell how they will fit together on my shoulder.
If the rose is inside the fist, it will be crushed or hidden;
if the fist is closed, as a fist by definition is,
it cannot reach out to touch the rose.

Yet the only tattoo I want this year
is of a fist and rose, together.
Fist, that helps you survive.
Rose, without which
                    you have no reason to live.

# The Y

BRENDA HILLMAN

They are bringing back the bones of Che Guevara
    so the system of universal capitalism
    will be reversed while a girl on the stairmaster
    reads *Anna Karenina,* pausing at the part
    where Vronsky, thinking Anna into the wrong coldness,
    might turn his back on her another time. The girl
    would name her dog for him if she had one. Legs with
    many tattoos of heavenly bodies (ceiling
    stars, moons, snakes) push weights; it all shakes, and
        east of here,
    aspen forests growing from root systems that never
    die send out shoots above ground anyway because
    the lust to be individual exceeds the
    desire to lie down anonymously above
    a mantle of fire. No one's arguing about
    formal necessity or the power below
    survival or if they wanted to be touched, there.

# *from* "The Life and Death of Philippe"

## PAUL STEINBERG

The next day was devoted to learning various rituals and, above all, the salutes. We were taught the *Mützen auf, Mützen ab,* the basic exercise that served as a common denominator in all the camps.

In the presence of an SS soldier you had to stand at attention and doff your cap, *Mützen ab,* slapping it against your thigh; it was the same for roll call. The command equivalent of "At ease!" was *Mützen auf,* "Caps on." If an SS man spoke to you, or even looked at you, you had to salute and recite your identification, that is, the number that would be assigned to you and tattooed on your left arm, the number that from then on would be your official identity.

The tattooing took place the following day, in fact, at the hands of the approved expert. We lined up for the last time in alphabetical order. Our series began with 156,900 and something. Philippe was baptized 157,090 and I became 157,239. It was all done with the same needle, a succession of rather deep shots, painful but bearable. (I've never experienced unbearable pain. Unless it was last year—and morphine managed to take care of it.) Just my bad luck, my family name started with *S,* which came right after the *R*s. And someone who had a last name beginning with that letter had a hepatitis virus. I was infected along with thirty or forty others who had no antibodies. The epidemic broke out after a few weeks' incubation, and I'm probably the only one who survived it.

# True Tattoo

## MAUREEN SEATON

Poet Gregg Shapiro wrote a tattoo poem in which his father had numbers carved on his forearm. The poem is wonderful, although a lie, and I always teach it to my beginning students so they know it's okay to lie in a poem. I bring Shapiro in as a guest. He's funny and lovable, and the students eventually forgive him for lying about his father's arm.

When my mother died, a refrain began in my head that I didn't recognize for days: "She isn't merely dead, she's really and sincerely dead." I was appalled at first to find this callous Munchkin melody repeating in my brain. Shapiro tells my class that his tattoo poem, although technically a lie, was written with love for his father and the Jewish people. When I tell him that the truth about my grief is that sometimes I find myself singing "Ding Dong the Witch Is Dead," he supports me because he is good at holding more than one truth at a time.

This is how I came to get my first tattoo. My friend Cobalt had been practicing tattooing on citrus fruit for weeks, so I shaved my leg just above the knee and held my breath as she dug in. I've described the pain as being splattered with hot grease every second for three hours. My mom's death took sixteen months. Believe me when I say that getting a tattoo reminds me a little of death, the surrender of skin, the grind of teeth, bones humming, soul chasing light.

# "I do not have a tattoo . . ."

## SUSI RICHARDSON

I do not have a tattoo. My brother Mark, however, did. He cannot tell you about his tattoo because one cold February day, just shy of his thirtieth birthday, Mark jumped from the 59th Street Bridge in New York City. In a city of millions, no one saw him fall, but someone did find his body in the East River sludge. At the morgue, another someone handled the waterlogged body, read the tattoo stamped on Mark's chest: encircled in red, with a diagonal slash to say *no,* the four black letters, E-X-I-T.

# Wings, Fish, Star

**LAURA A. GOLDSTEIN**

1.

I walked over the dark bridge
and into a city I
did not know.
I pointed to the shadow
on the wall and was
given my black wings.

2.

He drew the fish
and placed it
under my breast
and worked for three hours
until I passed out
and then worked for another hour.
He told me the story of the koi
and the dragon and the pearl
and left it in three colors
on my body.

3.

When I returned
from the South

I got a green star.
Green because it is
a Mardi Gras color.
Behind my ankle
because I wanted
it to make me fly—
so that when I run
I'll lift off from
the ordinary ground.
And mostly I do.

# Benediction

**KATHARINE WHITCOMB**

Goldfish, spewed from the sewer, gills starved
for oxygen, write hieroglyphs in the muddy creek bottom
with their tails, write *the Lord bless us*

*and keep us, make his face to shine upon us,* write in praise
of time and their golden skin. In the world above, a sparrow
    sings
his old story under the winter eaves, sings *oh be gracious*

*unto us and give us peace.* Bless my friend who leans
across the restaurant table and says sometimes we don't know
when we're suffering. But it's there in the lines on our palms:

the world is a dangerous place, landscapes drift toward us
threatening burial or exposure, we skid over the freeway, the
    snow
spelling messages, twenty-five below, having courage, *lift up*

*your hearts* . . . In the labor camps of Perm, Sakhalin,
    Yekaterinburg,
convicts tattoo themselves, each other, with a secret
alphabet, pricking with dye made from burnt rubber and
    urine.

Three dots on a woman's hand means thief. An eight-
    pointed star
on a kneecap says I bow to no one. The eyes of a housefly
ink the cheeks of the rapist. The book of skin reads: *we lift
    them up*

*unto the Lord,* what is left to lift. And now
I sit with my hands full of stones, warming them, feeling the
    story
of crushing, slamming water, the great blue continents
    ground

together and apart. Blood warm stones sing a million praises
to our terrible short flame, all we get and never enough,
the veins in the rock singing *world without end, amen.*

# Contributors

J. ACOSTA is a poet and fiction writer who lives in San Francisco. He is the author of *The Tattoo Hunter* (Gato Negro Books), *The Reader of Borges,* and *Violent Velvet.*

KIM ADDONIZIO is the author of three collections of poetry, most recently *Tell Me,* which was a National Book Award Finalist. Her other books are *In the Box Called Pleasure* (FC2), a book of stories; and (with Dorianne Laux) *The Poet's Companion: A Guide to the Pleasures of Writing Poetry* (W. W. Norton).

ROBERT C. ALLEN is twenty-two years old and has been incarcerated for the past five and a half years. All of his tattoos have been done in prison.

JENNIFER ARMSTRONG is a musical storyteller and devotes her time to giving performances, workshops, and residencies in singing, storytelling, and writing across the country. She makes her home in Belfast, Maine.

LESLEE BECKER grew up in the Adirondacks, where tattoo artistry was exhibited at the Champlain Valley Fair, along with other sideshow attractions. She has published a story collection, *The Sincere Café,* and has had stories in *The Atlantic, Ploughshares, The Iowa Review,* and elsewhere.

BRUCE BOND's collections of poetry include *Independence Days* (R. Gross Award), *The Anteroom of Paradise* (Colladay Award), *Radiography* (Ornish Award, BOA Editions), and *The Throats of Narcissus* (University of Arkansas Press).

RAY BRADBURY, one of the stellar science fiction writers of our time, is the author of numerous books, among them *The Illustrated Man, Dandelion Wine, The Martian Chronicles,* and *Something Wicked This Way Comes.*

MADAME CHINCHILLA of Triangle Tattoo and Museum is a tattoo artist of fifteen years. She is the author of three books: one poetry, one children's, and *Stewed, Screwed and Tattooed.* She's the curator of Triangle Tattoo History Museum and has appeared on the Discovery Channel's documentary "Tattoo, Beauty, Art, and Pain."

GARNETT KILBERG COHEN's collection of short stories, *Lost Women, Banished Souls,* was published by the University of Missouri Press in 1996. She's published

stories and poems in numerous literary journals. She received a Special Mention in Fiction from Pushcart Prize 2000 and was awarded a 2001 Illinois Individual Artist's Award.

LARRY CRIST lives in Seattle, where he writes and acts. He is currently working on a novel. His poems have appeared in *Slipstream, Poetry Motel,* and many other journals.

MARK DOTY's sixth book of poems, *Source,* appeared from HarperCollins in 2001. He's received NEA and Guggenheim fellowships, a Whiting Writers Award, and a Lila Wallace/Reader's Digest Writers Award. He is a 2001/02 Fellow at the Center for Scholars and Writers at the New York Public Library.

DENISE DUHAMEL's most recent title is *Queen for a Day: Selected and New Poems* (University of Pittsburgh Press, 2001). Her work has appeared in many anthologies, including four editions of *Best American Poetry.* She is an assistant professor at Florida International University in Miami.

CHERYL DUMESNIL's poems have been published in several literary journals, including *Calyx, Many Mountains Moving,* and *Bakunin.* A former creative writing instructor at Santa Clara University, she currently teaches privately in the San Francisco Bay Area.

LAURA A. GOLDSTEIN is working toward a master's degree in creative writing at Temple University as a poet. She teaches composition, writing, and yoga, and holds poetry workshops in Philadelphia.

KAROL GRIFFIN lives in Laramie, Wyoming, with her son, Sam. Her writing has appeared in numerous magazines, including *Northern Lights, Fourth Genre, Red Rock Review,* the *Owen Wister Review, Dark Horse Literary Review,* and *Vista: New Perspectives on the West.* "Zowie" earned the Wyoming Arts Council 2000 Doubleday award.

THOM GUNN is the author of twelve books of poetry, including *The Man with Night Sweats, Collected Poems,* and most recently, *Boss Cupid.* He is the recipient of a MacArthur Fellowship and other awards.

BOB HICOK's books are *The Legend of Light, Plus Shipping,* and *Animal Soul.*

BRENDA HILLMAN is the author of five collections of poetry, all from Wesleyan University Press. She teaches at Saint Mary's College in Moraga, California. She has two tattoos and plans for a third.

TONY HOAGLAND has published two books, *Sweet Ruin* (University of Wisconsin) and *Donkey Gospel* (Graywolf). He's won fellowships from the NEA and the Guggenheim Foundation. He currently teaches at the University of Pittsburgh and is completing a third collection of poems and a collection of essays.

FRANZ KAFKA (1883–1924), an insurance man by trade, spent his evenings writing brilliant stories like "The Metamorphosis" and "In the Penal Colony," and the unfinished novels *The Trial, The Castle,* and *Amerika.*

FRANK MARTINEZ LESTER has lived in the San Francisco Bay Area for almost fifteen years. His work appears in the anthology *Looking Queer: Body Image and Identity in Lesbian, Gay, Bisexual, and Transgender Communities* (edited by Dawn Atkins, 1998), and he received a 1997–98 grant from PEN Center West.

J. D. MCCLATCHY is a noted poet, critic, and editor whose works include *Ten Commandments, White Paper,* and *The Vintage Book of Contemporary World Poetry.* He is also editor of the *Voice of the Poet* audiotape series. Since 1991 he has served as editor of *The Yale Review.*

ELIZABETH MCCRACKEN is the author of the novels *The Giant's House,* a National Book Award Finalist, and *Niagara Falls All Over Again,* as well as the story collection *Here's Your Hat What's Your Hurry.*

HERMAN MELVILLE (1819–1891) authored the classic *Moby Dick,* as well as numerous other works of poetry and fiction.

LISSETTE MENDEZ's poetry has appeared in a number of literary journals. She is a student in the Creative Writing Program at Florida International University and is working on a memoir and a collection of poems. She got her first tattoo at eighteen and never looked back.

DEENA METZGER, a writer, healer, and counselor, is the author of several collections, including *Tree: Essays and Pieces* (North Atlantic Books) and *Writing for Your Life: A Guide and Companion to the Inner Worlds* (HarperSF). She teaches writing in Los Angeles and at workshops around the country.

JOSEPH MILLAR spent twenty-five years working jobs from telephone repairman to commercial fisherman. His poems have appeared in *Shenandoah, Double-Take,* and other journals. His first collection is *Overtime* (Eastern Washington University Press). He teaches at Mount Hood Community College and the Mountain Writers Center in Portland, Oregon.

SETH MNOOKIN is a reporter living in New York City. He has written for *The New York Observer, Salon, Brill's Content, Inside, Slate,* and other sundry publications.

RICK MOODY is the author of the novels *The Ice Storm* and *Purple America* and most recently of *Demonology,* a collection of short stories.

ALEJANDRO MURGUÍA is the author of *Southern Front,* which received the 1991 American Book Award. In 2002, City Lights Books published a new collection, *This War Called Love. The Medicine of Memory: A Mexican Clan in California,*

nonfiction, is being published by the University of Texas Press. He teaches at San Francisco State University, College of Ethnic Studies.

FLANNERY O'CONNOR (1925–1964) authored the novels *Wise Blood* and *The Violent Bear It Away*. Her many acclaimed short stories are collected in the books *A Good Man Is Hard to Find* and *Everything That Rises Must Converge*.

DZVINIA ORLOWSKY is a founding editor of Four Way Books, a contributing editor to *Agni* and the *Marlboro Review*, and teaches creative writing at Emerson College, Boston. Her second collection, *Edge of House*, was published in 1999 by Carnegie Mellon University Press.

SYLVIA PLATH (1932–1963), perhaps best known for her novel, *The Bell Jar*, and her poetry collections, *The Colossus, Ariel, Crossing the Water*, and *Winter Trees*, also authored a book of short stories, *Johnny Panic and the Bible of Dreams*.

SUSI RICHARDSON is a New Hampshire–based writer. Her poems have appeared in *The Christian Science Monitor* and *The Lyric*, among other places.

KIRSTEN RYBCZYNSKI lives in Northampton, Massachusetts, where she is a full-time bookseller. She coproduces Queer Girls Write, a local reading series, and runs workshops for writers of memoir and fiction. Her piece in this anthology is from her memoir-in-progress, *The Poem My Father Wrote Called Fish*.

MAUREEN SEATON's new collection is *Little Ice Age* (Invisible Cities Press, 2001). She is the author of *Furious Cooking* (Iowa, 1996), which won the Iowa Poetry Prize and the Lambda Award. With Denise Duhamel, she coauthored *Exquisite Politics* (Tia Chucha Press, 1997) and *Oyl* (Pearl Editions, 2000).

PAUL STEINBERG (1926–2000) was deported to Auschwitz at the age of sixteen. The excerpt in this anthology is from his recently published memoir, *Speak You Also: A Survivor's Reckoning*. He appeared as Henri in Primo Levi's *Survival in Auschwitz*.

DARCEY STEINKE is the author of *Up Through Water, Suicide Blonde*, and *Jesus Saves*. Her new novel is *Milk*. She teaches at the New School in New York City.

VIRGINIA CHASE SUTTON's poems have appeared in *The Paris Review, Ploughshares, Antioch Review, Western Humanities Review*, and many other literary publications. She has been the Louis Untermeyer Scholar in Poetry at Bread Loaf Writers' Conference and was a winner of the Paumanock Poetry Award. She lives in Tempe, Arizona.

SUSAN TERRIS's book, *Curved Space*, was published in 1998 by La Jolla Poets Press. In 1999 she published *Eye of the Holocaust* (Arctos Press) and *Angels of Bataan* (Pudding House Publications). Her journal publications include the *Antioch Review, Ploughshares, Nimrod*, and *The Missouri Review*.

PETER TRACHTENBERG's stories have appeared in *TriQuarterly, Chicago,* and other literary magazines. Author of the books *7 Tattoos* and *The Casanova Complex,* he works as a performance artist and lives in New York City.

STEVE VENDER is a private investigator who lives in San Francisco. He specializes in disorganized crime and criminal defense.

WILLIAM T. VOLLMANN is a journalist and author of numerous works of fiction, including, most recently, *Argall,* third in a projected seven-novel series about the European conquest of North America, and *The Royal Family.*

MICHAEL WATERS teaches at Salisbury University in Maryland. His recent books include *Parthenopi: New and Selected Poems* (BOA Editions, 2001) and, with the late A. Poulin, Jr., the seventh edition of *Contemporary American Poetry* (Houghton Mifflin, 2001).

KATHARINE WHITCOMB is the winner of the 2000 Bluestem Poetry Award for her collection, *Saints of South Dakota and Other Poems.* Her poems have appeared in many journals, including *The Kenyon Review, The Missouri Review,* and *The Paris Review,* and have been nominated twice for a Pushcart Prize.

JOY WILLIAMS has written several novels and story collections, including *The Quick and the Dead* and *Taking Care.* Her new book is a collection of essays, *Ill Nature: Rants and Reflections on Humanity and Other Animals.*

ELIOT WILSON recently completed his Ph.D. in American drama at the University of Alabama. His poetry has appeared in *Ploughshares, Many Mountains Moving, Willow Springs,* and *Beloit Poetry Journal.*

CHERISE WYNEKEN is retired from teaching and raising four children. She lives with her husband of fifty years in Fort Lauderdale, Florida. Her book of poetry is *Seeded Puffs,* from Dry Bones Press, Inc.

# Permissions

Kathy Acker: Excerpt from *Empire of the Senseless* by Kathy Acker, copyright © 1988 by Kathy Acker. Reprinted by permission of Grove/Atlantic, Inc.

J. Acosta: Excerpt from *The Tattoo Hunter* by J. Acosta, Gato Negro Books. Reprinted by permission of the author.

Kim Addonizio: "First Poem for You" from *The Philosopher's Club* by Kim Addonizio, copyright © 1994 by Kim Addonizio. Reprinted by permission of BOA Editions.

Bruce Bond: "Second Skin" appeared as "Tattoos" in *The Anteroom of Paradise*, QRL, copyright © 1991 by Bruce Bond. Reprinted by permission of the author.

Ray Bradbury: Prologue from *The Illustrated Man* by Ray Bradbury, Doubleday, copyright © 1951, renewed 1979 by Ray Bradbury. Reprinted by permission of Don Congdon Associates, Inc.

Madame Chinchilla: "Herstory" from *Stewed, Screwed and Tattooed* by Madame Chinchilla, copyright © 1997 by Madame Chinchilla. Reprinted by permission of the author.

Mark Doty: "My Tattoo" from *Sweet Machine,* HarperCollins, copyright © 1998 by Mark Doty. Reprinted by permission of HarperCollins Publishers, Inc. "To the Engraver of My Skin" from *Source,* HarperCollins copyright © 2001 by Mark Doty. Reprinted by permission of HarperCollins Publishers, Inc.

Karol Griffin: "Zowie" first appeared in *Northern Lights.* Reprinted by permission of the author.

Thom Gunn: "Blackie, The Electric Rembrandt" from *Collected Poems,* copyright © 1994 by Thom Gunn. Reprinted by permission of Farrar, Straus and Giroux, LLC.

Bob Hicok: "Becoming Bird" first appeared in *Quarterly West.* Reprinted by permission of the author.

Brenda Hillman: "The Y" from *Cascadia,* Wesleyan University Press, copyright © 2001 by Brenda Hillman. Reprinted by permission of the author.

Tony Hoagland: "The News" originally appeared in *American Poetry Review.* Reprinted by permission of the author.

Franz Kafka: "In the Penal Colony" from *The Metamorphosis, The Penal Colony and Other Stories* by Franz Kafka, translated by Willa and Edwin Muir, copyright © 1948 by Schocken Books. Copyright renewed 1975 by Schocken Books. Reprinted by permission of Schocken Books, a division of Random House, Inc.

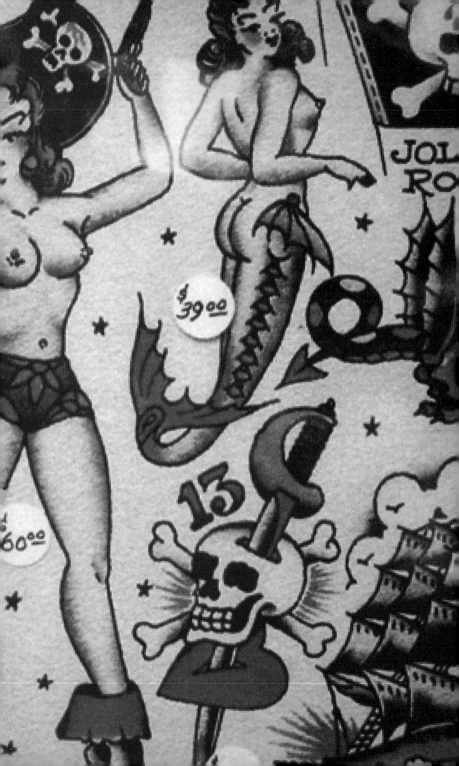